19-99 ✓

Electronic Imaging
Photographers

Electronic Imaging for Photographers

Adrian Davies and Phil Fennessy

Focal Press

Focal Press
An imprint of Butterworth-Heinemann
Linacre House, Jordan Hill, Oxford OX2 8DP
A division of Reed Educational and Professional Publishing Ltd

ℛ A member of the Reed Elsevier plc group

OXFORD BOSTON JOHANNESBURG
MELBOURNE NEW DELHI SINGAPORE

First published 1994 as *An Introduction to Electronic Imaging for Photographers*
Second edition 1996

British Library Cataloguing in Publication Data
A catalogue record for this book is available from the British Library.

ISBN 0 240 51141 6

Library of Congress Cataloguing in Publication Data
A catalogue record for this book is available from the Library of Congress.

Composition by Scribe Design, Gillingham, Kent
Printed and bound in Great Britain at The Bath Press, Bath

Contents

1
Introduction

Digital imaging, electronic imaging – the terms mean different things to different people. To the photographer it might mean filmless cameras, and an end to the processing and printing of film in darkrooms; to the darkroom technician it might mean image enhancement on a computer monitor; to the picture archivist it might mean storing a picture collection electronically, whilst to the printer it might mean scanning of images into desktop publishing programs and outputting straight to printing plate without the need for producing expensive separations.

It is really only within the last five years or so that electronic imaging has started to become an important tool to these people. But while electronic cameras have had a long and somewhat 'awkward' gestation period, desktop computers (without which none of the other technology could exist) have advanced extremely rapidly, with prices falling, and power increasing dramatically. A commonly used adage in computing is that prices halve every two years while power doubles every two years, and at present this shows no sign of slowing down!

For the photographer, whose technology has remained virtually unchanged for 50 years, the change has been, and will continue to be, dramatic – to some, very exciting with great potential, to others, a highly stressful period involving a steep learning curve and possible large capital investment. But there is no doubt that electronic imaging is here to stay, and while film will continue to be used for a considerable time yet (and in late 1995 an announcement was made by a consortium of the world's leading photographic companies about the Advanced Photographic System, aimed at revitalising the amateur photographic market with a new film system), no photographer can afford to ignore and must at least understand the potential of electronic imaging.

The electronic imaging chain can be compared with the traditional silver-based photographic chain. With film, the image is exposed in the camera, processed, then printed. With electronic imaging a similar chain can be seen, with image capture, image processing and image output.

Figure 1.1 illustrates some of the elements of electronic imaging, from image capture, either by electronic camera or by the scanning

Fig. 1.1 The imaging cycle. Electronic images can be obtained from both analogue and digital sources. Conventional video images, in analogue form, can be digitized using framegrabber boards, while conventional silver-based photographs can be scanned using a variety of digital scanning devices. Increasingly, digital cameras are available which can capture superb quality images and download them straight into a computer. The modern desktop computer is very much the central hub of modern electronic imaging, and a good understanding of its operation is essential for people using modern imaging technology. Generally, digital images are large, and require large amounts of storage space, and knowledge of the types of storage devices available is essential. Computers can perform a variety of operations to images. First, they may do nothing more than act as the means of transferring the image to a printer, into perhaps a magazine layout in a desktop publishing package, or into a multimedia program with other media. But of course, computers can also be used to enhance or manipulate images, or analyse them for their scientific data, and have become very powerful tools for this. Photographers are generally obsessed with the quality of the final output, and a good knowledge of the various methods of printing/outputting from the computer is essential if the best quality is to be obtained.

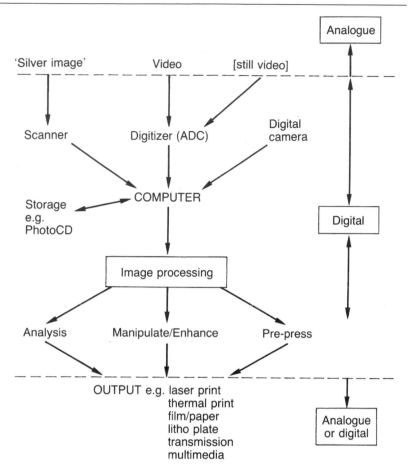

of 'silver-based' images, to image processing by computer, image storage and finally output by a number of different methods. Many photographers will be involved in just one part of the chain (capture or processing, for example) whereas others will need to know about the whole cycle. The traditional skills of the photographer – lighting, composition, dealing with models – are all still essential. But electronic imaging also opens up a host of new possibilities for photographers. Portfolios can now be stored on CD-ROM, duplicated and sent to agencies all round the world. Photographers can market their services on the Internet, not only still images, but also in multimedia formats.

But there are problems too. Photographers increasingly need to know about areas such as pre-press and desktop publishing, things which in the past have been the domain of graphic designers and reprography houses. Achieving acceptable colour, consistently, from computer to the printed page is still some way off, as is the production of inexpensive large runs of colour prints. By the same token, it is likely that many designers and others employed in the graphic arts industry will start to capture their own images with digital cameras and manipulate and enhance them on computer monitors.

Manipulation of images, whilst always possible photographically, is now much easier. This will lead to the generation of creative

images for advertising, for example. It will, however, also be abused by newspapers which already construct images on screen. The question of whether digitally manipulated images are admissible in photographic competitions is being actively debated around the world. Organizers of wildlife photography competitions are having to come to terms with the fact that while they may have a ruling banning digitally manipulated images, if these are done well, then no one will ever know! Also, many picture libraries may see their markets eroded with the advent of royalty-free images distributed on CD-ROM.

A frequently asked question is: 'when do we jump in ?' – when is the right time to make the investment into digital imaging? Of course there is no simple answer. With the rapid development of digital cameras, desktop computers, software and printers, machines can become 'obsolete' (though not useless!) within months of their purchase. One way to answer the question is to say that the investment is justifiable when clients start demanding digital services. Another is to look at one's overheads and see if digital technology can reduce them. A typical catalogue photographer, for example, may spend £40–50 000 per year on film and processing. If this can be replaced with a digital camera and computer then the cost is justified, *provided that the quality is good enough*. Many photographers are adding new services for clients, such as retouching and manipulation, or brochure design. For many photographers, the answer will be never – stick with film, and use a specialist facility whenever the need arises.

There are many other downsides to digital imaging. Imagine someone finding a stack of CD-ROMs in their attic in a hundred years' time. What will they play them on? Sure enough, CD players in their present form will not exist then (just look at the history of the gramophone record!).

This book is an attempt to explain the new technologies of electronic imaging to people without a computing or electronics background. It is not our intention to persuade everyone to 'convert' overnight to digital imaging, but instead to show the potential of the technology, to enable the readers to decide for themselves whether they wish to pursue it or not. One thing is certain – no one involved in the photographic or printing industry can afford to ignore it!

2
Image capture

Several methods are available for acquiring images and inputting them into a computer. Conventional silver-based photographs can be scanned, using a variety of scanning devices, while video images can be digitized using a 'framegrabber' card which converts the analogue information into the digital signal required by the computer. More recently, digital cameras which capture images directly in digital form have become commonplace, offering photographers the opportunity of replacing film with instant electronic capture.

The digital camera

The capture of an image using a digital camera has obvious advantages to the photographer. The image is immediate without the need for chemical processes and it can be assessed at the point of capture for composition and exposure. The image is in a form acceptable for introduction into desktop publishing applications, image analysis, enhancement, etc., without recourse to any further process. It is in a format suitable for transmission via networks, phone systems or radio transmission to a remote site. However, it should be noted that the digital camera is in its infancy compared with its film counterparts. In its simplest form, the digital camera uses the principle of a lens, shutter and film normally used in film cameras, but replaces the film with a system of electronic components to capture the image.

To create a digital camera three elements are required:

1. A system of recording the image in the camera.
2. A system of converting the image data into a digital file.
3. A system of storage within the camera when requiring multiple images.

Recording the image

The use of electronic components to measure light is widespread. They control security lights, measure exposure in film cameras,

operate parking lights in cars, and open doors as a person approaches. At the heart of all these systems is a light-sensitive photocell such as a 'photodiode'. The operation of the photodiode relies on the fact that light can be converted into electrical voltage, and the amount of voltage generated increases in proportion with the amount of light falling upon it.

The photodiode

The photodiode is a semiconductor device that converts light energy, in the form of photons, into electrical energy, in the form of voltage. This device utilizes the effect that light striking a metal or semiconductor will cause electrons to be emitted from the surface of the material. Materials which strongly exhibit this effect are termed photocathodes. By constructing a suitable photocathode material and semiconductors in layers, the effect can be amplified.

The light meter

In its simplest form, a single photodiode is connected to a moving coil meter or digital display. As the amount of light on the cell increases, the needle will move across the dial in proportion to the amount of light it receives. Provided that the meter is calibrated, the reading will indicate the amount of light. The dials on the meter are marked in either shutter speeds or the apertures, or EV (Exposure Values), and will indicate the suggested correct exposures for the film to record a scene.

Electronic photography has been in existence since the 1930s, when two rivals, Philo Taylor Farnsworth and Vladimir Kosma Zoworykin, produced imaging tubes know as the Image Dissector and Iconoscope respectively, both based on glass tubes using thermal valve principles. The Iconoscope, produced by Westinghouse, proved the most successful. In the UK, EMI produced the Emitron camera, based on the Iconoscope design, and this was the camera used by the BBC for its first television transmission from Alexandra Palace on 2 November 1936. Cameras based on imaging tubes were the standard capture method in the television broadcast industry until recent times when the lighter and more robust CCD (Charged Coupled Device) was perfected. This technology is based on solid-state semiconductor principles. Although the theory of such devices had been proposed as early as 1948, its use in camera imaging devices did not take place until 1972, when Bell Systems in the United States built the first viable design. Since then, their increasingly small size, low cost and reliability have led to the introduction of domestic video cameras or 'Camcorders'. The tube system is still used in industrial and scientific imaging where the definition and light response are of paramount importance.

The video analogue system

The video CCD sensor was designed with the purpose of producing an image suitable for transmission on a television system. In television

Fig. 2.1 Light reactive devices

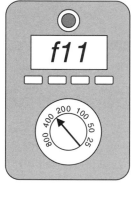

The calculator uses the solar cell to provide the power for its electronics

The photographic light meter measures the power output from the light reactive cell to calculate the amount of light present

The CCD sensor consists of thousands of light sensitive cells the level of light on each can be measured

transmission, the signal is made by interlacing two 'field' signals to produce a 'frame'. The field signal can be replaced 25 times per second to give the appearance of a moving image. By replacing only alternate field signals, the movement appears continuous to the human observer. The major problem with using video-based systems for still image capture is that the criterion for manufacture is to design a system which provides only enough information to produce a television picture. Close examination of a single frame from a video recording will show an image lacking in information when compared with a photograph. The television signal displays 25 of these frames every second, the effect of which is to give an apparently adequate image to the viewer.

The total image frame (two fields) is 625 lines on European systems and 525 lines on US systems. Not all the lines are used for

Fig. 2.2 Video interlaced scan pattern. After completing one scan to form a field, the beam flies back to scan another field, interlaced between the lines of the first. Two fields together give one video frame. The American NTSC system uses 525 lines. The European PAL system uses 625 lines.

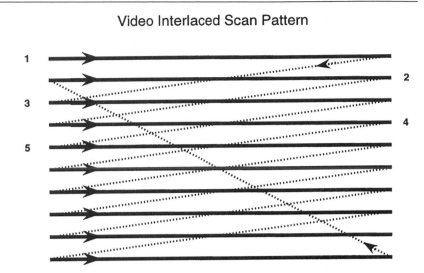

Video Interlaced Scan Pattern

Two Fields equals one frame

Fig. 2.3 Diagram of TV screen showing beams generated by three electron guns. A shadow mask ensures that each beam strikes the phosphor lines of only one colour.

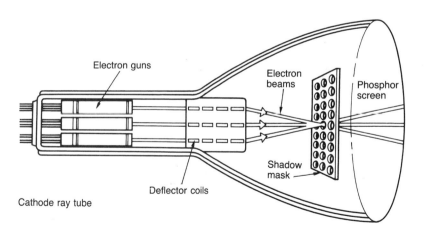

image information, and signal data can be encoded into line information to carry data such as channel code, CEEFAX or subtitles.

The image on a television screen is displayed as discrete points of light projected through a mesh screen. These points are displaced by dark space on the screen surface. When viewed from a distance the coloured dots blend together to produce a consistent colour.

CCD sensors specifically designed for video cameras are capable of producing excellent television pictures, but their use for still imaging purposes is limited by the relatively small amount of image information they produce. The signal they produce is in an analogue form i.e. the data is encoded into a wave-form.

Fig. 2.4 The analogue sample records all information.

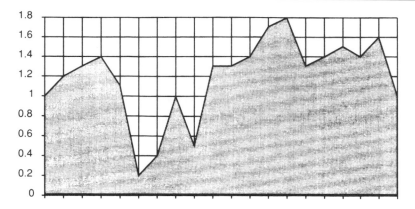

Analogue signals

Analogue signals are continuous over a range of data points, each being represented by a point on a curve. Continuously varying quantities such as voltage or frequency represent the image brightness over a given area.

In order to process this analogue data in the digital computer environment, it needs to be converted into a digital form. The signal is processed by an 'Analogue to Digital Converter' (ADC). In the case of connecting a video camera to a computer, this device would reside on a special card ('framegrabber') which would usually be fitted inside the computer.

Digital signals

Digital signals are discrete and they vary in specified increments over a given area of the image. In the case of a system utilizing an 8-bit monochrome image any discrete portion of the image would be represented by eight binary digits. This would give a possible 256 levels of brightness between black and white in the resulting image.

Fig. 2.5 Digital 'sampling' records the same information as analogue only in terms of discrete samples. The greater the number of samples, the closer the signal resembles its analogue counterpart.

The CCD

Most modern video cameras and all digital cameras now use CCD sensors as the imaging device. Their operation is highly complex, and only a brief explanation is given here. The manufacture of a CCD chip is a highly complex and difficult task (imagine any other manufacturing process where a ⅔-inch square surface has over a million components, all of which must function!). The exacting precision required means a high failure rate in production – a failure rate of 25 per cent or more of units is not uncommon in some of the larger sensor arrays, though this will undoubtedly improve in the future.

The CCD uses the property of photodiodes that produces an electrical charge when exposed to light, combined with a system of transferring the charge across the surface by altering the electrical potential, to provide attraction for the charge. Each sensor site (known as a picture element or 'pixel') has an electrical charge proportional to the amount of light illuminating it. This charge appears as a voltage, in the region of 0–2 volts.

The single photodiode site

The physical makeup of the site is in three elements:

1. The image capture area, sensitive to light.
2. The storage electrode in which the charge is stored.
3. A surrounding area to insulate the site from adjacent charged sites.

The system above could provide a suitable sensor, but each individual site would require connection to an individual ADC to read its charge.

The problem is overcome by the introduction of two extra elements to each site, 'shift registers', to store the charge during movement, and 'shift gates', to separate the individual charges.

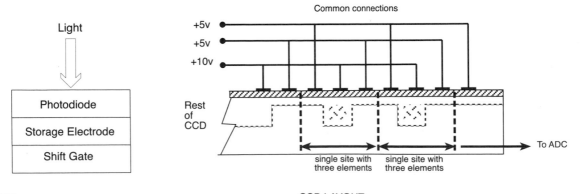

CCD sensor

Fig. 2.6 A single CCD site.

CCD LAYOUT

Fig. 2.7 Physical structure of a CCD.

The theory of a CCD

The basic operation of the system is to move a series of electrical charges across the material using a conveyor belt approach. The information recorded by the CCD can be read, a line at a time, into a common ADC. An analogy can be made with a stadium full of people, each holding a number on a piece of paper. Being a fully automated stadium, removing the people is achieved by having the seats on a belt system which moves all the seats in the row one step nearer the aisle at a time. The stadium is emptied row by row starting at the top. As each person reaches the aisle, they hand their numbers to an official.

The CCD in practice

A CCD is constructed of a sandwich of semiconductor materials on which is grown a layer of silicon dioxide to separate the individual elements. On the surface of this insulating layer is an aluminium metal plate. If a voltage is applied to the plate, a depletion layer is formed in the substrate to the charge, this layer is termed the 'potential well'. This, in effect, is an area within the material which is created to form a pocket of low resistance in which the charge can be stored.

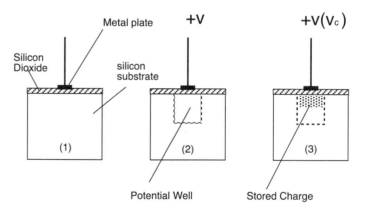

Fig. 2.8 Formation of potential well.

The charge from the photodiode's storage electrode is injected into this potential well and is attracted to the area beneath the plate. The storage of electrons in the potential well is termed an 'inversion layer'. The CCD surface is made of a large number of photodiodes each with an associated storage electrode. The CCD uses a three-phase system to move the charge through the substrate. The position of the potential well can be moved to the right by applying different voltages to the metal plates and increasing or decreasing the attraction of the potential wells. The major advantage to the three-phase system is that each row of sensor elements requires only three connections to the ADC, regardless of the number of sensors.

Stages of operation

Stage 1 The charge is stored from the photodiode in the centre of the three elements (a shift register). The voltage on the plates on either side effectively acts as an insulation to isolate the charge.

Stage 2 By raising the voltage on the plate to the left, the charge is attracted towards the new position (a shift gate).

Stage 3 The voltage on the site formerly containing the charge is lowered, creating a barrier and a new configuration of the three elements, moved one position to the left. The process can be repeated, moving the charge toward the waiting ADC unit at the end of the row.

In the practical production of a CCD, the number of sensors may number thousands of photodiodes per row, resulting in millions of individual sensor sites on the surface of the chip. Constructing metal connections at this scale is not viable. In practical fabrication, the surface of the CCD is coated with an insulating layer of polysilicon.

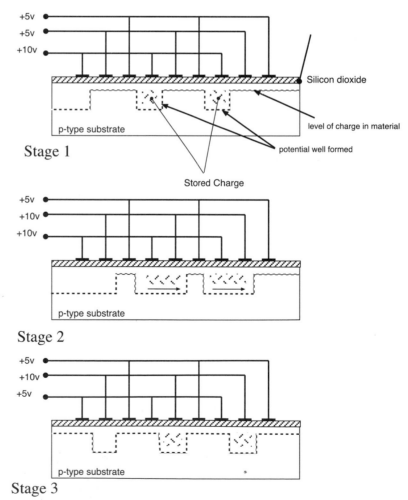

Fig. 2.9 Three-stage operation of CCD.

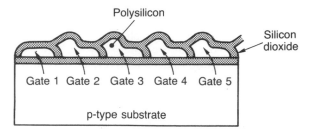

Gate 1 Gate 2 Gate 3 Gate 4 Gate 5

p-type substrate

Fig. 2.10 Manufacture of CCD. The principle of a silicon gate is shown by Fig. A layer of polysilicon (an insulator) is deposited on top of the silicon dioxide layer and is then etched to form one third of the required number of gates, i.e. every third one. A layer of silicon oxide is formed and is then etched away as appropriate to form the remaining gates, i.e. 3, 6, 9, etc. and then, finally, a layer of silicon dioxide is grown overall. The separation between adjacent gates is now only the thickness of a silicon dioxide layer and is much less than could otherwise be obtained.

This material is etched away to provide access to every third element and a layer of silicon dioxide is grown on the material to take the place of the metal contacts. By repeating the process twice more, the remaining elements of the three-phase system are constructed. The advantage to this procedure is that the separation of the elements is only the thickness of a layer of silicon dioxide.

Having completed the task of converting the light in the image into an electrical signal, the next step is to convert this signal using an ADC into a digital format, readable by a computer.

The ADC

The signal that is passed from the CCD is in an analogue form in that it consists of varying amounts of voltage. In order to be read by the computer, it needs to be translated into a digital form. The ADC is calibrated for the range of voltages that can be recorded on the CCD. The range will run from zero voltage representing no light and therefore the lowest digital number, to a maximum voltage representing the brightest light and corresponding to the highest number. In the case of an 8-bit system, the black of the image would record as 00000000 or zero, and the highest brightness as 11111111 or level 255.

CCDs: linear and block arrays

A 'linear-array' CCD is a single row of sensors on a long narrow chip. The process of recording an image is achieved by moving the array one line at a time, by either physically moving the chip ('scanning') or by a moving mirror system. The linear-array sensor provides greater flexibility in sampling an image at a lower cost than the block-array system. The number of samples recorded in a single row can be increased by moving the entire array a distance of half a single photocell, and interlacing two row signals to double the sampling rate. With a corresponding modification of the depth movement of the row, the resolution of the image can be doubled. The main drawback of this system is the time taken to record the image. This is not particularly important in desktop scanners, but when used in cameras, it means that only still-life subjects can be photographed.

The 'block-array' or 'area-array' system uses a two-dimensional matrix of hundreds of thousands or even millions of sensors laid out in rows and columns. The resolution of an image captured by such an array would be fixed, dependent upon the number of sensor sites

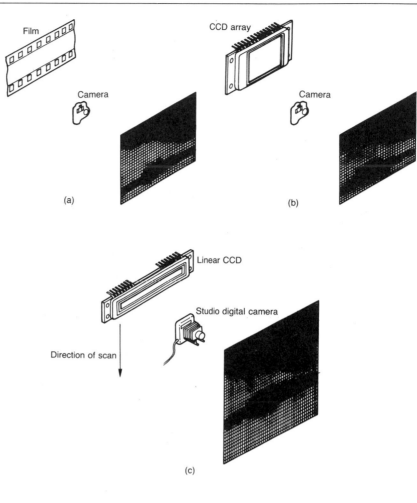

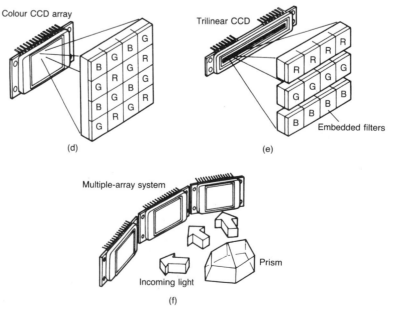

Fig. 2.11 (a) Conventional camera with film as the recording medium. (b) Digital camera with film replaced by a light-sensitive 'area-array' CCD. (c)Digital camera with film replaced by a light-sensitive 'linear-array' CCD which scans the image projected by the lens. (d) Area-array CCD with red green and blue filters. Note the pattern, with twice as many green-filtered pixels as red or blue. (e) Trilinear CCD: three linear-array CCDs, coated for red, green and blue, scan the image area. This CCD captures the image in one pass, eliminating registration problems caused by earlier three-pass systems. (f) Some digital cameras use a 'multiple-array' system, where three area-array CCDs receive light split into its component colours by a beam splitter.

on the matrix. The system does, however, have the advantage of providing an instant capture system for images, and can be used, for example, with electronic flash lighting.

The first block-array CCD was introduced in the early 1970s and had 100 rows by 100 columns giving an image with 10,000 pixels. Most CCDs used in video camera systems use an array of 512 × 320 sensor sites giving 163,840 pixels per image. The technology to produce higher resolution sensors increases constantly and sensors capable of recording 2,048 × 2,048 pixels (with images of 4.2 million pixels) and higher are currently available.

Digital cameras

Several different types of digital camera have appeared on the market over the last five years or so. They can generally be divided into two classes depending on whether they have the block-array CCD or the linear-array CCD. Initially, most digital cameras were additional units which could be attached in place of the film back to existing models of camera, such as the Kodak DCS range, or the Leaf range of camera backs. Increasingly, new designs, such as the Apple Quicktake, at the lower end of the market, and the Nikon E2s, are being introduced where the camera has been designed specifically for the purpose. Most operate in a very similar way to conventional film cameras, with a full range of apertures and shutter speeds. Many have variable 'ISO' ratings, which are equivalent to the exposure index (EI) system in silver-based photography. The chip has a nominal 'speed' or sensitivity, which can be increased through an amplification process within the camera.

Scan-back cameras

This system places a scanner (see section on scanners later in this chapter) in the film plane. The scanning device is a single row or array of pixels which scans the image projected by the lens to record a series of array rows along the depth of the image (or selected part of it). The main advantage of the system is that the array can be moved at different speeds changing the vertical sampling rate and therefore the resolution of the image. The horizontal resolution can be altered by either sub-sampling the array, or by moving the array half or a quarter of a sensor site to the left or right, and sampling the same vertical row twice or four times, thus doubling or quadrupling the resolution. The major drawback is the time taken to move the array – this results in exposures of several seconds or even minutes, so the subject must be still and the illumination constant. This system lends itself to studio still-life subjects, and many of these scan backs are manufactured to fit the large format cameras used by photographers for such work. All the movements of such cameras are available, to help the photographer maximize depth of field and control image shape. Several manufacturers, such as Leaf, Dicomed and PhotoPhase produce these scan backs, usually to fit medium or large format cameras. Many of the systems require continuous, flicker-free lighting which does not interfere with the scanning lines.

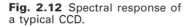
Fig. 2.12 Spectral response of a typical CCD.

Tungsten filaments flicker due to the heating and cooling of the filament at a rate of 50 Hz (UK mains frequency). Several of the backs recommend either high frequency fluorescent (usually using 40 Hz supplies), HMI (Hydrargyrum Medium Arc Iodide) light sources, or halogen lights running from a ripple-free DC power source. HMI uses a metal halide arc to provide a high intensity, daylight-balanced light source and is commonly used in the film industry. They are highly efficient: a 500 W unit will give roughly the same light output as a standard 2,000 W conventional halide source. These are expensive, particularly the HMI, and add considerably to the cost of setting up a digital studio. Generally, high frequency fluorescent lighting is not as powerful as HMI, and tends to be bulky due to the 'strip' nature of the fluorescent tubes. Units usually contain six tubes arranged either in a rectangular array within a softbox or bunched together in a cluster. Neither system offers photographers the flexibility of conventional studio lighting. The HMI gives out a large amount of infrared radiation, and many manufacturers of digital camera backs supply an infrared absorbing filter to absorb this (CCDs are inherently sensitive to infrared radiation, Fig. 2.12). Many of these scanning types of cameras can have effective resolutions of over 40 million pixels, and are currently used in the UK by photographers shooting, for example, still-life shots for mail-order catalogues.

Single-shot systems

The principle of the CCD chip dates back to the the 1930s, but it was not until the 1970s that Bell Systems in the United States started to use them for imaging. Manufacturers such as Sony were making great efforts to miniaturize home video cameras (their success is shown by the modern camcorder) and had developed small CCD chips for the purpose. They decided to put one of these chips inside

a still camera which was introduced in 1981 as the MAVICA (Magnetic Video Camera). This stored either 50 or 25 images (depending on the quality selected) on to a small two-inch floppy disk (also, each image could have up to nine seconds of sound recorded along with it). The recording system was analogue, so that the images still needed to be digitized before they could be loaded into a computer. The original MAVICA had a chip containing 380,000 individual pixels. It was only available commercially in NTSC format. Several other still video cameras have been introduced over the years, primarily by Canon, which still markets two models of the Ion camera, one with 230,000 pixels, the other with 470,000 pixels. These are likely to be discontinued in the near future.

The first true digital camera was the Kodak DCS 100, introduced in 1991, which used a ⅔-inch 1.5 million pixel chip attached to a Nikon F3 camera body. The images were stored in a separate digital storage unit (DSU) containing a hard disk, a small LCD display screen for 'in the field' editing, and transmission facilities for sending images via telephone lines. It was aimed primarily at the photojournalist.

The single-shot system uses a block array, a rectangular matrix of picture elements, which is fitted in the focal plane of the camera. The image capture is carried out in exactly the same way as a film exposure. The image is recorded as rows and columns of data and read off the array block sequentially by the ADC, starting at the top row and ending at the bottom row. The block-array system lends itself to the single-shot style of image capture relying on a single instantaneous exposure to the subject. This means that flash photography and the recording of moving objects becomes possible. The interval between exposures is entirely dependent on the time taken by the unit to store the digital file.

A major problem associated with block-array CCDs is their size in relation to the focal length of lenses. The 'standard' focal length of lens for a given format is derived from the length of the diagonal. So, with a 35 mm image, where the dimensions are 24 × 36 mm, the diagonal is 43 mm, which is usually rounded up to 50 mm, while with 6 × 6 cm cameras, the standard lens is usually 75 mm. The dimensions of the 1.5 megapixel chip used in the latest Kodak DCS cameras are 14 mm × 9.3 mm. This means that the 'standard' focal length for this chip is approximately 24 mm. For sport, and for other photographers who routinely use long lenses, this can be of great benefit, meaning that in effect their lenses immediately double their focal length – but for those photographers requiring wide-angle lenses, this becomes more difficult. To get the equivalent of 24 mm on 35 mm film will require a 10 mm or 12 mm lens, which are not only very expensive but can also distort the image. In an effort to solve the problem, Nikon and Fuji, in a joint project, introduced a digital camera in 1995, (the Fujix DS-515 and the Nikon E2S), which use the same chip, but contain an optical condenser system [Fig. 2.13], which reduces the 24 × 36 mm image produced by the lens to the size of the CCD chip. The format of the chip is 1.28:1, as opposed to 1.5:1 in 35 mm film, so that the horizontal coverage of the lens is 0.85 that which the lens would give on 35 mm film. A 50 mm lens from a 35 mm film camera would, in effect become a 42.5 mm lens on this system. While the camera has a relatively high ISO sensitiv-

Fig. 2.13 Optical condenser system in Fujix digital camera. Left: Optical system in conventional digital cameras. The CCD is smaller than the 35 mm films, so the image projected by the lens is larger than the chip. The effective focal length of the lens is doubled. Right: Optical system used by the Fujix DS-500 digital camera, where a lens is placed behind the lens to condense the light on to the chip and retain the focal length of the lens.

Conventional digital cameras

Conventional position of 35 mm film (results in uncaptured image data)

CCD

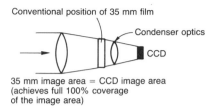

Fujix DS-505/DS-515 optical system

Conventional position of 35 mm film

Condenser optics

CCD

35 mm image area = CCD image area (achieves full 100% coverage of the image area)

ity, 800 ISO, the relay optics limit any lens used to a maximum aperture of *f*.6.7. It is likely that many more custom-designed digital cameras will appear on the market over the next few years.

Several cheaper 'point-and-shoot' models have become available over the last few years. They are low resolution, having CCD chips with 200,000–400,000 pixels. Generally costing just several hundred pounds rather than the thousands for professional models, these cameras seem to be targeted at the amateur photographer, graphic designer and users such as estate agents requiring large numbers of relatively low resolution images quickly. At least one weekly car sales magazine uses this type of camera for all of its imaging.

Colour recording

The photodiode system converts light signals into electrical potential. There is no account made for the colour of the light, and without modification, the CCD is a monochromatic device.[1] The CCD sensor is also sensitive to the near-infrared area of the spectrum, and filters are normally applied to either the sensor surface or the lens of the camera to remove this sensitivity. As a result the same camera can be made in three types:

1. A monochromatic camera.
2. A camera without the filters, which will record infrared information.
3. A camera capable of colour recording using a modified CCD.

The modification to the CCD will depend on the type of capture system used.

Colour systems

Linear-array cameras

Using the array system, three rows of CCDs are mounted together. Each of the rows can be covered by a red, green or blue filter. The

[1]CCDs are inherently sensitive to ultraviolet (UV) radiation also, but most have a glass filter applied during manufacture which removes the UV. Some CCDs are specially manufactured without the glass filter to give a UV-sensitive device. Some digital cameras have still been found to be quite sensitive to UV and it is worth investigating the extent of this if you either require it or wish to eliminate it.

image is recorded as three separate planes of these colours and recombined in the computer to give a normal colour image (see Fig. 2.11e).

Single-shot cameras

In order to record colour information using block-array CCDs, one of two systems must be used. Both will record an image signal composed of three channels of red, green and blue that will be recombined later in the computer.

Three-chip system

The simplest system is to provide three separate sensors, and filter the light to each sensor with a red, green and blue filter. The image from the lens must be passed through a beam splitter to separate the light (see Fig. 2.11f).

This system will provide an image with each pixel created from a discrete red, green and blue element. The size of the beam splitter and the three chips will increase the unit's size, bulk and cost. A new digital camera introduced by Agfa in 1995, the ActionCam, uses such a system, with three $1{,}528 \times 1{,}148$ pixel CCDs.

The filtered CCD system

This system uses a method of applying filters to the actual sensor sites to obtain the colour information. The sensor is divided into clusters of four sensor sites that each provide a single colour signal. The four sensor sites are covered with a red, blue and two green filters. The extra green is provided to give an image biased towards the human visual system (the human eye is most sensitive to green light). The raw file taken by this system will be a monochromatic image with the data of the filtration applied to the sensor, and will require processing in the computer before the colour information is added to the image.

The signal from each sensor still contains the image brightness data. However, the filter will affect the amount of light and the strength of the voltage potential stored. Since the density of the filter is a known quantity, the effect of each individual colour filter can be recorded. This means that the respective amounts of red, green and blue that the four sensor cluster receives from the image can be calculated.

G	B	G	B	G	B	G	B
R	G	R	G	R	G	R	G
G	B	G	B	G	B	G	B
R	G	R	G	R	G	R	G
G	B	G	B	G	B	G	B
R	G	R	G	R	G	R	G

Fig. 2.14 Filtered CCD showing the pattern of filters.

Since the brightness of the image across each site is recorded, the image still has a resolution of the number of sensor sites of the CCD. The colour information in the image is, however, a quarter of the effective resolution. Since the human eye relies far more on brightness information than colour, the image appears normal. The effect is dramatically decreased as the resolution of the sensor is increased.

Colour faults using filtered sensors

The sensor relies on the fact that in the majority of images, the frequency of colour and brightness data is less than the resolution of the sensor. The effect of a high frequency pattern across the colour filter cluster will result in spurious colour information. In the worst case, a low resolution sensor such as that found in a video camera will give strange patterns on anyone wearing a fine checked suit.

The system does provide a compact and cost-effective system of recording images with discrete brightness data, but with reduced colour information.

The three-pass system

This system is the exception to the single-shot camera. Using a single CCD chip, the unit captures the three colours of red, green and blue sequentially, using a rotating disk with the filters mounted in sequence. The image is effectively made up of three separate exposures for the subject.

This system will provide an image with each pixel created from a discrete red, green and blue element. The system is not suitable for some applications as the registration of the three colours requires no movement of the subject. New developments have led to a possible way of solving the problem. A system using an LED screen which can

Fig. 2.15 Block of four groups of filtered pixels. When toned or coloured subjects fit exactly within group boundaries, then the colour will be true.

Fig. 2.16 When the coloured subject overlaps two pixel groups, colour aliasing occurs, giving false colours. The pixel group at top right will become a light magenta, while the group at bottom right will become light yellow.

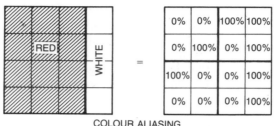

COLOUR ALIASING

RED: 100% R 0% G & B	LIGHT MAGENTA: 100% R & B 50% G
RED: 100% R 0% G & B	LIGHT YELLOW: 100% R 50% G 0% B

be switched between the three colours in milliseconds is being developed. Using this method, the three exposures would be made in the time that the camera normally exposed a single frame. Proving that the switching was fast enough, the camera could be used on all types of subject. This system could provide an image with discrete colour components of all types of subject, but current technology of the LED screen means that the LED will absorb a large amount of light and only transmit a very small amount to the sensor. Also controlling the purity of the three colours raises technological problems.

Image artefacts

Any imaging system, be it film or electronic, has its own characteristics inherent within it. Film is 'grainy', and while the photographer can reduce or enhance the effect of the grain, it is always present. In the same way, CCDs have their own characteristics, together with some faults, known as 'artefacts'. This is extraneous digital information perhaps resulting from electrical interference or optical problems associated with flare, etc. We give here just a short list and brief discussion of these.

Aliasing (sometimes referred to as 'staircasing' or 'jaggies') When recording curved or diagonal lines on the square matrix of the chip, the lines will appear to have a jagged rather than a smooth edge. The higher the resolution of the chip, the less noticeable this effect will be. Further details of this effect will be found in Chapter 4.

Blooming This is a problem with older CCDs that causes pixel level distortions when the electrical charge created exceeds the pixel's storage capacity, and spills into adjacent pixels. Newer CCDs incorporate anti-blooming circuitry to drain the excess charge.

Colour fringing An artefact in CCDs where colour filtering conflicts with information in the subject. It may be particularly apparent on finely patterned surfaces when it may cause a moiré effect.

Noise Random, incorrectly-read pixel data or extraneous signal generated by a CCD, even when no light is falling on it. It may be caused by electrical interference.

The final element of the camera to be considered is a method of storing the image in a permanent form.

Storage of the image

The electronic digital signal from the camera must be stored if the camera is to be a portable unit. The technology available to the manufacturers of digital cameras falls into three types:

1. The responsibility for storage of the image is passed to the computer. In this case, the term portable refers also to the portability of the host computer as the camera must be permanently connected to the computer. As the ADC converts the image, it is stored in the memory of the computer, or on its hard drive. The computer is required to run dedicated software to interpret the signal.
2. The signal can be stored within the camera body in an integrated Random Access Memory (RAM) chip. This type of storage is available in different types. Normal RAM, such as that used in computers, has the disadvantage of losing the stored data if the power supply is removed or interrupted. The solution is to use Static RAM which retains the information without a power supply. The installation of memory within the camera requires the physical connection of the camera to the computer to retrieve the images.
3. A better solution would be to provide a removable storage that could be read by the computer. Laptop and notebook computers have adopted a system of removable storage termed 'PCMCIA'. These units, the size of a credit card, are available in three types.

 Type 1 Static RAM devices which store up to 8 Mb of data on one unit. Storage of images on these units requires some compression of the image file in order to make them a viable storage method for digital cameras.

 Type 2 This classification covers such devices as network connect cards, modems and other connection units, and is not directly applicable to digital camera storage.

 Type 3 These cards contain miniature hard drives using the same mechanics as the hard drive unit in a desktop computer. Due to their small size, they require less power than a desktop unit, and they can record hundreds of images using the batteries within the camera. In terms of storage, they can record hundreds of megabytes of information. Due to the large amount of storage available, there is no requirement to compress the image.

 Using PCMCIA card systems, the base computer can be fitted with a card reader and the images can be retrieved from the card itself, thus removing the need to connect the camera to the computer. The user can also carry several cards and change them as they become full.

Camera-to-computer connection

The alternative solution is to connect the camera and computer physically to 'unload the film' or transfer the images to the hard drive of the computer. The modern computer offers two methods of connection to input devices.

The printer or serial port has a single pair of wires with which to connect to external devices. Although, as the name suggests, the information is being sent from the computer, in fact the connection contains a two-way flow of information. (When a printer runs out of paper, it must send that information back to the computer.) Connection using this port provides a simple method of attaching the camera, but the information transfer will be slow and a single 1 Mb image can take a minute to be transferred using this system. It does, however, have the advantage that the computer need not be switched off when connecting the camera. However, the slow speed is less important with cameras capturing relatively small files. The system also has the advantage that all computers are fitted with the required port.

The second method of connection of devices is via a 'SCSI' board. This system is the most popular as the transfer rate of the image can be much faster – typically a 4.5 Mb image can be downloaded in about 15 seconds. The nature of the SCSI system requires that the computer be switched off when a new device is attached, thus causing a delay on viewing images that are recorded away from the computer. The SCSI port required is not a standard item on all computers, and will probably require installation in the case of the PC platform.

Scanner input

The other main method by which images can be loaded into the computer is through the scanning of photographic film (transparency or negative) or print. Several types of scanner are available, giving a range of resolutions, speed and price. The factor most often overlooked is that of speed. Many picture libraries are currently digitizing their collections. If they have several thousand images to convert, this will be an extremely time-consuming business on a slow scanner.

Historical perspective

Until the advent of desktop publishing, using computers powerful enough to handle images, all image input was carried out by bureaus specializing in film and print scanning. These agencies would receive the image usually as a transparency (slide film) and produce a scan which was the correct size, colour balance and resolution for the printed page. The user would quite often place a dummy image at low resolution on the page, or produce a dummy page with empty areas where the images would be placed, gluing photocopies or photographs to produce a dummy of the final page. This method of using images dictated a particular working practice.

The choice of film type

Since the page designer had no way of viewing the image if it was supplied as a negative, the image was supplied as a photographic

print or a transparency which could be viewed on a light box. As the designer was making critical decisions based on the light box image, the larger the size of film, the better for assessment. The standard format used to record images for the published page was the drum scanner.

The drum scanner

This scanner is specifically designed to scan medium to large format film or print materials at extremely high resolution (1,800 to 2,400 dpi). The system works in two ways, by reflection or transmission.

Reflection scanning

The photographic print is secured with tape to a rotating drum. A light source is shone on to the print and a series of three detector 'Photomultiplier Tubes' (PMTs) measure the respective amounts of red, green and blue light reflected by each sample of the print. The drum rotates and the light source and PMTs are moved across the surface of the print measuring as they go. The action is to read the image in a helical path from top left to bottom right. The scanner operator can modify the resolution of the image by adjusting the number of samples per rotation and the number of samples across the print. The equipment can produce the correct level of image sharpening and conversion from the PMT's red, green and blue (RGB) into the required cyan, magenta, yellow and black format needed for publication. (Cyan, magenta, yellow and black are abbreviated to CMYK, the K to avoid confusion with blue.)

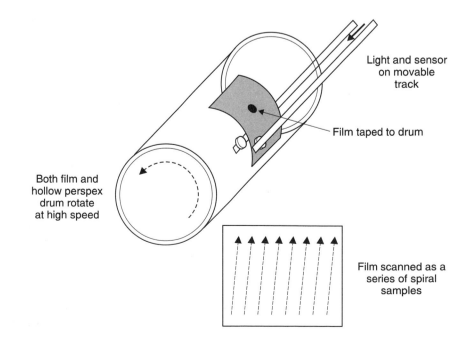

Fig. 2.17 Drum scanner.

Transparency scanning

The operation is similar to the above except that the drum is transparent, and the light source is transmitted through the film to the receiving PMT array. The film needs to be coated with oil to ensure perfect contact with the drum surface.

The calibration and operation of traditional drum-scanning systems requires highly skilled trained operators to ensure correct colour and tonal reproduction. The major advantage with the majority of drum-scanning systems is that they are operated in the environment of a publishing establishment, and can therefore be calibrated exactly to the parameters of the printing press on which the image will finally appear. The final file supplied to the user from a drum scanner will be in CMYK format and requires conversion to RGB if any retouching work is required.

The PMT technology used in drum-scanner units is capable of resolving a much greater dynamic range than the CCDs used in desktop devices. This means that the shadow and highlight detail available in transparency film is maintained in the final image. Another advantage to the system is the ability to mount up to 30 individual film originals on the drum, and providing that the image is given a geographical identity code, the scanner only need be operated once to scan all the images thus reducing the time of operation. The scanner operator calibrates each scan to the highlight and shadow detail specific to that image. These settings can be saved for future use.

Drum scanners cannot scan negative film as the integral orange mask causes problems when reading the colour information. The system is also slow and difficult to use with small formats of film. However, drum scanners do provide the highest quality of image from medium and large format film.

Maximum densities of various imaging systems:

1. D max limit of best PMT scanner
2. D max limit of best transparency
3. D max limit of Photo CD scanner
4. D max limit of good desktop scanner
5. D max limit of reflective print and printed page

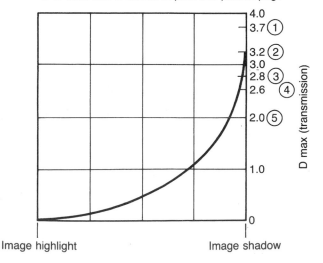

Fig. 2.18 Dynamic range of various imaging systems.

The major drawback to the drum-scanning system is that all critical decisions regarding cropping and placement must be made via communication between the scanner operator and designer.

With the advent of desktop computers capable of handling large images, the need for a method of inputting images directly to the page led to the development of the desktop scanner.

Desktop flatbed scanners

The cheapest and most widely available form of scanner technology is the 'flatbed' scanner. Primarily designed to digitize line drawings, or text for 'Optical Character Recognition' (OCR), these units start from a few hundred pounds. The flatbed scanner consists of a platen or flat piece of glass on to which the photograph or artwork is placed. The scanner has two modes of operation.

Line art/monotone mode
This is a representation of an image which only consists of black or white with no grey tones. The record of this image therefore needs only to register the presence of a line or its absence, a binary function. This is the easiest medium to scan as the only parameter which needs to be decided is the threshold (grey tone) which records as black.

Photographic mode
In this mode, the scanner processes a continuous tone photographic print input.

Monochrome flatbed scanners

The scanner uses a single array of CCDs to record the image as a series of horizontal rows, each the width of the image. The data is converted via an ADC in the scanner. Most of these scanners use Adobe Photoshop plug-in modules, or 'TWAIN' (Technology Without an Interesting Name!) acquire modules which allow the user to access the scanner through Photoshop or other similar programs.

Colour flatbed scanners

For systems operating in colour, three CCD arrays are used, recording the amount of red, green and blue in each pixel measured. The resulting file requires three times the information of a greyscale image. Additional software built into some scanners can convert this into a CMYK file, the format required by the printing industry.

The flatbed scanner

The scanner reader unit has a light source and a recording unit. The recording unit is based on CCD technology and can be either a single CCD, a row of CCDs the width of the scanner's operating plate, or a block of CCDs. The larger the number of CCDs, the faster the operation. This unit is mounted on a moving element

Fig. 2.19 Flatbed scanner.

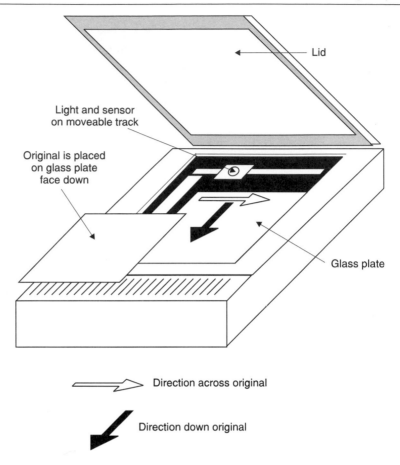

Lid

Light and sensor
on moveable track

Original is placed
on glass plate
face down

Glass plate

Direction across original

Direction down original

which transports the light and recorder in small steps between each scan. The scanner light reflects the original as the light moves across it and the recorder detects variations in light reflected from the grey tones in the original. In operation, the scanner starts in the home position at the upper right-hand corner of the scanner glass. Since the original is placed face down, the home position corresponds to the upper left-hand corner of the original. Therefore, from the point of view of the scanner, it scans the first line from left to right across the original, or in the case of a row of CCDs, it scans each line at a time. It then moves down the original and scans the next line. This process is continued until a complete image of the original is built up when the scanning head returns. The laser scanner can make measurement samples at a variety of rates – the sampling rate is chosen by the operator to match the size of output.

Film adaptors for flatbed scanners are available which provide an adjustable optic path to scan film originals rather than use the reflected light. However, the average sampling rate of a flatbed scanner would be in the range of 75–300 samples per inch and although this can give excellent results from a 10×8-inch piece of film, the result from 35 mm film would be very poor. The best results from smaller film formats are obtained from purpose-built transparency units.

Flatbed film scanners

An innovation is the introduction of dedicated flatbed film scanners. These use the same basic principle of the glass platen with a moving scan but provide much higher resolution and dynamic range suitable for the recording of film or printed originals. The design of these units allows the scan of film originals. They are primarily designed for the print industry, and allow the calibration of highlight and shadow detail, and automatically convert the image into the required size, resolution and CMYK file format for publication. Although expensive compared with a standard flatbed scanner, these units are designed to provide a production tool for publishing requirements without the level of scanner-operator skill required by a drum-scanning unit.

Film scanners

The major advantages of scanning film are as follows:
1. No optical loss of data from an enlarging system.
2. Ability to input from transparency material without expensive prints.
3. Process speed.
4. Minimal darkroom facilities needed.
5. Either colour or black and white can be produced from colour negative or transparency.
6. Facility to preview all film images negative and positive on a large colour monitor before use.
7. The film can be scanned in its original mount saving time in mounting and remounting.

Desktop film scanner

With the advent of the CCD sensor, manufacturers now build desktop scanner units which can scan film, typically only 35 mm or medium format. The production of an image on a desktop scanner uses one of two methods:

Linear sensor In this system, a single row of CCD cells is moved across the surface of the film using stepper motors. The physical resolution depends on the number of cells in the array and the accuracy of the motor. The colour information is recorded either by a three-pass system, once for each of red, green and blue elements of each pixel, or by a filter coating on the CCD surface to record colour in a single pass. Physical resolution is increased by reducing the distance moved by the stepper motors between samples.

Block sensor In the block sensor system, three consecutive images are captured using red, green and blue light. Although generally more expensive, this system produces much better results and is quicker than the linear sensor method. Physical resolution can be increased by moving the sensor a half pixel distance and combining two sets of the three colour images.

Fig. 2.20 Linear-array film scanner.

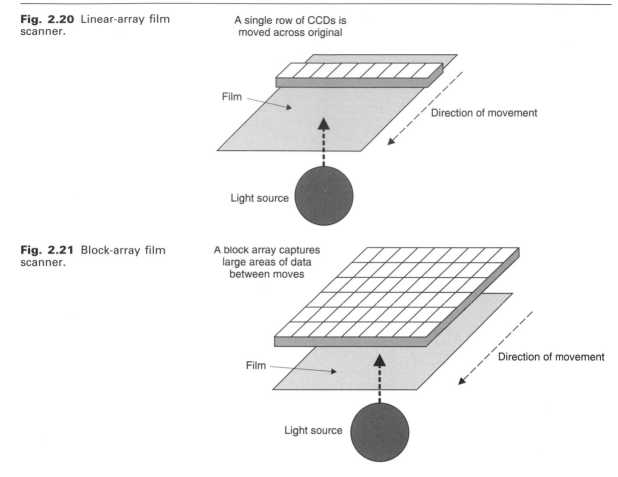

A single row of CCDs is moved across original

Film

Direction of movement

Light source

Fig. 2.21 Block-array film scanner.

A block array captures large areas of data between moves

Film

Direction of movement

Light source

Drum scanners

Operation advantages:
Highest quality resolution/dynamic range.
Automatic resolution, sharpening and sizing of image file.
Automatic conversion to required CMYK format.
Operated by skilled technician.

Operation disadvantages:
Expensive equipment.
Often in a remote site from desktop user.
Communication of correct crop/image/position required.

Desktop film scanners

Operation advantages:
Speed in scanning and placement of image.
User-defined crop and choice of image.
Low equipment cost.
User modification of image possible (retouching, etc.).
Ability to scan negative material.

Operation disadvantages:
CMYK conversion dependent on user's skill and knowledge.
Sharpening, sizing and resolution dependent on user's skill.
Not suitable for larger formats of film.

The future for digital image capture

It might be imagined that the logical area for improvement in imaging technology would be in the size of the chip. Produce a larger chip and the quality will improve. CCD chips are very difficult to manufacture – the failure rate is extremely high, hence their very high price. Producing a small item with 6 million elements, all of which must work, is very difficult. Also, the more pixels that are present, the greater will be the file size of each image. In mid-1995, Dicomed introduced a 6×6 cm chip, with $4,100 \times 4,100$ pixels (16,810,000) giving a 48 Mb non-interpolated, non-compressed RGB image. This can be captured instantly with conventional electronic flash. It might also be argued that the image given by the 1.5 million pixel chip is more than adequate for many of the applications likely to use it, for example, newspaper work where the quality of the final image is determined primarily by the newsprint on which the image is printed. Press photographers transmitting images do not want to be dealing with 18 Mb files! By comparison, it is worth pointing out that a typical film may have 3 billion silver halide grains in 1 cm^2 of emulsion!

Improvements will also be made to the design and usability of digital cameras, with higher capacity storage cards, better batteries, and facilities for editing in-camera. For example, the Fujix DS-515 camera has output facilities to television for instant previewing of the image, and an accessory LCD display which clips on to the hot shoe on top of the prism for the viewing of images 'in the field'.

One thing that can be fairly certain is that the present systems used with many cameras, of taking three separate exposures, or scanning the image area, will become redundant.

3
Computers in imaging

(Note: the term 'PC' will be used throughout to describe IBM-compatible computers.)

When small desktop microcomputers first became widely available ten years or so ago, they were slow, had small amounts of memory and required a great deal of knowledge to operate them. They were not ideally suited for imaging purposes. Various commands had to be typed into the machine in order to perform the required tasks. Very often, the users had to write their own programs for a specific application.

Within the last few years, this situation has changed dramatically. Computers have become user-friendly and much cheaper. No longer is it necessary to type in strings of commands. Instead, most computers have 'Graphical User Interfaces' (GUIs) whereby most operations are controlled with a pointing device, or mouse, which moves a cursor around the screen. Many of the computer functions are shown as symbols (icons). With modern computers, the display on the screen is analogous to that of an office, with a desktop, stores of files and a wastepaper basket. Files (collections of named data or images) are retrieved from their various storage places (hard disk, CD, floppy disk or external disk), and brought on to the desktop to be viewed or worked upon. A click switch on the mouse is used to move or access items, and menus on the screen give the user a range of command options. Files are deleted by dragging them into the wastebasket and emptying it. The Apple Macintosh computer has become very popular, almost a cult, with artists, designers and photographers as it is extremely easy to use. It was originally designed so that a small child could operate it without any knowledge of computers at all. More recently, the PC computer has also adopted the GUI approach of the Apple with its Windows 95 operating system, and many imaging and desktop publishing programs, previously only available for Apple computers are now available for PCs. Many companies and other institutions, particularly in the UK, are PC-based, and it would not make sense to introduce a new computer system into the institution, although Apples and PCs can be connected together on networking systems such as Ethernet for the sharing and transferral of files. However, for many people with little or no computer experience, the Apple is recognized as being the easiest and 'friendliest' of computers to learn. On the other hand, the PC is often regarded as

being the most adaptable and easiest to customize. With the advent of new microprocessors, it is now possible to run both DOS/Windows programs on the same machine as those for the Macintosh, and to transfer files virtually seamlessly between the two. This would seem to be a trend likely to continue in the future.

As to the question of which is the best machine for electronic imaging applications, there is no simple answer. Many different machines costing a range of prices will perform many of the tasks required by photographers, albeit at different speeds. Before investing in a system, photographers must ask themselves several questions:

What type and quality of output will be required?

While it is possible to print directly from digital files, many photographers will still need to output on to film for many purposes. If this is to be high resolution 10×8-inch transparency, a specifically designed imaging workstation is probably the best answer, but these are very expensive. There is much controversy regarding the size of files required to give sufficient quality for such purposes, and we discuss this in Chapter 7. Output to 5×4-inch and smaller film, or thermal print, can be achieved quite easily on a desktop computer, though it will invariably need to be equipped with a large amount of RAM.

What software is available?

Some packages are specific to particular computer platforms.

What other types of work will the computer have to carry out?

Will the machine be required to carry out other work, such as multimedia applications, hold large amounts of information in a database, or perform maths-intensive work in complex spreadsheets? Will the computer be required to run more than one application program at the same time, and swap data between them?

How upgradeable is the machine?

Is it capable of being upgraded with the latest processors (such as PowerPC and Pentium chips), and software, or be fitted with extra circuit boards such as framegrabbers, graphics cards to give 24-bit colour, and accelerator cards? How much memory can be fitted? Imaging software generally requires a large amount of RAM, and for high quality output, the machine may need 64 Mb or more.

How large is the budget?

This is obviously a major consideration for most people. Over the last couple of years, prices of desktop computers have fallen dramatically, but even so, computers for imaging have special requirements

of memory and speed which makes them relatively expensive. Remember to cost all of the extra items required for imaging purposes, such as additional storage systems such as magneto-optical disks, CD-ROM drives for PhotoCD, SCSI connectors and Ethernet cards if these are not included in the price of the machine.

In this chapter, we will consider some of the basic operations of computers and their application in imaging, and will make some broad generalizations as to the type and size of machine most useful. This is not a computer book, and more detailed descriptions about the various machines will be found elsewhere. We will concentrate on the two most common platforms as far as general photographers are concerned, the Apple Macintosh and the IBM PC. Rather than try to make direct comparisons between the two systems, we will look at the characteristics of each type separately, and compare them where appropriate. Other types of computer, such as Amigas and Acorn, are capable of being used for imaging and many of the remarks made here will be applicable to them. Others, from manufacturers such as Sun, Silicon Graphics, Barco, Dicomed, Crosfield and Quantel, are examples of 'high-end' systems, and are beyond the scope of this book. They are generally very expensive although within the last couple of years, prices have dropped greatly. The main difference between a desktop computer and a high-end system is the ability to work with very large images (perhaps 300 Mb) and work in real time. The principles of their operation are very similar to the smaller systems. The present speed of computer development means that by the time this book is published, any specific models mentioned would have been superseded, so we have tried to discuss them in general terms. Also, new processing chips and operating systems are constantly being developed which will mean that future computers will be able to perform more complex tasks to larger images at much faster rates.

When buying a computer system, we would strongly recommend that you see the machine in action, and running the *actual* programs that you will be using, on the *actual* monitor you are considering. Very often, different programs run at particular speeds irrespective of the processing chip in the computer. Magazines often publish speed tests in order to compare one computer or piece of software against another. These must be treated with caution, as there are very many variables, and often, when one machine performs one type of operation very quickly, it may not do so with another. It is essential too that the program is installed on the computer correctly, so that the memory allocation is optimized to give the best performance. If you intend using a computer for specific applications, then try to get your dealer to let you try it out. Try to perform the same set of operations, such as rotating an image through a specified number of degrees, or apply a certain filter to the same image, to compare speeds of operation. As with cars, it is not essential to know how a car works in order to drive it, but an understanding of the basic principles does help to drive it more efficiently and safely. So with computers, most operate more efficiently if set up correctly. Most programs have specific requirements as far as memory allocation goes, and it is important that you at least know how to configure this.

Bits and bytes

Before discussing the various components of a computer and differences between various systems, it is necessary to understand some fundamental concepts and terminology of computers, how they work and how information is stored.

Strictly speaking, microcomputers should be called digital computers, because they can only manipulate digital data. In fact this digital data must be in the form of binary signals, with only two possible values, on or off, pulse or no-pulse, just like an electrical switch. One item of digital data, represented by a 1 or a 0, is called a *bit* (short for binary digit). When several bits are strung together, meaningful instructions can be given. Two bits can give four instructions (i.e. 0 and 1 can be configured in four different ways: 00, 11, 10 and 01). A group of eight bits or switches gives 256 ($2^8 = 256$) possible combinations of 0s and 1s , and represent single letters, or other characters, for example. This is called a *byte*. Eight bits is sufficient for all of the upper and lower case characters and other symbols required on a standard keyboard. For example, a lower case 'a' is represented by the binary code: 01100001. Twenty-four bits give 16.7 million combinations. With digital images, a 1-bit system displays either black or white. With a two-bit system, black, white and two shades of grey are displayed: 00, 01, 10, 11. With 8-bit images, 2^8 shades are possible, i.e. black, white plus 254 shades of grey. This is known as the 'bit depth' of an image. Greyscale images are generally 8 bit (except for some medical applications which use 12 bit). In the 1930s experiments were carried out into the human perception of shades of grey. In a sample of people, variations from 157 to 315 individual shades were found, the average being 214. The nearest digital equivalent is 8-bit or 256 shades.

Originally, most personal computers using 286 processors were 16-bit machines, meaning that they could handle 2^{16} (65,536) bits at a time. Nowadays, PCs with 486 processors and Macintoshes (which are all 32-bit processors) can handle 2^{32} (4,294,967,296) bits at a time. Higher bit depths are like wider motorways, capable of handling more traffic.

The following terminology is used when talking about bits and bytes:

 8 bits = 1 byte
 1,024 bytes = 1 kilobyte (K)
 1,024 kilobytes = 1 megabyte (Mb)
 1,024 megabytes = 1 gigabyte (Gb)
 1,024 gigabytes = 1 terabyte (Tb)

(Strictly speaking, the term kilo refers to 1,000, but because we are dealing with a binary system, the numbers operate in a doubling fashion: 2, 4, 8, 16, 32, 64, 128, 256, 512, 1,024.)

The hardware

Hardware refers to the actual components of the computer system, which is generally divided into three main areas, the processor ('computer'), the monitor display, and the keyboard and mouse.

Many peripheral devices can be connected to computers, either for the inputting of data such as CD-ROM drives, scanners and graphics tablets, or for the outputting of data such as external storage devices and printers.

The main requirements for any photographic computer imaging system are large amounts of memory (RAM), large amounts of storage space, speed of processing the data and high resolution of monitor display.

The processor

The computer is controlled by a microprocessor, or chip, the type of which often gives rise to the generic type of computer (e.g. 386, 486, Pentium 586 in PCs). The higher the processor number, the more elements are available for communication, and therefore more powerful. The processor runs at a fixed clock speed, regulated by the pulses of a quartz crystal, which is the speed at which the Central Processing Unit (CPU) communicates with the various elements within the computer. The speed is rated in megahertz (MHz) – one megahertz representing one million instructions per second. It is not, however, sufficient just to compare clock speed of chips, as modern chips with integrated coprocessors and memory may run faster than older chips. For example, a modern Macintosh computer running at 25 MHz actually performs some tasks more than twice as fast as an older 40 MHz chip.

Another significant factor relating to performance is the size of the 'cache', which stores frequently used instructions in high-speed RAM. This is directly accessible by the CPU, saving processor time which would otherwise be using normal speed RAM. These higher speed chips are more expensive than ordinary RAM chips.

One major factor in determining the performance of a computer in handling large image files is the type of internal 'bus' used in the machine. Simply, a bus is a series of wires along which information is carried. 8-, 16- and 32-bit buses are available – a 16-bit bus can transfer data twice as fast as an 8-bit bus. Technical consideration of buses is beyond the scope of this book, but a brief mention will be made of some of the buses available. Apple Macintoshs use the ADB (Apple Desktop Bus) and NuBus. The mouse and keyboard use the ADB, while NuBus is used for expansion cards such as accelerators. It is a 32-bit self-configuring bus, which means that cards can be plugged in and used immediately. With PCs, the situation is slightly more complicated, with ISA, EISA, VESA Local-bus and PCI all available. Generally, the 32-bit PCI and VESA Local-bus are faster than ISA/EISA and more suited to computers intended for imaging. With the introduction of faster, RISC-based PowerPC 604 chips, Apple computers will have PCI buses leading to an increase in performance. The PCI is the latest standard bus which uses FIFO – First In/First Out transfer of data from the CPU. PCI cards incorporate Plug and Play capabilities, which configure expansion cards automatically.

It is worth remembering that 'native' software (i.e. software written with a specific family of chips in mind) will run far more efficiently on a machine with a specific chip – PowerPC or Pentium, for example. For imaging purposes, speed is a critical consideration

when selecting a machine. Various methods of accelerating certain processes are available and will be discussed later.

The central microprocessor can be accompanied by other devices such as a 'maths coprocessor' (or 'Floating Point Coprocessor' or FPU), which helps speed up applications requiring large amounts of mathematical computations such as graphics or complicated spreadsheets. Motorola 68 040 processors, used in Apple Macintosh computers, and several Intel 486 processors, used in PCs, have built-in maths coprocessors.

Operating systems

The operating system of a computer is basically a series of computer programs which enable other programs to run on the computer. It creates an environment enabling different programs to perform functions such as saving, displaying lists of stored files and deleting. Without an operating system, each program would need to have these functions built-in. The ability to 'cut and paste' items between programs is an integral part of the operating system of the computer. Until the middle of 1995, IBM PCs used MS-DOS (Microsoft Disk Operating System), which was replaced by Windows 95. Apple Macintosh computers currently use System 7. New operating systems are currently being developed, including Copland for the Macintosh. Until the advent of Windows 95, most PC users also ran Microsoft Windows on top of the DOS operating system (many programs will only run under Windows). This is really a collection of programs enabling the user to perform many tasks on the computer much quicker and more easily through the use of a GUI, rather than under DOS, which requires the typing-in of commands to instruct the computer to perform operations.

A criticism often levelled at PCs was the protocol for naming files. With Apple Macintosh computers, an image can be given a descriptive title, up to 31 characters in length (e.g. Seagull, on nest with chicks). Information about the file type is stored internally within the file. With MS-DOS, the computer recognizes the file type from a three-letter extension included as part of the file name. This file name is divided into two parts, the file name, which can only be up to eight characters long, followed by the three character extension. The file name is separated from the file type by a full stop (period). e.g. Seagull.TIF, Building.EPS. The first is a TIFF file, the second an Encapsulated Postscript file. This problem has been eradicated with the Windows 95 operating system, which allows file names up to 255 characters in length.

Apple Macintosh computers

Macintosh computers use microprocessors from Motorola, the 68 000 series. Only those using the 68 040 chip, running preferably at 33 or 40 MHz, or the new generation of PowerPC 600 family chips, should really be considered for serious imaging purposes. As mentioned previously, the Macintosh computer was designed specifically for ease of use. The mouse controls many operations such as opening

documents, saving changes and copying documents. It is now ten years old and revolutionized the publishing industry in the 1980s with the advent of desktop publishing programs such as PageMaker and QuarkXpress, and the ability to change typefaces to virtually any style or size. Nowadays, multimedia versions are available with video framegrabbers and sound cards for stereo output, built in CD-ROM drives and video editing programs which could well make traditional video edit suites redundant over the next few years.

IBM PC computers

IBM PC compatible computers use Intel processors, usually the 386, 486 or Pentium 586. For imaging purposes, the 486 or Pentium are really the only one to be considered. The 486 is available in several versions, including the SX, DX and DX/2. The SX is cheaper, but some types communicate with the RAM only at 16-bits at a time, whereas the DX series are 32-bit processors. We would recommend most strongly that the 486DX or DX/2 processor running at 50 or 66 MHz, or the new generation of Pentium 586 chips are best for imaging purposes.

Because PCs are much more common than Apples in business and domestic applications, there is a huge range of accessories, upgrades and add-ons available for them, making it possible to customize the PC to a very precise specification.

RAM (Random Access Memory)

Programs and other data are stored on disks, usually the internal hard disk of the computer. Before the computer can carry out any functions, the program must be transferred into RAM, together with the data required to be viewed or manipulated. RAM is temporary storage – when the computer is switched off, everything stored in RAM is lost. Anything that you wish to keep must therefore be saved either to the hard disk or other form of storage such as a floppy disk.

In general, the larger the effective RAM, the more easily tasks such as image manipulation can be carried out. The operating system software (DOS, Windows, System 7, etc.) will require its own allocation of RAM: typically, DOS requires 2 Mb RAM on a PC, with Windows requiring an extra 4–6 Mb, while it is recommended that Windows 95 runs best with 12 Mb. System 7 on a Macintosh needs at least 2 Mb to run. An imaging program like Adobe Photoshop requires at least 3 Mb RAM (preferably 5 Mb). Therefore, before an image has even been opened, we have used up at least 5 Mb of RAM. The images themselves will be large, anywhere probably from 500 Kb to several Mb. As a general rule, an image requires at least three times as much free RAM as it is large (this is because the program maintains a record of the image prior to manipulation to enable that operation to be 'undone'. In some cases it also reserves another block of memory to enable it to carry out sophisticated operations). Adobe recommend three to five times the amount for some operations! Thus a 1 Mb image (which would be a relatively

low quality colour image) needs at least 3 Mb RAM. This makes a total of 9 Mb RAM, and this really is a minimum figure. We would recommend most strongly that for serious imaging purposes, 16 Mb RAM is the minimum required, but preferably a figure of 24 Mb or more. As new programs become available, the amount of memory they require seems to increase! Many photographers routinely use machines with 64 Mb RAM, and this will obviously have a cost implication when budgeting the system.

Recently, software has been introduced which effectively doubles the amount of RAM in the machine. Known as 'RAM Doubler' from Connectix, it works by making more efficient use of system resources and compressing some of the memory not being used. It is remarkably cheap, works very efficiently with virtually no drop in speed, and is much faster than virtual memory systems. It is well worth installing.

When buying a machine, it is essential to check that the machine can be upgraded (increased) to the amount required. It is a relatively easy job to upgrade the RAM of the computer yourself by inserting extra memory chips – SIMMS ('Single In-Line Memory Modules') – into slots on the main circuit board. However, beware – many manufacturers say that doing this yourself will invalidate the guarantee.

New computers with faster chips are starting to use DIMMs (Dual In-line Memory Modules) rather than SIMMs. Unfortunately, these newer machines cannot use existing SIMMs!

One way of increasing the amount of memory available to open and manipulate images with a Macintosh is to make use of the Virtual Memory facility of System 7. This allows part of the hard disk memory (or another disk assigned as the 'scratch disk') to be used as RAM, so that very large images can be opened, even with relatively small amounts of RAM. However, this operation slows down the computer greatly, and is not to be advised unless absolutely essential. With PCs, a similar system operates, where a part of the hard disk is allocated as a 'swap file'. There are two types of swap file, temporary and permanent. A temporary swap file is set up when Windows is started, and deleted when Windows is shut down, while a permanent swap file is always on the hard disk. This is faster than the temporary swap file.

Monitors

Computer monitors use cathode ray tube (CRT) displays. Three electron guns (one for each of the three colours, red, green and blue) scan the screen and fire a stream of electrons at the screen in proportion to the intensity of the signal received from the digital to analogue adaptor in the computer. This device compares the digital values sent by the computer to a Look-Up Table (LUT) which contains the matching voltage levels needed to create the colour of a single pixel. With a VGA (Variable Graphics Array) monitor, 256 values are stored in the adaptor's memory. As the electrons strike the phosphor coating on the inside of the screen, light is emitted. Three different phosphor materials are used for red, green and blue. If a group of RGB phosphors is struck by equally intense beams of

electrons, then the result will be a dot of white light. Different colours are created when the intensity of the beams is varied.

Important considerations for imaging are the size of the monitor, the number of colours which can be displayed on a monitor (bit depth), and the sharpness of the image (spatial resolution). When running imaging programs such as Adobe Photoshop, it is assumed that 'photo-realistic' images are required. Photo-realism is a qualitative term which is used to describe how closely a digital image matches the photographic original.

With bit depth, for photo-realistic display, a minimum of 16-bits (32,768 colours) per pixel ('bit depth') is required, and preferably 24-bits (16.7 million colours) to give photographic quality images, although, if the budget is limited, 16-bit displays are almost indistinguishable from 24-bit with most images. (The 'bit depth' of an image refers to the number of grey shades or colours which a monitor can display. An 8-bit system can display 2^8 (256) greys or colours. A 16-bit system can display 2^{16} colours (32,000) while a 24-bit system can display 2^{24} colours or 16.7 million.) Strictly speaking, the monitor cannot display this number of colours at one time, but it is the number of colours stored in the LUT. It is really those images with areas of graduating intensity (e.g. graduated backgrounds on still-life pack shots) that the difference between 16-bit and 24-bit becomes important. It is generally reckoned that at least 160 levels for each of the three colour channels is required to show a continuous gradation without a banding effect (i.e. a 24-bit display).

The correct combination of computer, monitor and graphics card is required to give this facility, and must be checked carefully when selecting a machine. With some Apple models, for example, extra VRAM (Video RAM) chips can be added to give the required bit depth with some monitors. It is easy to calculate the amount of VRAM required for specific bit depth for certain monitor sizes from the formula:

VRAM required = bit depth × horizontal resolution x vertical resolution

A 14-inch monitor with a resolution of 640 × 480 pixels displaying just black or white requires 307,200 bits of information, or 38,400 bytes (bits divided by eight to give bytes) or 37.5 Kb (38,400 divided by 1024 to give Kb). To achieve 8-bit colour (256 colours or greys) this monitor will require 37.5 × 8 = 300 k. Therefore, a computer with 512 k of VRAM fitted as standard is capable of displaying 8-bit.

To achieve 16-bit (32,000 colours) requires 37.5 × 16 = 600 k.
To achieve 24-bit (16.7 million colours) requires 37.5 × 24 = 900 k.

With other monitors, graphics cards will be required. Different computers will require different cards, and advice should be sought from the dealer for each specific machine.

Spatial resolution is the number of pixels which can be displayed both vertically and horizontally. With low spatial resolution, edges of objects, particularly curves and diagonal lines, will exhibit a staircasing effect known as aliasing (see Chapter 4). The effect becomes

less the higher the resolution i.e. the higher the number of pixels per inch. Monitor resolutions are quoted in pixels (e.g. 640 horizontally × 480 vertically). A single pixel is created by several adjoining points of light on the display. The fewer dots of light used to create the pixel, the better the resolution. Most monitors have a resolution of 72 or 75 pixels per inch.

Some typical monitor resolutions in pixels

VGA	640 × 480
Super VGA	800 × 600
Macintosh 16-inch colour display	832 × 624

The size of a monitor is quoted in inches, and is measured diagonally from corner to corner. This may be misleading, however, as this figure will probably not be the actual image size, and manufacturers seem to use different criteria for measurement! A 19-inch monitor is 11.5 × 15.25 inch (292 × 388 mm), but only has an image area of 10.75 × 13.63 inch (273 × 344 mm). It is easy to calculate the usable image area of a screen, knowing the vertical and horizontal pixel count, and the screen resolution. In the example above:

19-inch screen (483 mm):
horizontal pixel resolution of 1,024 pixels
vertical pixel resolution 808
resolution 75 dpi

This gives an image area of 10.75 × 13.63 inch (273 × 344 mm).

Other specifications to examine when choosing a display monitor are the vertical scan rate (or screen refresh rate), and dot pitch.

Vertical scan rate

Television pictures are transmitted as interlaced signals. The electron beam first scans the screen once to give half of the picture or field, then does so again, with the second scan interlacing with the first to give a complete picture or frame. This is known as the vertical scan rate. In the UK, the PAL system of television is used, working at 50 Hz – the screen is 'redrawn' 50 times per second. However, with interlacing, only half of the image is redrawn at each pass, so that we end up with a framing rate of 25 frames per second. Computer monitors work at figures between 50 and 80 Hz, and are generally non-interlaced, so that the screen is redrawn at a rate of between 50 and 80 frames per second – i.e. each pixel is scanned at this rate. If the rate were too low, a flicker effect would result which, as we generally sit quite close to computer monitors, would become very uncomfortable to look at after a time. The image on a computer monitor is therefore much more stable than a domestic television. Generally, a scan rate of 70 Hz and over should give a flicker-free display. Some flickering may become apparent if the brightness level is high, or occasionally may result from a strobing effect with fluorescent lighting.

It is possible to buy non-interlaced displays to give static images, but these are usually more expensive than interlaced ones, and may be no better than a good quality monitor with high refresh rate and resolution.

Dot pitch

Dot pitch refers to the distance between the holes on the shadow mask, a thin metal plate with holes through which the electron beams pass before striking the phosphor coating inside the face of the cathode ray tube. Good screen displays have a small dot pitch (e.g. 0.26 mm), high dot pitches give coarse, grainy images. In Sony Trinitron-based monitors (which tend to give sharper and brighter images than those with a shadow mask), the shadow mask is replaced by an aperture grill (or tension mask) made of thin parallel wires. The specification in this system is referred to as a 'stripe pitch' rather than dot pitch.

While any size of high resolution monitor capable of displaying 16 or 24 bits per pixel is acceptable for imaging purposes, a reasonably large one is to be recommended, 17 or 19-inch are excellent. This allows an image to be displayed along with other windows for showing paint and brushes palettes and perhaps the 'curves' window as well. You will probably also want at times to display several images at the same time – the larger the monitor, the more information it can display.

When using monitors, especially with work intended for colour output, try to arrange a constant light source for viewing. Just as photographic colour printers use a standard tube for assessing colour prints, so a computer monitor should be viewed in standard conditions. Variable natural lighting should not be allowed to fall on the screen, and ambient room lighting should be as consistent as possible. Prevent other people from altering the controls of the monitor as this will affect the final output – some operators remove the knobs from their monitors for this purpose! Also, remember that monitors generate heat, and that as they warm up the shadow mask or aperture grill expands. If the monitor is to be used for accurate colour calibration, wait for at least 20 minutes until it has reached its optimum condition.

Mice and graphics tablets

The pointing device known as a mouse supplied with most computers is fine for most purposes, but not very good for drawing precise outlines and other imaging applications. Several alternatives using larger balls called trackballs are available which are more controllable. An alternative to the mouse is the digitizer or graphics tablet, a flat plate usually A5 or A4 in size. Drawing and pointing is carried out with a stylus which looks and acts very much like a pen. Much finer control over drawing or making selections is possible with the stylus, which is usually pressure sensitive. When painting in programs such as Letraset's Painter or Adobe Photoshop the more pressure that is applied to the stylus, the more 'paint' is applied. Unlike the mouse which can be raised and moved to another part of the mat without altering the position of the cursor on the screen, the positioning of the stylus on the tablet dictates the position of the cursor. When selecting a graphics tablet, do not be tempted by the adage that 'biggest is best'. For many applications, an A5 or even A6 one is excellent, and can be used on the knee rather like a

notebook. A4 and larger tablets are useful, but are not so manoeuvrable on a desk, and are more expensive!

Digitizer (framegrabber) board

If the image required is to be obtained from a video or still video source, then, as discussed in Chapter 2, it needs to be digitized. Several framegrabber boards are available from a variety of suppliers for PCs and Apple computers for converting an analogue video signal into a still digital one. Various examples are available including those from Neotech, Kingfisher and Screen Machine. Depending on the board, they will generally take a variety of input signals, e.g. Composite video, SVHS, etc., and convert them into a still frame. Many newspapers regularly 'grab' individual frames from transmitted television pictures with a framegrabber board. For multimedia applications, boards are also available for digitising moving video sequences. An example is the Video Spigot board for the Macintosh.

Connecting other devices to the computer

When connecting peripheral devices such as scanners, external disk drives and printers to computers, the information needs to be sent quickly through the cable system used. On PCs, there are two types of socket, or 'port' used, serial and parallel ports.

The serial port on a PC is an industry standard, the RS-232 port, though even with this standard, the variety of connectors can be confusing. It is a multi-purpose port for connecting mice, modems and other devices to the computer. The basic principle of the serial port is to have one line to send data, another to receive data and several others to regulate the flow of that data. The data is sent in series, i.e. one bit at a time. This is somewhat inefficient, but no problem for communicating with a device like a mouse, which does not require speed, and for modems connected to standard telephone lines which can only handle one signal at a time.

The parallel port is often referred to as the Centronics port and is most often used for connecting to printers. The parallel port has eight parallel wires which send 8-bits (1-byte) of information simultaneously, in the same amount of time which it takes the serial port to send 1-bit. One drawback with the system is that of 'crosstalk' where voltages leak from one line to another, causing interference of the signal. For this reason, the length of parallel cables is limited to approximately 10-feet (3-metres). Most PCs have both serial and parallel ports. The Macintosh computer generally has one or two serial ports, one for the printer, one for a modem and another called a SCSI connection.

SCSI connections

SCSI (Small Computer Systems Interface, pronounced 'Scuzzy') is a port that permits high speed communication between the computer and a peripheral device, such as a scanner, external hard disk, CD-ROM drive or even a digital camera.

Fig. 3.1 Example of a SCSI chain, showing an external disk drive and scanner attached to a computer. It is essential that each peripheral device has its own identity number, and that the last device in the chain is fitted with a terminator. Some devices have built-in terminators, so check with the instructions before attaching it. Always turn on the peripherals before starting the computer, otherwise the computer will not be able to recognize them as SCSI devices.

computer

CPU: i/d no. 7
Hard disk i/d no. 0
(These numbers are
pre-set and cannot
be changed)

terminator

external disk drive
SCSI i/d no. 2

scanner
SCSI i/d no. 3

Up to six extra SCSI devices can be connected to the computer. They are linked, or daisy-chained together, with each device being assigned a specific identity number. This ID can be set on each device using switches on the back. By convention, the internal hard disk of the CPU is ID 0, and the computer itself is 7, which means that six other devices can be connected. SCSI is a form of 'bus' – a common pathway for the relaying of data, shared by several devices. A terminator (terminating resistor) must be used at the start and end of the chain to identify the limits of the bus and prevent signals reflecting back on the bus after reaching the last device.

The SCSI bus on a Macintosh Quadra can send 5 million characters (5 Mb) per second. It does this by sending the information in the form of 8-bits in parallel mode. SCSI 2 is a wider pathway, enabling 32-bit data transfer. SCSI accelerator cards are available.

When using SCSI devices, always ensure that the devices are switched on before the computer. Generic software such as SCSI Probe, is available, often through shareware and public domain software suppliers enabling you to check that all SCSI devices in a chain are connected ('mounted') properly.

The majority of PC machines lack SCSI connection, although the facility can be added by using a SCSI card which is fitted inside the computer. Problems may arise in fitting these cards to portable computers if only because of lack of space inside the case.

New SCSI interfaces will become available as cards which slot into the PCI expansion slots of the latest computers. Several new versions will become standard, under the general umbrella of SCSI-3.

Accelerator boards

A major problem found when using desktop computers for image manipulation is that of speed. Even with the fastest possible processor, many operations such as applying filters or rotating the image can take an appreciable amount of time to carry out. Many companies manufacture accelerator boards, often specifically designed to work with applications like Adobe Photoshop. These may contain Digital Signal Processors (DSPs) which help speed up mathematically intensive operations. DSPs are now being built into some new

computers, although they may have no effect until software is written to take advantage of the facility. Accelerators can speed up many operations by as much as 2,300 per cent! They are generally expensive, but if the computer is to be used primarily for dealing with large images, they are well worth considering.

One company, Connectix, has recently begun to market a software accelerator for the Macintosh, known as Speed Doubler. It works through a combination of memory allocation and disk-caching techniques and is said to speed up operations such as saving and loading documents to disk, launching applications and the copying of files. It will probably not replace a good hardware accelerator for image processing.

Future developments in computing

Developments in the computing world over the next couple of years will mean that Apple Macintosh and IBM clones will move closer together. Talks between Apple, IBM and Motorola have led to the development of PowerPC, a new generation of microprocessors which will perform operations much faster than existing chips, and allow MS-DOS/Windows, Windows 95 users to run all their programs on Macintosh computers. These new PowerPC 601 and 603 RISC-based (Reduced Instruction Set Computer) processors enable the CPU to process instructions very efficiently, by using independent execution units to handle multiple instructions simultaneously. Existing 68,040 processors use CISC architecture (Complex Instruction Set Computer) which sends instructions through different units one at a time. These new processors became available in early 1994, and there are plans for several others to follow. Apple Macintosh computers can now run MS-DOS and Windows applications as well as all the existing Apple software. In many instances, the two systems operate seamlessly, so, for example, a file can be dragged from a Windows application straight into a Macintosh application.

Alongside this development, Intel, the manufacturer of 486 chips, have produced a new generation known as Pentium 586 chips, and have already announced the P6 chip, to be launched probably in late 1996. Like the PowerPC processors, the new Pentium chips will operate much faster than existing chips.

Practical advice on setting up a computer-based imaging system

Absolute minimum specification

A computer capable of having at least 48 Mb of RAM, a hard disk of at least 750 Mb and a 24-bit colour display.

Hard drive storage

No hard disk is too large, and the difference between 500 Mb and 1 Gb when purchasing a system can be as low as £100. It therefore pays dividends to purchase the maximum size drive possible with the

system. The only thing that can be guaranteed in computing is that within six months a hard drive will be full!

The CD-ROM drive has become an essential accessory for imaging. Besides being able to access PhotoCD, many software manufacturers offer the option of their programs on CD. These make it much easier to install the program and many use the extra space available on the disk to supply tutorials and sample images as well as demonstrations of other programs.

Expansion

Make sure that the computer is capable of expansion – imaging systems often require the addition of accelerator boards to speed up processing. Some PC systems require that SCSI cards are added before scanners and cameras can be connected. Some systems are primarily designed as home machines and offer very little opportunity for expansion.

The minimum system should offer at least three expansion slots for cards to allow for improvement of the machine.

RAM

RAM memory or SIMMs (Single Inline Memory Modules) are the most expensive element of the computing system. RAM is fitted inside the machine plugged into SIMM sockets on a memory board.

The important thing to note is the maximum amount that can be fitted – this is limited by the number of SIMM slots on the machine. SIMMs or memory chips come in different sizes normally 2, 4, 8, 16, 32 or 64 Mb modules.

On some older machines, it is not possible to fit SIMMs except in groups of four.

For example, with the PowerMacintosh 6100 computer, 8 Mb of memory is an integral part of the computer circuit board ('motherboard'). This machine has two slots available for the addition of extra SIMMs. This offers the potential of a maximum of 72 Mb as follows:

> to upgrade to 16 Mb: 2×4 Mb SIMMS,
> to upgrade to 24 Mb: 2×8 Mb SIMMS,
> to upgrade to 40 Mb: 2×16 Mb SIMMS,
> to upgrade to 72 Mb: 2×32 Mb SIMMS.

When buying a new system it makes sense to have larger SIMM chips fitted. So for a configuration of 40 Mb on a system with 8 Mb on the circuit board and four slots, rather than use all four slots on a 16 Mb + 8 Mb + 4 Mb + 4 Mb configuration a single 32 Mb will leave three slots free for further expansion. Also smaller SIMM chips tend to have little exchange value when a system is later expanded.

Monitors and colour display cards

When purchasing a system, remember that you may be spending a great deal of time looking at the screen so a good, sharp monitor is a very worthwhile investment. This is one area where the Macintosh system beats the PC system, as many Macintosh computers are

capable of displaying 24-bit colour straight out of the box. PC colour display cards can be very expensive if they are to give the same quality of colour on screen.

Software

All software piracy is theft and a crime. The FAST (Federation Against Software Theft) organization is dedicated to tracking down software copying and fining the perpetrator. Software can be an expensive investment and most software companies offer demonstration software with the save option disabled to enable a customer to test out software. These are normally distributed on 'try and buy' CDs on which the full version of the package can be unlocked by payment to a phone number with a credit card.

Where to buy

Look for a reputable dealer who is local to your area. This may not appear to be the cheapest option in the short term but if you encounter any problems it will rapidly become an investment. Purchase from a dealer who offers the appropriate level of support to your needs. Some dealers may offer a more expensive deal but this may include training for customers who are not conversant with computers. Clarify the service offered at the time of the initial quote and get it put in writing. This should include the terms of guarantee, the scope of service if included and the details of what will be supplied and installed.

In any imaging system, the result is only as good as the weakest link. It therefore makes no sense to connect a £7,000 scanner to an £800 computer and expect the results to be anything but poor. No photographer would use cheap lenses on their Hassleblad camera, and the same philosophy should apply to computing.

4
Digital image processing

Digital image processing is a general term used to describe a wide range of operations carried out to digital images. Strictly speaking, any digital image that is modified in any way by a computer has been processed, and the applications are widespread. Much of the technology has resulted from the work of NASA, which has been enhancing and analysing images transmitted back from spacecraft for over 30 years. The most famous example is perhaps that of the Hubble space telescope, whose distorted images were partially corrected by digital image processing before it could be physically repaired in space. Other major applications include medical imaging, machine vision (where cameras monitor production lines, and can be programmed to reject faulty components automatically), and the whole area of image enhancement and manipulation, which relies on the techniques of scientific image processing. This chapter will discuss some of the basic principles of image processing, illustrated with examples from Adobe Photoshop 3.0, and a 'public domain' image analysis program, NIH Image 1.57. It is not intended as a substitute for a good training manual, nor as a textbook on digital image processing!

Digital image processing can perform a huge range of functions to images, including:

- enhancement of brightness and contrast;
- alteration of colour balance;
- addition or subtraction of colour or grey tones either for scientific or creative use;
- blurring and sharpening of images;
- removal of parts of images to aid analysis;
- modification of images to extract information;
- distortion of the image, usually for creative effect.

In addition to the above, a huge range of 'special-effects filters', generally for creative use, are available for image processing programs to add textures, simulate a lighting effect and even add the effect of lens flare to an image!

There are very many different programs available, varying both in their capabilities and price. Many of the less expensive programs will

still carry out a wide range of image enhancement and retouching procedures, and it is worth examining these carefully to see if they are adequate for the purpose required. Image processing programs are known as 'paint' programs, where the image is composed of a rectangular grid of pixels known as a 'bitmap'. Each pixel is assigned a value, from 1 bit (black or white) to 24 bits per pixel for full colour images (some programs work with 32 bits, where a fourth 8-bit 'alpha channel' stores information relating to masks and layers, etc.). Because bitmapped images contain a fixed number of pixels, the resolution (pixels per inch) is dependent upon the size at which the image is printed. Other programs, used primarily for drawing and graphical illustration are known as 'object-oriented' or 'vector-based' programs, and include Adobe Illustrator and Macromedia Freehand. These use mathematical formulae to define lines and shapes (for example, a circle can be described by the formula $x^2 + y^2 = z^2$). The artwork is built up from a series of separate components, or objects, each of which is independently editable. Vector images are stored as a display list describing the location and properties of the objects within the image. Objects can include the letter 'A', in Helvetica font, italic style, 12 point, a square, with sides 50 mm, and line width 0.5 mm, and a raster image scaled to 5×8 cm. Because an image composed with an object-oriented program is made up of mathematical data, the resolution is dependent upon the output device, be it a laser printer or high resolution imagesetter. Also, images stored as bitmaps tend to be much larger than vector-based images as the computer needs to have information about every pixel within the image.

When desktop computers suitable for imaging first became available, most of the programs were written for the Apple Macintosh computer, but now many programs, including Adobe Photoshop, are available for PCs and other computer platforms. Images can be easily transferred between platforms using standard file formats such as TIFF, or file conversion programs such as PC Exchange, and increasingly, with the development of new RISC processors, the computers themselves will be cross-platform. Programs are updated at regular intervals by the authors, and it is very important to register your software immediately with the manufacturer to ensure that you receive the latest versions and upgrades. The potential of the programs is huge, and here we can only look briefly at the operations possible. It is essential to spend time reading the manual supplied with the software, and carry out the suggested tutorial exercises. It will take a long time to become proficient with all areas of the program, but the basic operations will become familiar relatively quickly.

Adobe Photoshop *(The following text relates to the use of Photoshop on an Apple Macintosh computer. It works in virtually the same way on a PC, except for some of the key combinations.)*

Adobe Photoshop has become in recent years the industry standard program for image enhancement and manipulation on desktop computers. It is capable of a huge range of functions including

Fig. 4.1 Screen view of Adobe Photoshop 3.0 on PowerMacintosh computer, showing toolbox and menu bar, open image, brushes palette and 'info' window. This shows *x, y* coordinates and 'K' (black) density of pixel under cursor. Also, layers window showing background and one layer. Note image size at bottom left of image: 1.07 Mb and 2.33 Mb (the first figure indicates the size of the 'flattened' file as it would be sent to a printer, the second shows the size of the file with all layer and channels data). The desktop itself shows: hard disk icon, Syquest icon, PhotoCD and floppy disk icons, networking 'alias' and Soft Windows software, enabling the machine to run certain DOS/Windows applications.

Fig. 4.2 Adobe Photoshop 3.0 toolbox containing a range of selection, cropping, drawing, painting and enhancement tools.

conversion to CMYK for output to printing plate. It also acts as the host for many digital imaging devices, which come with small programs called plug-ins which are accessed through Photoshop. Many third-party developers also write extra plug-ins for the program, including extra filters. Similarly, 'export modules' allow the output of images directly to various printers through Photoshop.

Written for photographers, Photoshop has many tools familiar to photographers such as dodging sticks and burning-in tools. Many other similar programs are available, and many of the remarks made here about Photoshop will be applicable to them also.

Images stored in a large range of file formats can be opened, including Photoshop's own proprietary format, TIFF, JPEG and PhotoCD. Upon opening the program, the screen displays a menu bar at the top, and a toolbox running vertically down the left-hand side.

The toolbox contains items familiar to photographers such as pencils, paintbrushes and buckets, rubbers, dodging sticks, together with others for selecting areas of the image, creating text, cropping images and filling selected backgrounds with a gradient.

Tools are selected from the toolbox by clicking the cursor on the required one, then taking it into the image area. With most of the tools, holding the option key and clicking with the mouse brings up a range of further options which may be selected. For example, option clicking on the *blur tool* allows you to switch between the blur and sharpen tools.

Selection tools

These tools enable you to select parts of an image for modification or adjustment. The *marquee* tool enables selections of rectangular and elliptical (they can be constrained to be squares or circles if

required) shapes, while the *lasso* tool is used to make freehand selections. The *magic wand* is used to automatically select parts of the image based upon the colour similarities of adjacent pixels. It can be used to select part of an image such as an even-toned background. Once selected, the required area is outlined by 'marching ants', an animated dotted line. When applying modifications to the image, only the area selected is affected. The most precise way of selecting a part of an image is the *pen tool*, found in the Paths palette from the window menu. The required area is selected by making various points around the item. The selected area can be saved as a *path* which can be edited very precisely. Selections can be 'feathered' – their edges can be softened by varying amounts to make it easier when merging them with other images for example. The *move* tool is used to move selections and layers.

Cropping tool

This tool is used to select a part of an image and discard the remainder, in much the same way as trimming a photographic print. Always crop an image to remove any redundant or unwanted information to obtain the smallest possible size, and thus save on memory.

Text tool

Text can be entered on to an image in a range of sizes, font style (those installed on the computer) and colour. Images can be labelled or captioned. The colour of the text is that of the foreground colour palette, so ensure that this is set before adding the text to an image. Text can be moved around on an image until it is in the required place, when clicking outside it will 'lock' the text on to the image. The style of the text can be selected, and it can be filled with, for example, a gradient colour. While the text option with Photoshop is useful, it must be remembered that the text is bitmapped, and is the same resolution as the rest of the image so that magnification of the images will show 'aliasing' or 'staircasing' on rounded letters. While anti-aliasing software (Adobe Type Manager) is supplied with the program, which helps smooth out this effect, it never matches the quality of text generated by a desktop publishing program producing PostScript language type, and if good, high quality type is required it is worth considering taking the image into another type of program for adding text afterwards. The same applies to the drawing of diagonal lines.

The hand tool

Where an image is larger than the displayed window, the hand can be used to drag the image within the frame.

Fig. 4.3 Aliasing: a. aliased text, b. anti-aliased text, c. vector text.

The zoom tool

This tool allows you to zoom in on an image or zoom out. When first selected, the magnifying glass displays a plus sign, and enlarges the image when clicked, to a limit of 1,600 per cent. If the option key is held down, a minus sign appears, and the tool now zooms out, or reduces the magnification, to a limit of 6 per cent. Placing the tool on a particular part of the image enlarges that part.

Painting and drawing tools

The next eight tools in the Photoshop toolbox are concerned with painting and drawing. The *pencil, paintbrush* and *airbrush* are all self-explanatory. Their size and characteristics can be altered in the Brushes palette. The colour applied will be the colour displayed in the foreground colour box at the bottom of the toolbox. The *pencil* is used to paint hard-edged lines or dots, the paintbrush soft edged strokes, while the airbrush lays down a diffused spray of colour. The way in which the colour is applied can be altered in the Brushes palette. Adjustments can be made to the opacity, saturation and many other modes of application. The shape of the brush can also be altered.

The *eraser* is used to erase parts of an image. The eraser removes the image down to the background colour displayed at the bottom of the toolbox. When working with layers, the colour removed by the eraser is replaced by transparency.

The *line* tool is used for laying down straight lines, at any angle or length. It has the option to have arrowheads at the start or end, and be drawn in a variety of thicknesses. It is useful for producing annotated photographs. As with the text tool, the line is bitmapped so that diagonal lines exhibit aliasing.

The foreground colour in the toolbox can be selected by clicking the eyedropper tool in any part of the image. This colour is now used by the other drawing tools until another is selected.

The *cloning* (or *rubber stamp*) tool is potentially one of the most useful in the toolbox. It allows you to sample a part of an image and place an exact copy (clone) of it elsewhere in the image, or in another image. Extensive options allow the cloning of patterns, or with an 'impressionist' style.

Dodging, burning and *sponge* tools: these operate in much the same way as dodging and burning-in in the darkroom, making areas of an image lighter or darker. The size of the tools can be adjusted in the Toning Tools Options palette, as can the degree of dodging and burning. The sponge option is used to change the colour saturation of part of an image.

The *smudge* tool smears colour in an image, in much the same way as dragging a finger through wet paint.

The *blur/sharpen tool* blurs or sharpens small areas of an image, without resorting to the blur/sharpen filters from the filter menu. There is not so much control over the process as with the proper filters.

The menus

The menu bar at the top of the screen contains sub-menus for such operations as changing the mode of display of the image, adjusting

brightness, contrast and colour balance, applying filters and controls for copying and pasting parts of images together.

Mode

This menu allows you to convert an image displayed in one mode to another. For example, a greyscale image can be converted to a colour RGB display. Although it will not look any different, it now allows the addition of all of the colours within the paint palette – like hand colouring a monochrome print. One consequence of this conversion is that the file size will increase by a factor of three.

Another conversion for greyscale images is to produce duotones, tritones or quadtones, whereby the image is printed with two, three or four inks. In duotoning, for example, an image can be displayed using black and one other colour, perhaps an orange. This will result in a sepia-toned image. The colours chosen relate to industry standard printing inks such as the Pantone range.

RGB images can be converted to CMYK, enabling photographers to produce the four colour separations required for four-colour litho printing, including all the necessary registration and calibration bars. While this is an easy operation to carry out, the process itself is rather complicated with many variables and is beyond the scope of this book. It requires calibration of monitors, printers and inks, and photographers regularly requiring this facility are advised to liaise closely with their printer. Many printers and bureaus recommend that photographers supply their digital images as RGB files, and have the separations made by the bureau. Another option within the mode menu is that of 'indexed colour'. In this mode, Photoshop builds a colour look-up table (CLUT) based on a uniform sampling of colours from the RGB spectrum. Indexed colour images can only hold 256 colours. If a particular RGB colour is not present in the colour table, the program matches the colour to the closest one in the table, or simulates the colour using those that are present. You can edit this CLUT very precisely to improve the colour rendition of the image. An 8-bit indexed colour image can be almost as good as a true 24-bit image, yet occupy only one third of the disk space (though it is worth noting that indexed colours cannot be compressed using JPEG). For this reason, many multimedia programs which include large numbers of high quality still images often use indexed colour.

Enhancement of brightness and contrast

When printing monochrome negatives in the darkroom, the photographer can control the brightness (density) of the print by varying the exposure, and its contrast, through the use of different grades of paper. In digital imaging, the same controls are available, but to a much higher degree. The simplest form of control found in the program is a simple slider bar, allowing the brightness and contrast of the whole image, or selected part of the image to be controlled. This works well, but very often a much tighter control is required, perhaps of just one area of the image such as the shadow or highlight. In this case, the image can be altered by manipulating

either the histogram ('levels'), or the 'curve' (equivalent to the characteristic curve of a film emulsion).

The histogram, or levels control, is a graphical representation of the distribution of pixel values within an image. The horizontal axis of the histogram represents the brightness of pixels, usually from 0–255 for 8-bit grey scale images. For RGB colour images, histograms for each of the three colours are available. The vertical axis is the number of pixels which fall into that brightness value.

Histograms can show the experienced viewer whether an image is generally too light or too dark, or high or low contrast, and how much of the available dynamic range of the image is being used. Many image processing programs offer the ability to manipulate the histogram to alter the image quality. The two most common forms of histogram manipulation are *histogram stretching* and *histogram sliding*. Both of these operations redistribute the levels of brightness within an image, to enhance its contrast characteristics. If the image data is 'stretched out' to fill the histogram, gaps appear in the histogram (see Fig. 4.4d). This absence of pixels in certain areas can lead to 'posterization' effects or tonal banding. These may not be noticeable, or may only become obvious when other corrections or enhancements are made to the image.

Another adjustment available within programs such as Photoshop is the 'curves' control. This is similar to the characteristic curve of a film emulsion, but can be adjusted to almost any degree on screen, either for image enhancement, or for special effects such as solarization. When used with colour images, each channel of an RGB or CMYK image can be adjusted independently, allowing fine control of colour balance and contrast.

The *x*-axis of the graph represents the original brightness values of the pixels in an image, and the *y*-axis represents the new output values. Upon opening the dialog box, the default display shows a straight line at 45° i.e. every pixel has the same input and output value. This curve can now be adjusted, either by altering the slope of the whole curve, or part of it. As with a photographic characteristic curve, the steeper the angle, the higher the contrast of the original. Tones on the curve can be pegged, and the rest of the curve made to pivot around that point. The illustrations show a low contrast scanned image enhanced to give good highlight and shadow detail by applying an 'S' shape to the curve. An 'auto' setting automatically maps the darkest pixel in the image to black, and the lightest to white. An arbitrary curve can be drawn with the pencil tool to give special effects such as solarization.

Enhancement and alteration of colour balance

Digital photographic colour images are generally displayed as either RGB or CMYK images. The overall colour balance can be altered, or the image separated into its component channels, and each channel modified independently. In Photoshop, a colour balance dialog box can be displayed whereby slider controls can be used to add or subtract red, green or blue, or yellow, magenta and cyan. This can be applied to the whole image, or just areas such as the shadows or highlights of the image. One instance where this could prove

Fig. 4.4 Histograms for different image types.

a. Fossil fish: here, most of the pixels are concentrated in the centre of the graph, indicating more mid-tones than highlights or shadows.

b. Badger: this nocturnal photograph is very low key, with large areas of shadow. Note how the pixels are concentrated towards the black end of the graph.

c. Green heron: histogram for 'raw' file from PhotoCD.

d. Green heron: histogram for image enhanced for brightness and contrast showing posterization effects – i.e. absence of pixels in certain areas.

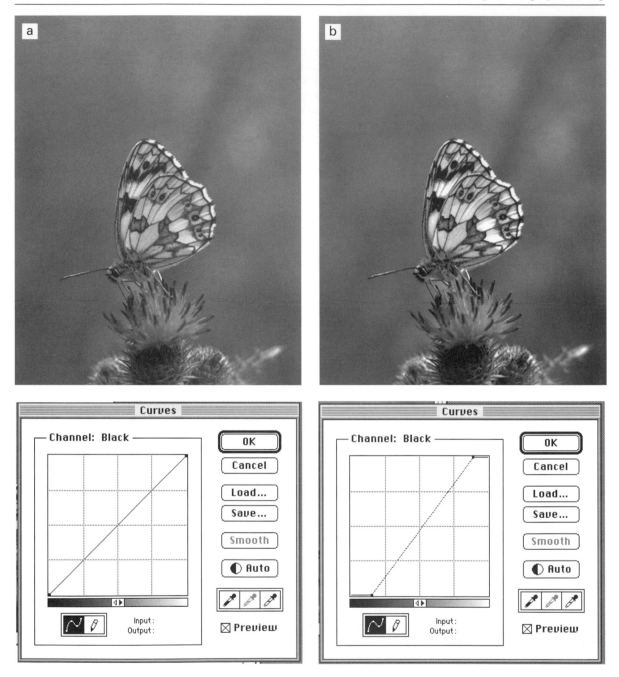

Fig. 4.5 Curves control in Photoshop.
a. Marbled white butterfly – 'raw' image from PhotoCD with associated curve.
b. Marbled white butterfly – image enhanced for brightness and contrast using curve control. This complex control acts in a similar way to the characteristic curve of a film emulsion. In this case, increasing the angle of the curve leads to an increase in image contrast. Like the photographic 'zone system', particular tones in an image can be mapped to particular points on the curve.

extremely useful is with a poorly processed negative, with 'crossed curves', where the image has, for example, green highlights and magenta shadows, and it is impossible to remove the cast when printing it. A 'colour variations' facility is available, which is similar to the 'colour ring-around' used in photographic colour printing. A range of variants of the image are displayed, showing the effect of adding or subtracting various colours. Again this can be applied to highlights, shadows or mid-tones only. Finally, the hue, saturation and brightness of each colour can be altered, again enabling fine control over the final image.

Photoshop is capable of displaying 'out of gamut' colours. As discussed elsewhere, the gamut of a colour system is the range of colours which can be displayed, or printed in that system. It may not be possible to print colour displayed on a monitor in RGB mode when converted to CMYK. While Photoshop automatically brings all out-of-gamut colours into gamut, you may wish to see them so that modifications can be made manually. Photoshop will display an exclamation mark (!) in the appropriate dialogue box for out of gamut colours.

Image

In this part of the menu, images can be rotated, their shape distorted and even the perspective corrected. Images of buildings displaying 'converging verticals' when photographed on small or medium format cameras can be corrected here. Images can be resized, and the resolution changed (resampled). Resizing can be carried out by percentage or specific measurements. If the image size is to be increased, then it may be necessary to increase the resolution. This, however, does not necessarily produce a higher quality image, as in order to increase resolution, the software has to create new pixels through a process called 'interpolation'. This

Fig. 4.6 Interpolation examples. A 72 dpi image resampled to 200 dpi using the three interpolation methods available in Adobe Photoshop. The nearest neighbour option copies or replicates the adjacent pixel when creating the new one. This is the fastest option, but least effective. The 'bilinear' option smooths the transitions between adjacent pixels by creating intermediate shades between them, creating a softened effect. The third option, bicubic increases the contrast between pixels following the bilinear option, offsetting the softening effect. This takes time, but offers the best quality of image.
a. normal;
b. bicubic;
c. bilinear
d. nearest neighbour.

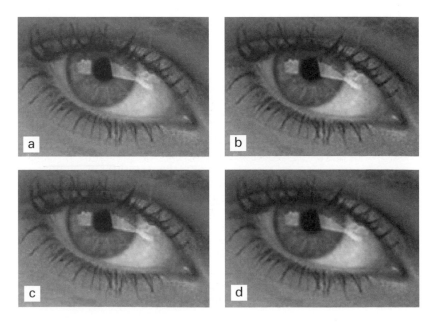

process is also used by the software when images are rotated by anything other than 90° increments or distorted. Photoshop has three methods of interpolation for image resizing: bicubic, nearest neighbour and bilinear.

The nearest neighbour option copies or replicates the adjacent pixel when creating the new one. This is the fastest option, but least effective. The bilinear option smooths the transitions between adjacent pixels by creating intermediate shades between them. It creates a softened effect. The third option, bicubic, increases the contrast between pixels following the bilinear option, offsetting the softening effect. This takes time, but offers the best quality of image.

Filters

Image processing filters are the electronic equivalent of the glass filters which photographers place over lenses, but are capable of a vastly more comprehensive range of effects than their glass equivalents. Electronic filters can be generally divided into two basic types: corrective or enhancement, and destructive. In very simple terms, a filter is a mathematical weighting which can be applied to the whole image or selected part of the image. The formula can exaggerate the differences between adjoining pixels, remap those or make them become different values. The filters are made up of 'kernels' or blocks of pixels, usually 3 × 3, 5 × 5 or 7 × 7. The 'convolution mask' contains coefficient or multiplication factors which are applied to the values of the pixels within the kernel and then summed to calculate each new pixel value.

Taking the example of a 3 × 3 kernel of nine pixels: eight pixels surrounding the central one being processed. If the central pixel has a value of 100, and its eight neighbours all have a value of 60, the sum of the neighbouring pixels is therefore 480, which, added to the 100 of the central pixel gives a total value of 580 for the kernel. This is divided by 9, giving 64. The central pixel is given this value, which is less than the original, making it therefore darker (or lighter if the image processing program used, e.g. Image 1.57, has a Look-Up Table where white is given the lowest value).

The filter will be applied to all the pixels within the image (or selected area of the image) and has the effect of smoothing (blurring or softening) the image, and is known as a 'low pass' filter. This type of image filtering is known as spatial filtering which affects the rapidity of change of grey levels (or colour) over a certain spatial distance. Low pass filters accentuate low frequency details leaving high frequency details attenuated, or reduced, as a result.

Processing time will obviously depend on the size of the image and power of the computer. Applying such a kernel to a 640 × 480 greyscale image means that the process has to be applied 640 × 480 = 307,200 times. As each pixel will require nine multiplications and nine additions, this means that the whole image will require nearly three million calculations!

Fig. 4.7 Filter examples:
a. Photomicrograph of blood cells.
b. As a, using 'shadow' filter to enhance image.
c. As a, using 'trace edges' filter.
d. As a, using 'sharpen' filter to enhance image.

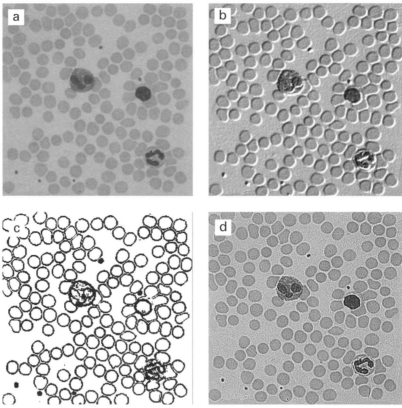

Examples of filters are given below.

Sharpen

–1 –1 –1
–1 9 –1
–1 –1 –1

This is just one of many types of sharpening filter.

Smoothing

1 1 1
1 1 1
1 1 1

This filter blurs (softens) an image and can also reduce 'noise'.

Shadow.

–2 –1 0
–1 1 1
 0 1 2

This produces a shadow effect with the light appearing to come from lower right.

Trace edges.

1	1	1
0	0	0
−1	−1	−1

traces horizontal edges

−1	0	1
−1	0	1
−1	0	1

traces vertical edges

Reduce noise

This is a 'median' filter, where each pixel is replaced with the median value of its 3×3 neighbourhood. This is a relatively slow operating filter because, for each pixel in the selection, the nine pixels must be sorted, and the central pixel replaced with the value of the median/fifth. This is a useful filter for removing any noise generated by CCDs in digital cameras.

Sharpen filters

One of the most commonly used (and abused!) types of filter are the various sharpening filters available in Photoshop, Image and most other image processing programs. Basically, a sharpening filter increases the contrast between neighbouring pixels, giving an apparent increase in sharpness. The filters cannot bring an out of focus image into sharp focus! However, they are very useful for sharpening scanned images, or images prior to reproduction. Perhaps the most useful is the 'unsharp mask' filter, named after a photographic technique employed to perform a similar function. This particular filter can be modified by the user to give an optimum effect. Plate 1 shows the effect of various degrees of unsharp mask on a PhotoCD image. Do be careful not to overdo the effect! If necessary, carry out similar tests to the example shown here, to establish an optimum degree of sharpening for your particular application.

KPT Convolver

A recently introduced plug-in called Convolver offers a novel way of working with filters and other image enhancements. It enables the almost real-time operation of filters, as well as brightness and contrast adjustments, and a whole range of other alterations such as depth and shadowing effects. It works with just a small portion of the image. When the right result has been achieved, then the various processes can be applied to the whole image. It has both creative and scientific uses – both the FBI and NASA have used it, for example, in experiments for enhancing fingerprints, or terrestrial detail in satellite images.

Working with layers

Unlike previous versions, Photoshop 3.0 has the ability to store various elements of images as layers, each of which can be moved or modified. When an image is first opened in Photoshop, this becomes the background, rather like a canvas before paint is applied. Layers can then be added to this like sheets of transparent acetate. Each layer can be edited independently and their order altered so that they can overlap each other.

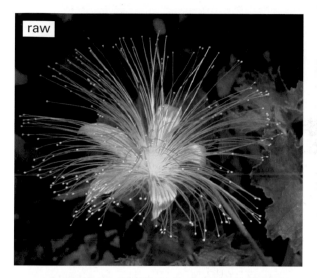

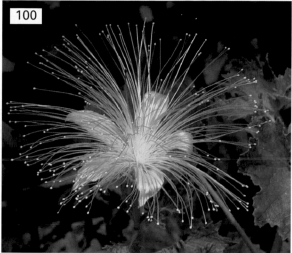

Plate 1 Unsharp masking.
Image 1 is a raw image from a
PhotoCD at base resolution.
Subsequent versions have had
an unsharp mask applied: 100,
200, 300, 500 per cent.

Plate 2 One type of image that benefits from digital imaging technology is the old, damaged photograph. In the example shown, the low contrast, faded sepia print was first scanned in a flatbed desktop scanner at 300 dpi and saved as a TIFF file. It was converted to greyscale, and the brightness and contrast enhanced using the curves control. The blemishes were retouched using the cloning and pencil tools. The image was then converted to RGB and hand-coloured using the paintbrush and airbrush tools. The choice of colour used is determined by the operator, and will probably bear no resemblance to the original clothes!

Plate 3 (next page) 'Cheetah Chasing Impala', by Steve Bloom.

This image was created from five component images on a high-end imaging workstation such as a Barco or Dicomed system, although it could equally have been created on a smaller desktop computer, where it would have taken much longer! It shows the huge potential of image processing and manipulation. Various components of the cheetah have been taken from the two originals (photographed on 35 mm film in a cheetah breeding centre) and merged together. The body has been re-shaped, rather like modelling a piece of Plasticine. The background has been given the effect of blurring to enhance the movement of the cheetah. Various elements of the two impala images have also been combined. The shadows were painted in afterwards. A great deal of time was spent analysing film and videos of running cheetahs and impala before the image was created to ensure that it was anatomically correct.

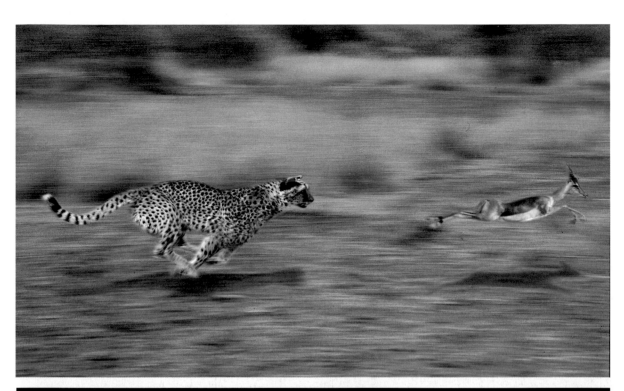

Plate 4: Series of images showing effects of compression of file size and quality:
Image 1: normal TIFF image from scanned 35 mm original.
Image 2: detail of above: file size = 247 Kb.
Image 3: as above but saved with LZW compression algorithm within TIFF. File size = 140 Kb.
Image 4: JPEG file format on 'fair' image quality setting: file size = 10 Kb.
Image 5: JPEG file format on 'excellent' image quality setting: file size = 82 Kb.
Note 'blocky' appearance of highly compressed JPEG image.

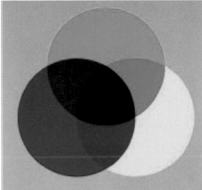

Plate 5: colour mixing circles.

Additive colour Subtractive colour

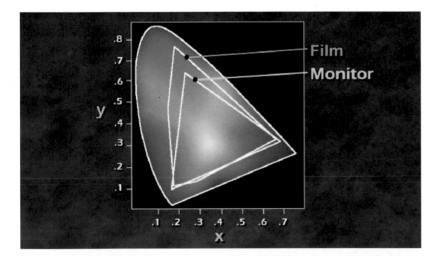

Plate 6: Gamut plate no. 1 (top); Gamut plate no. 2 (bottom).

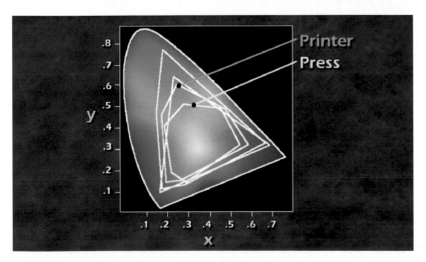

Plate 7: CIE chromaticity diagram.

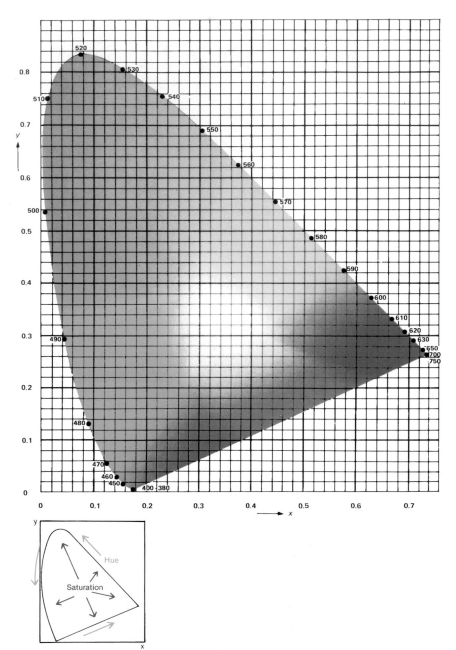

Plate 8 'Water Babies', by Zena Holloway, was composed using Adobe Photoshop, and was made up of 20 separate photographs. These were scanned into a PowerMacintosh using a Nikon 35 mm film scanner. The underwater images, including the babies, were all photographed underwater, and images of real fish tails and fins were added. The head, arms feet, thigh and chest of the main baby are all taken from different pictures. The light beams were added afterwards.

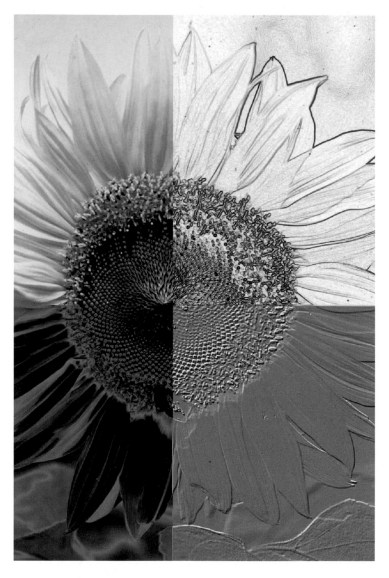

Plate 9 'Sunflower', by Adrian Davies.

This image shows the effect of three filters found with Adobe Photoshop. A 35 mm transparency of a sunflower was scanned at 2,000 dpi, giving a file size of approximately 18 Mb. Using the rectangular selection tool, starting at the centre, rectangular selections were made for three quadrants of the image, and filters applied. At the top right, the 'solarize' filter was applied, found in 'filters – stylize – solarize'. For the bottom right quadrant, the 'find edges' filter was applied, again found in the stylize menu. Finally, for the bottom left quadrant, the emboss filter from the stylize menu was applied, using settings of 146°, height: 5 pixels and an amount of 200 per cent. These settings were arrived at by trial and error, using the preview window in the filter. The colours were then adjusted using the hue/saturation controls in 'image – adjust – hue/saturation'. The whole image then had an unsharp mask applied to it of 150 per cent.

A major drawback with programs like Photoshop is that you must work with the resolution of image required when correcting or manipulating it. This could mean working with 20 Mb and more sized images, which can be very slow, and require large amounts of memory. Also, Photoshop has only one level of 'undo' so that if you have sharpened an image, then perhaps applied one or two other filters, you cannot undo the sharpening, unless you have saved a separate version of it. Recently, a different way of dealing with digital images has been introduced, with programs such as Live Picture and X res. Adobe Photoshop keeps three copies of an image in its memory. One is displayed on the screen, and when a manipulation such as a sharpen filter is applied it is applied, to a copy of the image, so that it can be undone quickly if the cancel option is exercised. A third copy is also kept if you decide to 'undo' the operation. Thus, Photoshop requires three times the amount of RAM (five is recommended) as the size of image you wish to open. Live Picture and other similar programs approach the problem in a different way, and enable you to work with very large images, perhaps 200 Mb, in almost real time on a fairly standard desktop computer. Instead of storing the whole high resolution image in memory, Live Picture converts it to a file known as an IVUE file. This file is generally 150 per cent larger than the original file, but apart from storage requirements, this has no effect on the processing. From this file the program creates a 'view file' at screen resolution (72 dpi) so that the largest image, on a 21-inch monitor, will only take up a maximum of 2.2 Mb. All processing is carried out on this image, and is performed very quickly, with virtually no delay. As changes are made, a list is compiled in a file known as a FITS. This list is applied to the on-screen image during editing – the original remains untouched. When completed, the alterations recorded in the FITS file will be applied to the IVUE file, producing a TIFF file. This can be generated at a specific resolution, dependent on the output device being used. This 'post-processing', or 'building' of the image may take several minutes.

Image analysis programs

Scientific image analysis programs have been available for PCs for a few years now, and several are now available for the Macintosh. Like the retouching and manipulation programs, there is a wide variety available, many with very specific uses. They are used by biomedical photographers, for example, for analysing microscope images or electrophoresis gels, police forensic units taking measurements from scene of crime pictures, and remote sensing units for analysing data from satellites. At least one is available for analysing sporting motion, being able to calculate velocity, plot trajectories of throws, etc.

For the PC, good examples are: Optimas, Global Lab Image and LView Pro, while for the Macintosh, Optilab and NIH Image 1.57 are excellent programs. NIH Image and LView Pro are both remarkable in that they can be downloaded from the Internet. Image is a public domain program, i.e. it is free, while LView Pro is shareware and must be registered.

For those with Internet access, Image can be obtained via anonymous FTP from zippy.nimh.nih.gov[128.231.98.32]. Enter 'anonymous' as the user name, and your e.mail address as the password. The latest version of Image is found in the /pub/nih-image directory. Versions are available for machines with and without floating-point coprocessors. The author, Wayne Rasband, can be contacted at the following e.mail addresses:

Internet: wayne@helix.nih.gov
CompuServe: >INTERNET: wayne@helix.nih.gov

LView Pro is available from:

ftp site at: ftp.atreide.net in the sub-directory/incoming/public
or: ftp.ncsa.uiuc.edu in the sub directory/mosaic/
 windows/viewers

In many respects, at first sight an image analysis package such as Image 1.57 (Fig. 9.8) is similar to a paint program like Photoshop with a toolbox containing selection tools, pencils and brushes, and a menu bar with menus for adjusting modes of display. Also like Photoshop, various filters are available for increasing sharpness and reducing noise. Image has the facility for writing one's own filters for specific uses.

The main purpose of the program, however, is to analyse images, and gather data from them. The package can count particles, measure areas, lengths or perimeters, measure densities and produce density plots from a line drawn across an image. This is commonly used, for example, in the analysis of electrophoresis gels in biology laboratories (a scanner can, in effect, be converted into a densitometer for various photographic purposes). Density slices can be made from an image, highlighting all parts of an image having equal density. Several examples are shown in Figs 4.9–4.12.

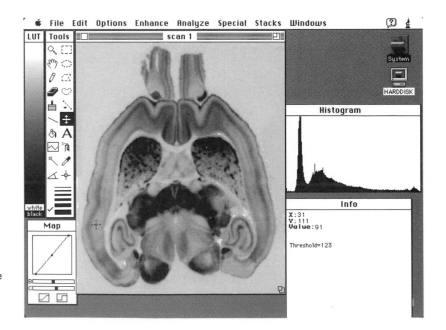

Fig. 4.8 Screen shot of Image 1.57 showing image, 'histogram', 'info' and 'map' windows.

Fig. 4.9 As 4.7, using 'surface plot' command.

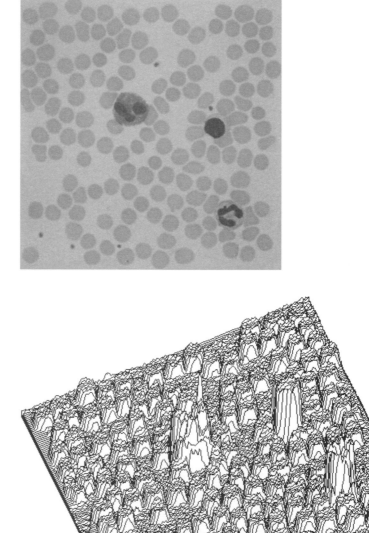

Filters

Image analysis programs have a similar range of filters to Photoshop (Image 1.57 can support many of Photoshop's plug-in filters), such as the sharpening filter, but also include many others to enable photographers and scientists to extract information from images. Specialist filters with names like Laplacian, Sobel and 'Mexican Hat'

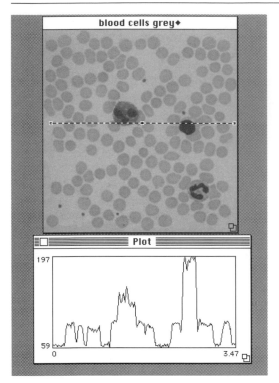

Fig. 4.10 As 4.7, showing density trace.

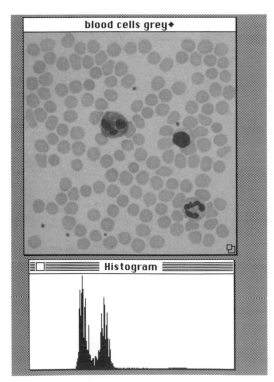

Fig. 4.11 As 4.7, showing histogram.

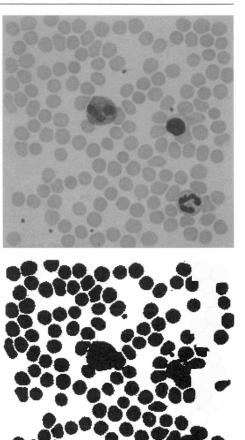

Fig. 4.12 As 4.7, showing threshold command (centre), similar to photography of subject with line/lith film, and (bottom) showing particles numbered in 'analyse particles' command.

can, for example, isolate vertical or horizontal lines, sharpen or reduce 'noise' in images.

Image can support a number of framegrabber cards, and can be used for simple animation techniques. A number of separate images, perhaps from a time-lapse sequence, can be stacked together and animated. The software will cycle through the stacked frames and play them like a cine-projector. Areas of the images which have not changed will remain static, while areas that have changed, perhaps a plant growing, will show as movement.

A fundamental feature of Image is the ability to write one's own 'macros' (small programs designed to automate complex or repetitive tasks) in the Pascal-like programming language used by the software. Consideration of this is beyond the scope of this book, but many readers will find the program very useful for this type of work.

File formats

When images are captured electronically, either by digital cameras or by scanning conventional silver-based photographs, they must be stored as a particular type of file, known as the 'file format'. Many different image file formats exist, and it is essential to have at least a working knowledge of the main ones to ensure that a particular image can be transferred to another program, such as a desktop publishing package, or sent in the correct form to a printer or other form of output medium. Some programs will only open specific file formats, whereas others, such as Photoshop will open a wide range. Some programs (for example, DeBabelizer and CH–Interchange) are available with a primary function of converting files from one format to another. Examples of file format used for both Macintosh and PC computers include TIFF and EPS.

Whatever the format, image file formats generally consist of two parts, a file header, and the image data. The header will contain information such as: horizontal and vertical dimensions in pixels; type of image data (greyscale, colour, etc.); bit depth of image; compression technique used (if appropriate).

This header information must provide all necessary information to reconstruct the original data and its organization from the stored data. After the header information is the image data. This data might have been compressed or stored in a variety of ways. The header information will allow it to be recreated perfectly. An 8-bit greyscale image, 600 pixel × 800 lines in size could be described as follows:

Header
width = 600
height = 800
format = greyscale
no. bits/pixel = 8
compression = none

Image data
480,000 bytes of image brightness data

This format typically assumes that the data is organized in lines from the top left to the bottom right of the image.

Some computers (such as mainframes) and some scientific packages save images in formats which cannot be read by programs such as Photoshop. However, Photoshop can open 'raw files'. These are streams of numbers which describe the colour information in an image. The colour value for each pixel is described in binary format – one code for each of the RGB or CMYK channels.

Major file formats

Examples of the more commonly encountered file formats are given below.

TIFF (Tagged Image Format File) This file format was developed jointly in 1986 by Aldus and Microsoft to try and standardize the growing number of images being produced by scanners and other digital devices which needed to be imported into desktop publishing programs. It was specifically designed to be portable across computer platforms, and to be flexible to allow for growth over time. Blocks of data within the file are interpreted by the use of tags which identify them. Even so, there are several versions of TIFF currently available, though these generally pose few problems. It is a very widely used file format for bitmapped images for both the Apple and PC platforms, and is the best format to use for transferring images from one system to another or supplying images to a bureau. It is used extensively when making colour separations. While most file formats contain a small number of 'headers' which describe the properties of an image, TIFF images can include up to 60 tags, each defining a specific property such as size, resolution, etc.

Within TIFF, a lossless compression routine known as LZW is available (see image compression). Adobe Photoshop is able to read and save captions in TIFF files, particularly useful when used with the Associated Press Picture Desk, which uses the same caption fields.

PICT This is the native graphics format for the Macintosh computer, and works equally well with both bitmapped and object–oriented artwork. The current version is PICT 2, which supports images in any bit depth size or resolution. It is particularly effective at compressing images containing large flat areas of colour. If you have Quicktime installed on the Macintosh, then PICT images can be JPEG compressed. Such files can be opened up into word processor packages such as Microsoft Word, and Apple's own TeachText. It should not be used for desktop publishing applications.

EPS (Encapsulated PostScript) EPS uses the PostScript page description language to describe images and is used to export files (particularly those in colour) to page-layout programs. It can be used for storing object-oriented graphics, as well as bitmapped images, though these may give very large file sizes. The way in which images are described by the PostScript language, using vectors, means that the resolution of the image is dependent on the resolution of the output device. EPS files can also include halftoning information such as screen ruling, and angle and dot shape.

A variation of EPS, developed by Quark for its QuarkXpress desktop publishing program is called DCS (desktop colour separation). This format enables users to print colour separations of imported artwork and photographic images. When saved in DCS format, five files are created: yellow, magenta, cyan and black, and a master document which is a PICT preview of the image which can be viewed and positioned within page layouts. The DCS-2 format is used with files containing more than four component colours. These can be used to define spot colours, for example.

PCD (PhotoCD) PCD is the format used to store Photo CD images which have been encoded in the YCC colour model (a variant of the CIE colour space), and compressed. By opening PhotoCD images directly, the YCC images can be converted into Photoshop's Lab colour mode, ensuring no colour loss. As discussed elsewhere, there are several different PhotoCD formats (e.g. PhotoCD Master, Pro PhotoCD). A technical limitation of the scanner used to produce Photo CD's is that the maximum density it can read is only approximately 2.8, resulting possibly in loss of shadow detail from transparencies which may have densities well above 2.8 (no such detail is lost when scanning negatives which have a maximum density of 2.0). At present, photographers cannot make their own PhotoCDs – they must be written on a PhotoCD workstation, which scans the images, compresses the data and stores it in a standard format.

Photoshop This is the native file format within Adobe Photoshop, and can retain information relating to masking channels, etc., which may be lost when saving in another file format. Photoshop 3.0 has a lossless compression routine built into it. The format is recognized by many other programs which can open images stored as Photoshop format directly. As is the case with most software when it is upgraded, Photoshop 3.0 will open Photoshop 2.5 files, but not the other way round.

While the above are perhaps the most common and familiar formats, a wide range of others are available, a selection of which are given below:

Amiga IFF (Interchange File Format) This is Amiga's all-purpose graphics file format, similar to PICT on a Macintosh.

Window's Paint BMP This format is native to Windows and can be used to save monochrome and colour images up to 24 bit.

PCX This is the file format used with one of the oldest paint programs for DOS, PC Paintbrush. A number of versions are available.

CompuServe GIF (Graphic Interchange Format) CompuServe is a commercial on-line bulletin board using its own format for sending compressed 8-bit images by telephone lines. The compression used is similar to the TIFF LZW. The GIF89A version is used for placing images into 'Web pages' on the Internet.

RIFF (Raster Image File Format) Letraset's proprietary alternative to TIFF. Stores up to 32-bit information, but is only used with Letraset programs such as Colour Studio.

Targa (TGA) This is a bitmap graphics file format, used to store images up to 32-bit in RGB mode, used particularly for overlaying graphics and video.

JPEG This is a lossy compression routine, capable of compressing images to a ratio of 20:1. It has rapidly become an industry standard. Users can set their own quality settings on a sliding scale within the software (Chapter 5). Several variants have been developed, and it is likely that a lossless version will become available.

IVUE This is Live Picture's own pixel-based image format. To edit images in Live Picture they must be in IVUE format. An IVUE file must be converted back into its original format for printing.

FIF (Fractal Image Format) An uncommon format as yet, but one which may become increasingly important for storing large single images or video sequences. The thousands of images on the multi-media encyclopaedia 'Encarta' are fractally compressed.

FlashPix In July 1996, Kodak, in conjunction with Live Picture, Hewlett Packard and Microsoft, announced a new multi-resolution file format, allowing the user to work on a low resolution screen image, and make alterations which are subsequently applied to a high resolution version of the same image.

Other types of software for electronic imaging

Image data bases One major sector of the photographic industry eager to utilize the technologies of electronic imaging is picture libraries and archives. Some libraries are looking to the technology to store digital copies of their images, while others are looking to replace their printed catalogues with CDs, which can also contain keyword search databases. Obviously, for a library consisting of perhaps several million images, huge databases are required. However, for the individual photographer with perhaps several thousand images, smaller programs are available which are none the less very powerful in their search and retrieval capabilities. Examples are Kodak Shoebox, Aldus Fetch and Digital Catalogue. Photographs can be given a number of keywords to describe them, which can be compiled into a database. The user can sort through images of different file types using low resolution thumbnails on the screen and keyword search databases. Most of the programs available can handle many thousands of images – for example, Aldus Fetch can handle up to 32,000 images, and Digital Catalogue can theoretically handle 13 million images. Each of these images can have up to 14 pages of text associated with it, each word of which can be used as a 'keyword' for search purposes.

Optical character recognition (OCR) for scanners While not strictly an imaging program, many photographers will find this software very useful. Pages of text, either typed or printed, can be scanned on a desktop scanner, and the text read and converted into a format readable and editable by a word processing package. Most of the software available nowadays, for example, Omnipage, is very good and will recognize pages of typed and dot matrix printed text as well as good quality laser printing. It works best with plain

typefaces such as Times or Helvetica, in sizes from 9 to 12 pt. It is not so efficient with type that is too large, or printed on poor paper where the ink has spread.

Desktop publishing With the ability to design and lay out brochures, magazines and books on the computer screen, desktop publishing revolutionized the publishing industry in the 1980s. A basic grid layout is designed, as a master page, on to which text, graphics and photographic elements can be imported. The text can be flowed around the graphical elements, and boxes can be drawn and filled with greys, colours or textures. Many desktop publishing programs have powerful imaging facilities within them, particularly for separating the image into its CMYK components (although most bureaus and printers would recommend that they are sent RGB TIFF files, and perform the separations themselves, as they know the characteristics of their output device and the requirements of the separations). Probably the best of these programs are QuarkXpress and Aldus PageMaker, both of which are available for both Macintosh and PC platforms. Generally, images need to be imported as TIFF or PICT files, usually at low resolution to act as guides for the designer (known as an FPO, 'For Position Only'). When sending material to a printer or bureau for output, it is necessary to leave the FPO in the document, and also include the original picture files so that they can be output correctly by the imagesetter. For example, if you are sending a photographic TIFF file and a piece of artwork saved as an EPS file created in a drawing program, both the original TIFF and EPS files must accompany the document file to the printer.

As well as page layouts, desktop publishing programs are excellent for producing photographer's letterheads and invoices, etc. The letterhead can be saved as a master page on to which letters and other documents are added. This can then all be printed as one document, reducing the need to have large quantities of stationery printed at one time. This can even be done relatively cheaply now in colour, on small desktop colour bubble jet and other types of printer.

Paint programs Several programs such as Letraset Painter are available where photographic images can be painted over to give the effect of oil paint or various other textures and effects. These are best used in conjunction with a digitizer tablet and pressure-sensitive stylus, enabling various amounts of 'paint' to be applied.

Presentation and multimedia programs Although 35 mm slide projectors will survive for a good few years, many computer programs are now available enabling photographers and others to produce high class presentations for conferences and seminars, etc. They are much more versatile than the conventional multi-projector presentation as all types of elements from single photographic and graphic images to animations and even video clips can be incorporated into the same presentation. This can be easily edited on screen, without the need for producing new 35 mm slides, although the information can be output to slide via slidewriters if required. Video projectors are now extremely high quality (though very expensive!), and remove the need for several slide projectors to be aligned

together. Typical programs are Aldus Persuasion and Microsoft PowerPoint. With these programs, a master slide or template can be made consisting of such items as a background, logo or frames, into which the various elements can be placed. When preparing images for these presentation programs which are only going to be viewed on a computer monitor at 72 dpi, then do make sure that they are not too large, or storage space and memory will be taken up with redundant information.

True multimedia presentations are now relatively easy to produce using programs such as Macromedia Director. Here, graphics, animation, video, high fidelity sound (including musical instruments via MIDI – Musical Instrument Digital Interface) can all be combined into highly complex presentations. Multimedia 'authoring' requires all the skills of the film director, with scripting and story-boarding, with the added dimension of possible interactivity with the viewer.

Video editing Over the last couple of years, huge advances have been made with the handling of video on small desktop computers. Video digitizers are available for most desktop computers which will digitize video sequences (and their associated sound in some cases) from a variety of sources such as videotape and camcorder. This can be edited on screen using programs such as Adobe Premiere which can link sequences together with a huge variety of wipes, fades and other transitions, and mix sound with the video. Some computers and various video boards will convert the digital video to analogue and output it back on to videotape. Video requires huge amounts of storage space. As an example, a high resolution 13-inch monitor has 307,200 pixels (640×480 pixels) In 24-bit colour mode, each pixel must represent 24 bits of information (8 bits for each component of the RGB signal). With 8 bits to 1 byte, 24 bits is equal to 3 bytes. Thus each frame of digitized video is $307,200 \times 3 = 921,600$ bytes. At 30 frames per second, 2 seconds of digital NTSC video will take up more than 54 Mb!

A typical 10-second sequence captured from a colour video capture with a Video Spigot board on a Macintosh takes up nearly 8 Mb of space. As with still images, a number of compression routines are available which reduce the storage space required. Examples are MPEG and Compact Video.

All Macintosh computers have QuickTime software, which is an extension to the system software. It allows the user to play and record dynamic time-based data as opposed to static data such as text and still images. QuickTime incorporates two types of compression – temporal and spatial. Spatial compression reduces information within a single frame by looking for areas of even tone. In an image with a black background, rather than identifying pixel 1 as black, and pixel 2 as black and pixel 3 as black, etc., it identifies the groupings of black pixels. Temporal compression works by describing changes between frames – a process known as 'frame differencing'. QuickTime 'movies' can be copied and pasted into other documents, and are being used increasingly for teaching and training applications, where instructions in the form of text can be supplemented with a video clip showing the actual operation of a piece of equipment, for example. On PCs, Video for

Windows has recently become available, which performs a very similar task.

Morphing Many advertisements and feature films include sequences where an object gradually merges into another. In the film *Terminator II*, a blob of molten metal gradually becomes a human figure, while several car advertisements show one style of car merging or 'morphing' into another. Morph by Gryphon allows you to select a 'start' image and a 'finish' image. The computer then automatically fills in the middle, gradually merging one into another. A very specialist piece of software!

Using the computer

It is not the intention of this book to be a computer manual – much better advice can be found elsewhere, in some of the books listed in the Further Reading. However, good working practices are important, and some of those specific to digital imaging are given here.

1. Always save an image after scanning or digitization *before* commencing any enhancement or manipulation. Most programs have a 'revert' option, enabling you to revert back to the previously saved version of an image. If you have not saved it, you will have to start the process all over again.
2. Because images are large, always crop out any redundant information such as unwanted borders to reduce the file size to a minimum.
3. If you are carrying out complex manipulations or enhancements to an image, save several versions so that you can go back to a particular one. Most current image processing programs on desktop computers only let you undo the very last operation carried out. If you are not sure whether a particular manipulation is right, then save it with a different file name for reference.
4. Don't work with images that have higher resolution than is necessary. As can be seen in Chapter 3, when the resolution is doubled, the file size increases by a factor of four. If the final output is to be low resolution or small size, then consider resizing the imaging to a lower resolution, in the same way as you would decide what camera/film combination to use for a particular photographic job.
5. If you are manipulating images and perhaps adding new elements or moving existing elements of an image, be careful to ensure that the result looks right, e.g. the lighting direction and quality is the same for all the components used.

Computer viruses

A virus is a computer program deliberately written to disrupt the normal operation of a computer. They may crash the computer, display messages, delete files or cause other strange things to happen on the screen. They can cause a great amount of damage within a

computer, perhaps erasing whole hard disks. Many are designed to come into force on particular days. They can enter a computer via floppy disks, modem links to bulletin boards or through networks. To minimize the risk of viruses getting into your computer system, it is essential to take certain precautions:

1. Install a virus checker (sometimes known as disinfectants) on your computer. Many are freely available from public domain and shareware suppliers, and come into action the instant the computer is switched on, checking all files for viruses. Windows now has a built-in virus checker.
2. Do not use floppy disks given to you by other people (particularly with games!) unless you have a virus checker on your machine.
3. By their very nature, virus checking programs are always one step behind the authors of viruses, so cannot be relied upon to identify all current viruses.

Health and safety considerations

1. Sit comfortably, preferably in a chair with a good backrest, and adjustable height. You should try to sit upright, and at a height where your forearms are in a horizontal position when using the keyboard.
2. Adjust the monitor height and angle to minimize head and neck movement (European laws now insist that all computer monitors are on tilt-swivel stands). If possible, try to have it at such an angle that you are looking down at the monitor slightly. Do not sit too close to the monitor.
3. Place the monitor sideways to windows, thus avoiding reflections on the screen.
4. Take frequent breaks from the computer. Walk away from the computer to get some exercise and rest your eyes as much as possible.

5

File size, compression and storage of digital images

It will be apparent by now that digital images take up large amounts of storage space, and that one of the main problems of electronic imaging is that of storing and accessing the images.

The following table gives some examples of file sizes from different resolution scans of a range of print/transparency sizes. Scanner resolution is usually quoted in dots per inch.

Tables of scan sizes

scanning resolution (dpi)	file size for colour	monochrome
35 mm transparency		
500	1.1 Mb	0.4 Mb
1,000	4.5 Mb	1.5 Mb
2,000	18 Mb	6 Mb
6 × 6 cm transparency		
150	373 K	124 K
300	1.46 Mb	497 K
600	5.83 Mb	1.94 Mb
1,200	23.32 Mb	7.76 Mb
5 × 4-inch transparency		
150	1.29 Mb	440 K
300	5.16 Mb	1.72 Mb
600	20.63 Mb	6.88 Mb
1,200	82.52 Mb	27.51 Mb
10 × 8-inch print		
150	5.3 Mb	1.7 Mb
300	21.3 Mb	7.03 Mb
600	85.5 Mb	28.1 Mb

A simple formula can be used to calculate the approximate file size of an image:

no. of pixels horiz. \times no. of pixels vert. = total no. of pixels

$$\text{total no. of pixels} \times \frac{\text{no. of bits/colour}}{8} = \text{total no. of bytes}$$

For example:

image has $1{,}200 \times 800 = 960{,}000$ pixels

$960{,}000 \times (24/8) = 2{,}880{,}000$ bytes (2.9 Mb)

The final file size will be determined by the format used to save it. As we have already seen, many file formats have compression routines built into them which will reduce the file size.

Image compression

There are various methods of compressing digital information, depending on the type of data – text, graphic, photographic or video. There are three basic types of compression method: 'lossless' where no information is lost during the compression and decompression process, and the reconstructed image is mathematically and visually identical to the original; 'lossy', where some information is lost during the process, and 'visually lossless', where the image data is sorted into 'important' and 'unimportant data' – the system then discards the unimportant data. PhotoCD uses this last method. A very important consideration here is whether the lost information is noticeable in the final output. Huge savings in file size can be achieved, and if the result is good enough for the intended purpose, then its use can be justified. Bear in mind that if the final image is to be analysed for scientific purposes, then the compression techniques used, while not visible to the human eye, may affect the analysis. Compression is dependent upon the software and hardware in use, the amount of detail within an image and the quality requirement of the final image.

Compression relies on the fact that any digital data generally contains redundant information. With images, this might be repeated patterns or areas of common brightness between multiple pixels of the image.

Lossless compression

This type of compression looks for patterns in strings of bits, and then expresses them more concisely. For example, when giving directions to someone you might say: 'turn right at the traffic lights, drive past one road on the left, then another, then another, then another, then turn left.' Instead, it is much easier to say: 'turn right at the traffic lights and take the fifth road on the left.' This is an example of a process known as 'run length encoding', where a repeated series of items is replaced by one item, together with the count for the number of times which that item appears. The system depends on a continuous series of data that is the same.

An example of run length encoding is used by 'Huffman compression.' This assigns patterns with a code – the most frequently used patterns are assigned the shortest code. (This is similar to Morse code where the most common letters are assigned the shortest codes, and the least common the longest, e.g. S = dot, Z = dash, dash, dot, dot.) However, because digital documents vary in their type, so the Huffman code must create a new set of codes for each document.

As an example, the words DIGITAL IMAGE can be processed as follows:

Character	Frequency
D	1
I	3
G	2
T	1
A	2
L	1
M	1
E	1

This can then be coded as follows:

Character	Frequency	Huffman code
I	3	0
A	2	00
G	2	01
D	1	110
E	1	111
L	1	000
M	1	001
T	1	101

Huffman works best with text files, and variants of it are used in certain fax machines. While it does work with images, it requires two passes of the data, the first to analyse the data and build the table, the second to compress the data according to the table. This table must always be stored along with the compressed file. Because of the way Huffman encoding analyses the data, the process is known as a 'statistical compression method'. A refined version of it which uses a 'dictionary method of compression' is called 'LZW compression'.

This method, which was developed in the late 1970s, is named after the three men who developed it – Abraham Lempel, Jacob Ziv and Terry Welch – and it is an integral part of the TIFF file format. At the beginning of the file, LZW starts a small table, like the Huffman compression. It then adds to this table every new pattern it finds. The more patterns it finds, the more codes can be substituted for those patterns, resulting in greater compression. It does this in one pass resulting in greater speed. LZW can compress images up to 10:1. Another format which uses LZW compression is GIF, used by CompuServe for compressing 8-bit images for transferring through networks.

Lossy compression

The most common form of lossy compression, and one which has become virtually the industry standard for greyscale and colour images, is JPEG (Joint Photographic Experts Group) which was developed during the 1980s and became available in 1991. This group was created to define a standard for compressing photographic images, and is a joint effort by the Consultative Committee on International Telegraphy and Telephony (CCITT) and the International Standards Organization (ISO). It relies on the fact that the human eye is much more sensitive to changes in brightness (luminance) in an image than to colour (chrominance). The image data is separated into luminance and chrominance, and lossy compression algorithms are then applied to the chrominance data. (This is similar to television, where a medium resolution monochrome signal is overlaid with a low resolution colour signal.)

It is a three-stage process. The system divides the image into blocks of 8 × 8 pixels, to which a mathematical transform known as 'Adaptive Discrete Cosine Transform' (ADCT) is applied, transforming the image from the spatial domain into the frequency domain. This has its roots in Fourier transforms used by engineers for analysing the frequency components of signals. The data in each 8 × 8 block is converted into an output block representing the frequency components. The process averages the 24-bit value (or 8-bit value if a greyscale image) of every pixel in the block. This value is stored in the pixel in the top left-hand corner of the block. The other 63 pixels are assigned values relative to the average. This step produces an 11-bit per colour file, with values ranging from –1,024 to +1,023. This is actually larger than the original file, but prepares the data for the compression process to follow.

The next step is quantization. Here, the values produced by the ADCT process are divided by values in a quantization matrix. The ADCT process produces matrices which tend to diminish sharply from the top left to the bottom right corner. When a quantization matrix with sufficiently high quantizing values is used, then many of the values are reduced to zero. This can mean that, when a file is decompressed, the 8 × 8 blocks representing low spatial frequency parts of an image (e.g. blue sky) are made up of 64 pixels of the same value, i.e. the zero values indicate that there is no difference from the average value stored in the top left-hand corner of the block. A practical result of this is that when compressing images heavily, a 'blocky' appearance may result.

In areas of high spatial frequency (i.e. detail) only values further towards the bottom right-hand corner of the block are reduced to zero.

The third stage in the JPEG process is entropy encoding. The 8 × 8 pixel block is now represented by a stream of quantized figures, many of which are zero. JPEG uses a combination of Huffman encoding and run length encoding to produce the most effective compression for a wide range of image types. During the reordering of the data, most zero values will occur in one part of a 'run' through the data in the 8 × 8 blocks, which can be represented by a very short piece of computer code.

Fig. 5.1 JPEG dialog box.

Image Quality: Fair Good Excellent

Compression: Excellent Good Fair

[Save]

[Cancel]

Practically, when saving images using the JPEG algorithm, you are presented with a choice relating compression to image quality. 'Fair' compression gives 'Excellent' image quality and vice versa.

JPEG works best with continuous tone images, where there is a gradual transition in tone between neighbouring pixels. Areas of flat tone may give a 'blocky' appearance when compressed heavily. JPEG is a cumulative compression process. Photoshop recompresses the image every time it is saved in JPEG format. So there is no problem with repeatedly 'saving' an image during processing because JPEG always works on the screen version of the image. Data is lost, however, every time the image is closed, reopened and saved again.

Obviously, the determination of whether image quality has been lost is subjective, and depends on the viewer and the quality of output device being used. Various tests have been carried out using different types of image, viewed by groups of individuals. Most of these tests show that with a compression setting of 'good' and above, there is, to all intents and purposes, no perceptible loss in image quality, though it must be re-stated that there is inevitably loss of data with the system.

The JPEG compression routine is found in programs like Adobe Photoshop and MicroGrafx Picture Publisher. It is also available as a stand-alone package from companies like Storm, which produces a program called PicturePress. This has a much wider range of options, including the ability to compress only selected portions of an image. This can be coupled with a 'Digital Signal Processor board' (DSP) to speed up the process enormously. Other companies such as Colour Highway have modified the JPEG algorithm to produce higher quality compression with standard images, and a range of compression facilities with EPS and DCS files.

Compression with PhotoCD

A standard Kodak PhotoCD Master disk can hold up to 100 colour images. Each image is stored at five resolutions in an 'image pack' yielding uncompressed file sizes of 18 Mb, 4.5 Mb, 1.25 Mb, 312 K and 78 K. As compact disks can only hold 650 Mb of information, it will be seen that in order to put 100 image pacs on the disk some form of compression must be used. In fact, the average size of an image pac for 35 mm images is 4.5 Mb though this will vary according to the type of image.

The compression method used is a proprietary system which uses chroma (colour) subsampling, and relies on the limitations of human vision, whereby colour information is not so important as detail. Colour

information can therefore be discarded more readily than detail before it is perceived. In the case of PhotoCD, the loss is visually lossless.

The scanner used in the PhotoCD Workstation for 35 mm film utilizes a three-element moving array to scan the film to give a 12-bit, 2,000 dpi (base ×16) scan of the film giving a 24 Mb file. This is transferred to the 'data manager', a powerful high speed computer dedicated to converting the 12-bit RGB image file created by the scanner into an 8-bit 'PhotoYCC' format reducing the file size to 18 Mb.

The PhotoYCC format used by PhotoCD is Kodak's proprietary image compression system, where the RGB values of an image are converted to PhotoYCC. This is similar to a television system, which uses a luminance signal and a chrominance (colour) signal). In PhotoYCC, 'Y' (equating to the luminance or brightness values within an image) is calculated using values for red, green and blue. This accounts for most of the image detail. 'CC' are colour difference signals representing the colour information of an image:

C (chroma 1) = blue – Y
C (chroma 2) = red – Y

Since the values of the red and blue components of the image are recorded along with the greyscale (luminance) value, the green can be calculated.

This file format has three main advantages. First, the signal can be read and displayed on a standard television set without recourse to any form of computer. Second it allows the use of visually lossless compression using image deconstruction. The last, and the most important reason is that the YCC format can contain all the information from the 12-bit RGB scan. This means that the file can contain virtually all the contrast and colour information from the film original.

As each pixel in the original scanned image is converted from RGB to YCC, a process known as 'chroma decimation' is applied.

Chroma decimation

The image is formed of rows of pixel elements each made up of the three channels: luminance, chroma 1 and chroma 2. The decimation process removes the chroma channels in each alternate pixel in the odd rows of pixels and all the chroma channels in the even rows of pixels.

The reduction in file size is derived from the following:

original file size = 6 Mb luminance + 6 Mb C1 + 6 Mb C2 =18 Mb

In the new file, each pixel with a chroma value is surrounded by three pixels without chroma values:

new file size = 6 Mb luminance + (1/4 × 6 Mb C1) +
(1/4 × 6 Mb C2) = 9 Mb

Image decomposition

This 9 Mb file is then reduced by a two-step colour averaging and subsampling process. This removes every alternative pixel and

Fig. 5.2 PhotoCD chroma decimation – (a) before and (b) after.

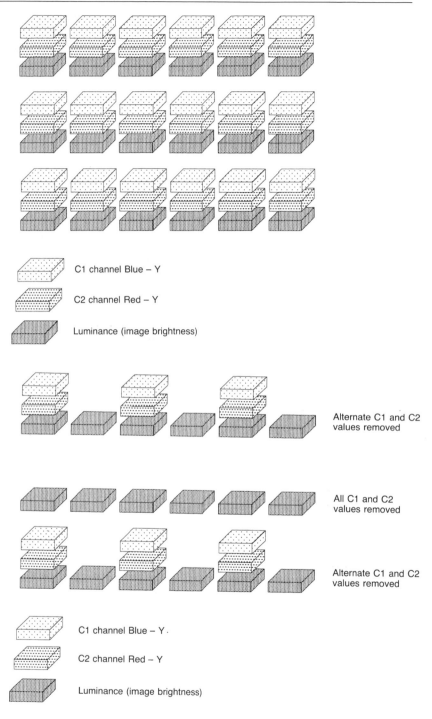

C1 channel Blue – Y

C2 channel Red – Y

Luminance (image brightness)

(a)

Alternate C1 and C2 values removed

All C1 and C2 values removed

Alternate C1 and C2 values removed

C1 channel Blue – Y .

C2 channel Red – Y

Luminance (image brightness)

(b)

creates a new pixel which is the average of adjacent colour and luminance values, to give a file half the width and half the height of the original, one quarter of its size.

The data manager of the PhotoCD system now contains in its memory a 9 Mb file and the new subsampled file reduced to 2.25

Mb. It expands the smaller file by interpolation to create a virtual copy of the 9 Mb file. The differences between the original and the virtual copy are stored as 'residuals'. These residual values then undergo quantization. Using a form of Huffman encoding, a short code is allocated to common elements which reduces the actual number of bytes required to store the information.

This procedure is carried out twice to give a 9 Mb file consisting of residual values and a 2.25 Mb file consisting of residual values.

The halving process continues three more times, but as only relatively small files are created in this process, they are stored in their original form.

The YCC PhotoCD image pack is now assembled and written to the disk. The image pack now contains the following information:

Name	Contents	File size when expanded
Base × 16 image	Residual values	18 Mb – 2,048 × 3,078 pixels
Base × 4 image	Residual values	4.5 Mb – 1,024 × 1,536 pixels
Base	563 Kb YCC file	1.25 Mb – 512 × 768 pixels
Base/4	140 Kb YCC file	313 Kb – 256 × 384 pixels
Base/16	35 Kb YCC file	78 Kb – 128 × 192 pixels

The technique used for the two largest files in the five-file image pack is termed 'lossy plus lossless residual encoding'. Using this method, all losses occurring during the compression process are offset by the addition of information from the residual files.

Fractal compression

Whereas lossy compression can achieve compression ratios up to 100:1, fractal compression can achieve 600:1. The system uses the property of fractals that very complex shapes can be generated from relatively simple mathematical equations. Compression generally takes a long time – far longer than say JPEG, though dedicated hardware is available to speed up the process. Like JPEG, fractal compression is 'lossy', but the data lost is less than JPEG, so that compression ratios of up to 50:1 are possible without any real noticeable loss in quality. Compression ratios of up to 20,000:1 are reportedly possible. One major use will be the compression of video, where perhaps the loss of quality is not as important as with still images. Fractally compressed images are resolution independent, as with PostScript, so that they can be expanded to any size.

MPEG

This is a file format, similar to JPEG, used specifically for video sequences. Simply, it works by saving individual frames, then, if the succeeding frames are similar, storing just the differences between those and the first.

Most national newspaper photographers now shoot exclusively on 35 mm colour negative film, which is then scanned using a 35 mm slide

Fig. 5.3 PhotoCD image pack.

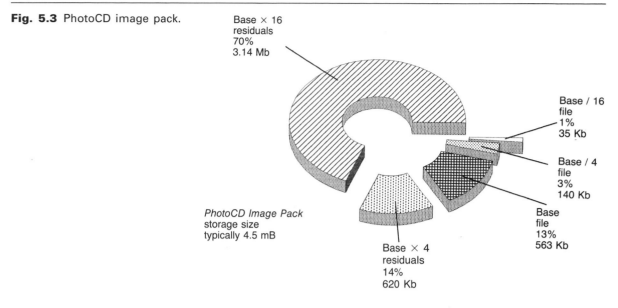

Base × 16
residuals
70%
3.14 Mb

Base / 16
file
1%
35 Kb

Base / 4
file
3%
140 Kb

Base
file
13%
563 Kb

PhotoCD Image Pack
storage size
typically 4.5 mB

Base × 4
residuals
14%
620 Kb

scanner and downloaded directly into a portable computer 'in the field'. Selected images can be captioned, compressed using JPEG or another compression program, and transmitted, via modem back to the newspaper's head office for publication. After much experimentation, they have found that scanning the negatives at 1,000 dpi (giving a file size of 4.4 Mb for a full frame 35 mm negative), then JPEG compressing the file gives sufficiently good quality for reproduction on newsprint, at a file size small enough for rapid transmission.

The table of file sizes at the start of the chapter gives a clear indication that, before too long, compressed or not, the storage of digital images is going to lead to great problems, even if they are compressed first. Several systems are available, and it is worth thinking very carefully about the system before investing. Some will be relatively slow, and more appropriate for 'backing-up' other systems, or for archival storage, while others will be better for transferring data to another location, perhaps a printing bureau. In this last case, it is most important that your bureau has a drive capable of reading your chosen storage medium. New technologies are emerging all the time, but it may take longer for a bureau to acquire a drive to use it!

Floppy disks

The 3.5-inch disk is familiar to anyone using a computer for word processing, etc. The outer casing is rigid plastic and the magnetic disk inside is flexible, hence the term 'floppy'. A shutter opens when the disk is placed in the disk drive, to allow access for the reading and writing heads of the disk drive.There are basically two types: double density and high density disks. The double density disk can store approximately 700 Kb of information, the high density approximately 1.4 Mb. Before use, the disks must be formatted (Apple refer

to this as 'initializing') where the disk is divided into tracks and sectors by the disk drive. This enables it to receive the information to be stored on it. The disks can be locked, in much the same way as audio cassette tapes, preventing accidental addition or erasure of information stored on them.

Most electronic images will be too large to fit on to floppy disks unless they are compressed, though some software offers the option of saving to multiple disks if no other medium is available.

Hard disks

Most computers nowadays are fitted with an internal hard disk. Typical sizes are 40, 80, 230, 500 Mb and 1 Gb. Hard disks are used not only to store documents and images, but also the various programs used. For the storage of images, obviously the larger the better, and prospective purchasers would be well advised to get a 500 Mb or 1 Gb if possible. External versions are available, which connect to the computer, usually via a SCSI cable.

Like any type of disk, hard disks can become corrupted or 'crash' causing the loss of some or all data on them. It is essential to keep a back-up copy of that data on another disk or other media.

Removable hard disks

Several companies, in particular Syquest, manufacture high capacity removable disks which can be used in a similar fashion to floppies. With the Syquest, a hard disk is enclosed in either a 5.25-inch or 3.5-inch casing, which is inserted into a disk drive, usually attached externally to the computer via a SCSI cable. Syquest cartridges are available in three sizes, 44, 88 and 105, 200 and 270 Mb.

A now virtually redundant system was the Bernoulli drive, which made use of a concept in physics, the Bernoulli principle, which explains how an aerofoil gives an aeroplane lift. When the flexible recording media in the disk spins at high speed, the created air pressure forces the medium to rise up towards the read/write head. There is no contact between the head and disk, there being a gap of about 10 millionths of an inch between them. The system has the advantage that in the case of a power failure or knock, the disk loses some lift and falls away from the head, thus greatly reducing the risk of physical damage. The technology is now somewhat outdated, and is likely to become redundant within the next few years.

Because the disks are removable, they are an ideal way of transferring large image files from one computer to another, perhaps to take an image to a bureau for output. The Syquest cartridges are an industry standard, and most bureaus will have facilities for accessing the information from them.

Many new systems have come on to the market over the last couple of years, including Zip and Jaz Drives. Like the Syquest, these are basically removable hard disks. The Zip is available in 25 or 100 Mb disks, while the Jaz is 1 Gb. They are remarkable inexpensive and are likely to become widely used, though, as with any new

technology like this, it is worth waiting to see if imaging bureaus adopt them.

Magneto-optical drives

This drive uses a laser beam, which is focused down on to a minute area of a disk composed of a crystalline metal alloy just a few atoms thick. The laser beam heats the spot on the alloy past a critical temperature, at which the crystals within the alloy can be rearranged by a magnetic field. Read and write heads similar to conventional disk drives align the crystals according to the signal being sent. Two different sizes of disk are available, 5.25 and 3.5-inch, in various capacities including 128 Mb, 230 Mb, 650 Mb and 1.2 Gb. These devices take about twice as long as conventional disk drives to record or read data, but they are relatively cheap.

DAT (digital audio tape) tape drives

These drives allow the storage of large amounts of information on small cheap tape cartridges. They work on a similar principle to videotape recorders except that the data recorded is digital rather than analogue. Using a recording drum, with two heads spinning at high speed, tape is moved past the heads at a slight angle so that data is written to the tape as narrow diagonal tracks rather than a continuous track along the length of the tape. This increases the usable area of the tape allowing more information to be stored. The format of the data on the tape conforms to the DDS (Digital Data Storage) standard. As well as the raw data, indexing information is included to speed up retrieval of the data. Also, most drives have built-in hardware compression, which is much faster than software compression. Two types of tape are available – DDS and DDS-2. DDS tapes are 60 or 90 m long, the latter storing approximately 2 Gb of uncompressed data. DDS-2 tapes are 120 m long and can store up to 4 Gb of uncompressed data, and have faster drive mechanisms. DDS-2 tapes cannot be used in DDS drives.

Several sizes are available, such as a single 4 mm-wide tape capable of holding 2 Gb of data. One problem with all tape systems is that if the information required is in the middle of the tape, the tape must be wound physically to that point. This makes them relatively slow for jumping backwards and forward between files, but excellent when recording large amounts of information in a sequential fashion. While the tapes are very cheap and the system is very reliable, the drive units themselves are quite expensive.

RAID (redundant array of independent disks)

This is a generally expensive and complex system for data storage, more useful for the large user such as a large image database rather than an individual user. The basic idea is to use two or more drives which are combined into a single logical drive. Data is written on to the drives in sequence. Various levels of RAID exist, and in its most

sophisticated form, the data is error checked as it is written. The system offers very fast writing and retrieval. In some cases, one of the drives can fail, yet be replaced without loss of data, and without shutting down the system. Several major picture libraries use the system for archival storage of their images.

CD-ROM and writable CD

Audio compact disks have been available for over ten years now, and vinyl records have become virtually extinct, with many new music releases only being available on tape or CD. The technology of storing digital information on compact disk has, within the last three years or so, become available to photographers, librarians, educationalists and others involved in publishing. CD-ROMs are now available that contain encyclopaedias and dictionaries, multimedia presentations, and huge databases of library references and chemical and drug data. Many publishers are investing heavily in 'electronic publishing'. CD-ROMs can store up to 650 Mb digital information on a single disk, but differ from other forms of storage in that the information is 'read-only' (ROM stands for 'read only memory'), and cannot be altered. The disks have to be etched or inscribed with a laser, meaning that producing disks is beyond the means of most photographers, although a new generation of disk recorders (CD-R) has become available within the last couple of years for under £1,000 making it economical for the small-scale production of disks. Many companies offer a service of making disks from supplied information. Concern has been expressed in the media about the life expectancy of CDs. Estimates vary, but it is generally thought that undamaged disks can last for up to a hundred years. (Syquest disks are guaranteed only for five years, as are many digital tape systems.)

The introduction of the medium into the music world gave a cheap reliable method of storing 72 minutes of digital sound. The industry produced a drive that spun at a speed of around 200 rpm and would take 72 minutes to read a disk. The computer industry saw the disk as a good medium to distribute software, text and images. The drives used in the computer industry were modified music drives and therefore took 72 minutes to read a disk regardless of how fast the computer could process the information.

This speed has become the 'standard' speed drive. Because computers can process information at much faster rates, faster drives are now appearing on the market. The speeds of these drives are normally quoted in multiples of the standard drive speed. There are now double speed, triple and quad speed drives. However, the increase in speed of a double speed drive does not mean a halving the time taken to transfer data, as factors such as memory buffers, method of connection and even software will slow down the process.

The major advantage to the photographic industry is that the compact disk format offers a method of storing, transporting and distributing the vast amounts of data needed to store photographic images at a low cost.

All CDs have several layers: a polycarbonate substrate which provides rigidity and keeps any scratches and blemishes on the

surface out of the focal plane of the laser, a layer of metal acting as a reflective surface for the laser beam, and an acrylic layer on which the label is printed and which protects the metallic surface. Data is stored on the metallic layer as a pattern of reflective and non-reflective areas known as lands and pits. Lands are flat surface areas and the pits are minute bumps on the surface. These patterns are originally etched into the CD by means of a minutely small, focused laser beam. When reading the disk, the laser penetrates the polycarbonate layer and strikes the reflective metallic layer. Laser light striking a pit is scattered, while light striking a land is reflected directly back to a detector, from where it passes through a prism which directs the light to a light-sensing diode. Each pulse of light striking the diode produces a small electrical voltage. These voltages are converted by a timing circuit to generate a stream of 0s and 1s, binary data which the computer can recognize.

The data is recorded along an extremely thin spiral track (approximately a hundredth the thickness of a human hair) which, if straightened, would be about 3 miles long. This track spirals from the centre of the disk outwards, and is divided into sectors, each of which is the same physical size. The motor which spins the disk employs a technique known as 'constant linear velocity', whereby the disk drive motor constantly varies the speed of spin so that as the detector moves towards the centre of the disk, the rate of spin slows down.

The new writable CD-R disks are made in a similar fashion except that the laser is made to heat a spot in a layer of dye. This heat is transferred to the adjacent area of the substrate which is physically altered such that it disperses light. In areas left untouched by the

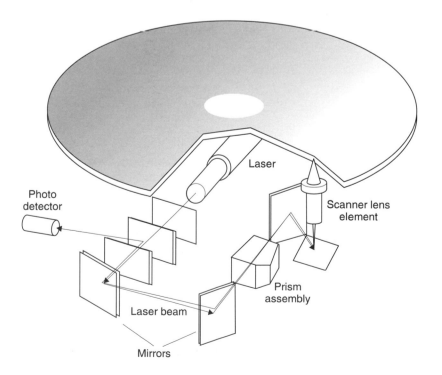

Fig. 5.4 CD driver assembly.

laser, the substrate remains clear allowing the laser light reflected from the metallic layer through so that it can be read by the detector.

The major advantages of the CD is the size of the disk and the cost per unit. The writable CD allows the storage of 650 Mb of information at a cost of between £5 and £10 per disk. This works out around 1p per Mb, one of the cheapest forms of digital data storage available. Improvements to the storage capacity of disks is likely over the next few years – already, IBM has patented a disk with ten layers, capable of storing over 6 Gb!

The operation of the writer allows the user to choose the form in which the data is stored. This can be either specific to the platform on which the disk was created, or, in the case of ISO 9660, independent of the platform and readable by other types of computer.

In order for a CD drive to function in conjunction with a computer three elements are required:

Hardware

The CD drive is a SCSI device and as such needs a SCSI card in the computer. Apple Macintosh computers have these as a standard fitting already installed as part of their system. PC computers do not, and require a printed circuit card physically placed inside the computer to allow the connection. Most PC cards combine the SCSI connection with a sound facility and are called 'sound cards'.

Driver software

This tells the computer what sort of drive is connected. The software should be supplied by the supplier of the drive. If, when installing a CD drive on a PC system, problems arise, check that the correct software has been installed. The main problem is that in the case of ready-made systems, most suppliers only bother to install all the relevant software on the first machine and then make a copy and use this as a quick way of preparing subsequent machines. If the supplier changes the type of CD drive they use, for example, to multi-session, the drives will not read the disks properly.

The drive

There are currently two types of drive available: multi-session and single session. Both recordable and PhotoCD disks allow the user to add more data to an existing disk. In order to access this later data, the drive needs to be multi-session, also known as 'XA compatible'. A single session drive will only read the first recorded session of data. Various speeds of drive are available, single speed, double speed and now quad speed.

CD Formats

Digital audio

The establishment of a standard for recording music to CD was outlined in a book known as the CD-DA or Red Book. The data

format divided the disk into a table of contents, the position and length of each track in terms of minutes and seconds. Care should be taken not to play other formats of disk in music players as this can damage the player.

CD-ROM

The first standard agreed for computer applications was the CD-ROM outlined in the Yellow Book. This type of disk was primarily designed as an advanced form of music storage with methods of checking the validity of the data with the added capacity of storing computer data. The format is not in current use for computer data.

High Sierra

This was the first true computer data format and the disk organization allowed it to be recognized by Apple Macintosh, PC and Unix machines. Again the format has been superseded by later methods.

ISO 9660

This is one of the currently supported formats by most authors of disks. The format will allow the data to be read by Macintosh, PC and Unix workstations. There are certain restrictions in writing ISO 9660 disks, the most relevant is that file names on the disk must only be seven letters long.

CD-ROM XA

This system is similar to ISO 9660 but allows the addition of data to an existing disk.

Other formats include CDI, CD-R, CD-MO and CD BRIDGE. These have been developed to support the home entertainment players for games and films and are not computer-playable disks.

PhotoCD

PhotoCD is the name given to Kodak's own specific type of CD image storage system. It offers an inexpensive method of scanning images at high resolution. The format is supported by all the leading players in the computer and film marketplace and looks like becoming an industrial standard for image recording.

The Photo Imaging Workstation

Kodak PhotoCD disks are created on a Photo Imaging Workstation or PIW. These units represent a substantial investment and will only be found in environments such as imaging bureaus, large institutions, image libraries or publishing houses. The major factor in the cost of such units is the intensive computing power required and the need for very high speed film scanners. These units can be regarded as factories for the production of PhotoCDs and as such require large

numbers of images to be scanned and written to disk to justify their existence.

The medium

A PhotoCD consists of two components:

1. The disk: a CD-type disk playable in Apple Macintosh and PC machines and also viewable on a domestic television using a PhotoCD or CDI player.
2. The image packs: on the disk, each image is recorded at five different resolutions or qualities of picture.

Table of image pack quality

Resolution	Dimensions	Size	Usage
Base/16	128 × 192 pixels	72 K	Thumbnail for database
Base/4	256 × 384 pixels	288 K	Large thumbnail for database
Base	512 × 768 pixels	1.1 Mb	Television quality
4Base	1,024 × 1,536 pixels	4.5 Mb	HDTV quality
16Base	2,048 × 3,072 pixels	18 Mb	Publication quality scan

The combination of the image pack on a CD is termed PhotoCD.

The standard PhotoCD is made from any type of 35 mm film, slide, negative or black and white. Each disk can have a combination of any of the three types of film. The consumer service is offered by the majority of film developing outlets, and subsequent films can be added to the disk at later dates to a maximum of 100 images per disk.

Pro PhotoCD

The launch of PhotoCD was followed by Pro PhotoCD. The main difference between the two systems is that the Pro disk can scan larger formats than 35 mm. The bureau will charge more than the consumer services but they provide far more in terms of control over the image scan and of course provide a much quicker service.

The Pro disk is produced by a professional bureau and the service offered can be regarded as the difference between having your film processed at a high-street chemist or a professional photographic laboratory.

PhotoCD structure

A CD disk is a 4.75-inch disk of polycarbonate plastic with an ultra-thin layer of gold bonded to the top surface of the disk. A protective surface is then coated on to the gold layer for protection. The PhotoCD is produced by burning a series of pits into a dye layer on to the underside of the gold layer writing from the inside of the disk out toward the edge. This information is then read by a laser diode in the CD drive and converted into image information.

The PhotoCD stores all images in a YCC format. The PIW scans the film and produces the top resolution image. This file is duplicated, and the copy examined. Every alternate pixel of information is discarded to produce a file half the height and half the width, therefore one quarter the resolution. This process is repeated four times (for further details, see compression section). The workstation then holds the five images in its memory. It then records the three lowest (base/16, base/4, base) as normal files. It then interpolates (invents) a 4Base image from the base resolution and compares it with the real 4Base image. Where the two images data matches, it does nothing, but where the interpolated file is incorrect, it saves the information from the real file. It repeats this process with the 16Base image and saves only the differences between the real and invented file (residuals). By this method 24 Mb of information can be reduced to some 5 Mb.

YCC Colourspace

The YCC colour space records information in three channels, one for luminance (brightness), and two for chrominance (colour). The advantages of this system are as follows:

1. It allows high levels of visually lossless compression of the image.
2. It provides a system that gives consistent representation of images from negative or positive originals.
3. It provides the widest gamut of colour space in which to store colour information.

Physical file structure

On opening a PhotoCD disk, the information is divided into two directories. The disk itself will be called after the individual number which is printed on the centre of the disk.

The first directory is called CDI and contains all the relevant information to play the disk on any Philips CDI-compatible system.

The second directory is called PhotoCD and contains several files pertaining to the images.

1. INFO.PCD:1 A file with global information about the disk including its creation date, last update and serial number.
2. OPTIONS.PCD:1 The type of disk.
3. OVERVIEW.PCD:1 The assembled contact sheet used to print the cover of the disk.
4. STARTUP.PCD:1 The PhotoCD logo shown at the start of all viewing sessions on a player.
5. A subdirectory: IMAGES This contains the image packs for each image.

Apple PhotoCD access

On the Apple Macintosh, an extension is available with the Apple CD300 software which works in conjunction with Quicktime. This extension creates three virtual directories which appear to be on the PhotoCD. In fact, these files reside in the memory of the computer.

1. SLIDE SHOW This is a Quicktime movie of all the images on the disk.
2. SLIDE SHOW VIEWER This is the application that runs the show.
3. A subdirectory called PHOTOS with five subdirectories, one for each of the image sizes in the image pack. All images in these folders are represented by tiny thumbnail images. Clicking on a thumbnail will result in the Quicktime software generating a PICT file of the image at the specified resolution from the information in the image pack.

The Pro PhotoCD system also offers the option of a higher quality resolution (64Base) added to the image pack. This will, however, limit the images on the disk to 30.

Pro PhotoCD formats

The reason behind the differing sizes of image is that the software makes the assumption that the image size is 35 mm; therefore any image not in the 35 mm format is packed with blank pixels. The Table below shows the information content of the unpacked image.

Format	16Base pixels	64Base pixels
35 mm	$2,048 \times 3,072$	$4,096 \times 6,144$
6 × 4.5 cm	$2,048 \times 1,536$	$4,096 \times 3,072$
6 × 6	$2,048 \times 2,048$	$4,096 \times 4,092$
6 × 7	$2,048 \times 2,390$	$4,096 \times 4,780$
6 × 9	$2,048 \times 3,072$	$4,096 \times 6,144$
5 × 4 inch	$2,048 \times 2,615$	$4,096 \times 5,230$

The major advantage of the professional service is the control you can have over the scanning process, but in order to exercise this control, an explanation of the technology is necessary.

Photographic control

To obtain best results with the PhotoCD system, certain photographic requirements are necessary. The first is the exposure of the film. Wherever possible, the exposure should be controlled to give a density range of no greater than 2.8 (this applies to any scanning process utilizing CCD technology, including drum scanners). Many photographers often underexpose transparency material by a half stop to increase colour saturation. In the case of PhotoCD, aim to give the film the 'correct' exposure. While super-saturated transparencies may look good on an art director's light box, they cannot always be reproduced successfully in print! The photographer can control the density range of the emulsion by the use of reflectors, fill-in flash and the like. Where control is not possible, it is recommended that colour negative film is used rather than transparency film. Colour negative film that is normally exposed and processed gives a density range of 2.0 in the

highlights, making it an ideal film type for the reprographic process.

Guidelines for submitting film to bureaus for transferring to PhotoCD

- Scan price for roll film is less if unmounted and uncut.
- Label each film.
- Specify if 64Base is required.
- Specify any colour corrections to be made.

PhotoCD was originally developed for the consumer market, enabling people to view images on their domestic television sets. A range of PhotoCD players is available, with analogue output to a television. Sequences of images can be programmed, and simple manipulations such as zooming and rotating images are possible. They have had limited success in this area, having found far more success with professional photographers and other imaging professionals. One major use is for exhibition displays where companies can show a series of images on large TV monitors. PhotoCDs can also be played on the CDI players marketed by Philips.

CD publishing

Many book publishers are investing heavily in CD-ROM publishing. Encyclopaedias, dictionaries, bibles and other traditional 'books' are now available in CD format, often as multimedia versions. Every secondary and primary school in the UK has a CD-ROM drive offering publishers a huge potential market for educational material.

The adoption of CD drives by computer users is increasing at a dramatic rate, and many computers have CD drives fitted internally as a standard fixture. Given the huge increase in potential users, many companies are now distributing copyright free images on CD disk. These disks contain images of subjects such as cities of the world, backgrounds for presentations, historic cars, etc. They are increasingly being published in PhotoCD format to enable the disk to be read by all the different computer platforms.

Recent examples of CD publishing that utilize photographic images are discussed below.

Letraset phototone backgrounds

This is a collection of over 500 images suitable for background material to illustrations and presentation. The CD comes with a database program on the disk to allow the user to browse through the images and create their own personal database on their computer. The collection includes such material as marble surfaces, wood bark, abstract images of nature and industrial products. The system adopted by Letraset is to supply the images in a quality suitable for display on a computer screen. Letraset grants the copyright use of the images in presentation packages at computer

screen resolution. Higher quality images can be ordered by telephone and a 5×4-inch transparency will be dispatched by post.

Coral Draw professional photos

These are a large series of disks covering a wide range of popular subjects. The disks are supplied with the images in PhotoCD format. However, the disk is not a true PhotoCD and will not play on the domestic television player. The supplied images are 'royalty free', so once the disk has been purchased, the images can be used without further payment in brochures, books, magazines, calendars and advertisements, etc. There is great controversy about their use as many photographers and photographic libraries see them as undermining their business. The cost per image is usually far smaller than traditional library fees.

Creative interactive database

This is a portfolio of the work of photographers and illustrators, created to provide designers commissioning work with examples of the character and style of various photographers and illustrators. After finding a suitable photographer, the user is then given details of the address and a contact phone number to arrange further contact. The images are designed only to display the photographer's work and no copyright is granted to the disk user on the image displayed.

Marketing images

The simplest method of marketing images on CD is to contact one of the companies currently distributing photographic images on disk. These companies are orientated towards distributing collections of similar subjects. From the photographer's point of view, a series of perhaps a hundred photographs on a specific theme would be the most attractive. Subjects could range from British birds, steam trains, classic cars, etc. As with conventional picture libraries, it is worth contacting the companies first and asking for a list of frequently requested subjects prior to any submission.

A further development would be to create and market your own images. The cheapest solution would be to have PhotoCD disks created from a number of images and advertise these in a relevant journal. A further step would be to purchase a CD writer and create your own disks, choosing the type of image file most suitable for your market.

CD writable also provides a relatively low cost method of supplying photographic work in digital format to the customer, especially as the ISO 9660 format means that any conflict between the computer platforms will be overcome.

A further development in the PhotoCD product is the implementation of the 'Portfolio' format. This allows the user to create a presentation combining PhotoCD images, photographic images from other sources, graphic files and sound to produce a presentation program on their computer. This program can then be transferred on to a Portfolio disk. The major advantage of the system is its ability

to play on any platform of computer combined with the ability to be used on a portable PhotoCD player with a domestic television without the need for a computer. The system allows the creator to incorporate a level of interactivity with the program and create menu screens allowing users to navigate their own paths through the program.

The use of products such as Portfolio and PhotoCD provides a dynamic method of presenting a photographer's work to potential clients. The relative low cost of duplicating disks compared with duplicating film originals means that a larger market can be targeted. The fact that the disk is also only a copy of the original films means that the potential loss of a disk is a less damaging from the photographer's point of view.

Mastering disks

The writable medium provides a cost-effective method of distributing small numbers of disks. When producing larger numbers of disks, economies of scale can be provided by creating a master disk and pressing copies. The cost of mastering a disk is quite high, but subsequent copies are much cheaper than their writable counterparts.

6
Outputting the image

Obviously the capture and manipulation of digital images is of little use without a method of producing printed output. The difficulty in describing output devices relates to the historical background of the technology involved in computer printers. Until fairly recent times, very few computers were capable of producing anything like a photographic image. Their main use was in word processing; consequently, printers were designed with the production of black and white text in mind. Colour printers were designed, in the main, for the production of graphic-type images, and the only photographic quality printers were designed for military satellite image production.

Graphic file formats for printers

There are two common methods of representing an image in the computer environment, bitmapped files and PostScript descriptions. Most printing devices are designed to print one or the other type of image.

Bitmapped images

These include file formats such as TIFF, PICT TARGA, etc. In a bitmapped image, the elements of the picture are mapped as individual screen display pixels. The image is stored in an array of binary information. Each pixel of the picture is represented by one bit or binary piece of information. (In the case of a greyscale bitmap, each pixel requires 8 bits which can represent 256 levels of grey.)

Magnification of a bitmapped image will show the pixel elements in its construction.

PostScript files

PostScript is an interpreter between the computer and the output device. The PostScript file translates the picture into a series of PostScript graphic drawing routines with a degree of resolution much

finer than can be represented on the screen of the computer. The image of a house could, for example, be represented by a square with a triangle on top. In the PostScript system, enlarging this image would only create a larger square and triangle. The bitmapped image would break down into the dots forming the lines of the square and triangle.

PostScript cannot record photographic images, but it can, however, handle text and graphic elements with great effectiveness. In a PostScript file, photographic elements are saved as bitmaps. Bitmap printers will print photographic elements faster and better than a PostScript printer, but the quality of text and graphic elements will not be as high. The main reason why PostScript has become the industry standard for sending desktop published pages to printers is that it is device independent – in other words, the graphical objects are defined mathematically, and it is not until the page is output on to paper that it takes on the resolution of the printer being used. The PostScript version of a printing system will normally cost more due to a licence payable to Adobe, the authors of the technology.

Printing photographic images

The printing of digital continuous tone (photographic) images varies enormously, and the quality of the output is dependent on the type of output device and the technology used. In order to understand the shortcomings or advantages of the various methods, an explanation of the methods used to emulate continuous tone is necessary.

We first need to examine the two most common forms of colour image: photographic images and images on a printed page.

Photography

In the photographic image, colour is generated by having three layers of dye, each layer corresponding to one of the primary colours, red, blue and green. Dyes are composed of a complementary colour to the layer in which they are formed, i.e. yellow dye is formed in the blue-sensitive layer, magenta dye is formed in the green layer and cyan dye in the red layer. The silver halides in these layers are converted into microscopic dye clouds, and due to the fact that each layer is transparent, a full spectrum of colours can be reproduced. The colour is controlled by increasing the density of the dye to increase the saturation of the colour. Examination of the photographic image under a magnifying glass will show a seamless graduation of colour and shade. This type of image is termed 'continuous tone'.

The printed page

Photographic images are printed (using either lithography or photogravure) in books, magazines and newspapers by a process known as halftoning. This is a method of representing the images as groups of differing size dots from the four inks used: cyan, magenta, yellow and black. The system produces all other colours by printing

mixtures of these inks, and by altering the size of the dots to emulate the new colour visually. When viewed from a distance, the impression is given of full coloured image. For example, a chequered pattern of cyan and yellow will appear green to the viewer at a distance. Close examination of any published image with a magnifying glass will show the individual dots. The size of the smallest dot is dependent on the quality of paper. Cheaper paper such as newsprint is more absorbent and the size of the dot will spread (dot gain). The higher the quality of the paper, the smaller the size of dots printable.

In the digital publishing environment, neither of these technologies lends itself to the production of a unit either affordable or small enough to be suitable for a desktop unit. Several different technologies are available, but first the decision has to be made as to the purpose of the output and the quality required.

Output devices for computers fall into two categories: printers and proofers. Printers are designed to produce prints on paper which can be used in display albums or for exhibition purposes. Proofing devices produce an emulation of how the image will look when it appears on a printed page.

The following systems are available.

Laser printers

Primarily designed as black and white printing devices, good quality colour lasers are becoming increasingly common. Their prices have fallen substantially over the last couple of years.

Method of operation

The printer contains a rotating metal drum coated with a fine layer of photosensitive material. An electrostatic charge is applied to the whole drum which can be removed by applying a light to its surface. The image to be printed is applied to the drum via a laser beam or row of LEDs (Light Emitting Diodes). A negative image of the subject to be printed is projected on to the surface of the drum The result of this is to 'undraw' the image on the drum as it rotates. The process is similar to producing a statue by chipping away all pieces of stone until the statue is complete. The end result of the operation is to leave an image of the original as an electrostatic charge on the drum. The drum rotates past a toner dispenser containing ink. The ink used has an electrical charge and is attracted to the charged image on the drum. This can then be transferred on to paper by giving the paper the opposite electrical charge leaving a black ink image on the paper. The light source scans the surface of the drum forming the image by a series of overlapping individual dots. The minimum size of the dot is the width of the light beam as it is focused on the drum. This means that all images are formed by multiples of a single dot. Note that the size of this dot does not change – larger dots can be formed by groups of overlapping dots. Colour laser printers use four drums and store image colours in cyan, magenta, yellow and black elements (Figure 6.1).

Fig. 6.1 Laser drum.

Image 'written' on to drum by laser
is coated in toner

Toner attracted to paper

Photocopiers use the same laser technology in constructing their copies, the only difference being the method of inputting the data to be recorded on to the drum. A number of large size colour photo-copiers work in a dual mode either scanning the flat copy in a similar method as the flatbed scanner system or via a computer linked directly to the printer with the information being fed to the laser drums via a dedicated computer running a Raster Imaging Program (RIP). Units such as this provide output up to A3.

Thermal wax transfer

Method of operation

This printing method works by heating a coloured wax sheet and melting it on to a paper surface. The wax is transferred or 'ironed' on to the paper by thousands of individually controlled heating elements each heated to 70–80°C which will melt a tiny pinpoint of colour. Colour is created by a four-pass system, cyan, magenta, yellow and black. Theses units tend to be relatively inexpensive (Figure 6.2).

Inkjet

Method of operation

The cheapest form of computer printer is the inkjet printer (although high-end inkjet printers, such as the Iris range, can produce near photographic quality prints at large sizes). This uses four cartridges, each filled with cyan, magenta, yellow and black ink. The cartridge contains liquid ink which is forced into a tiny nozzle either by the application of heat or pressure. As the ink heats, it forms a tiny bubble at the end of the nozzle, hence the common name of 'bubble-jet' printers. All inkjet printers work best with dedicated paper types,

Fig. 6.2 Thermal wax transfer system.

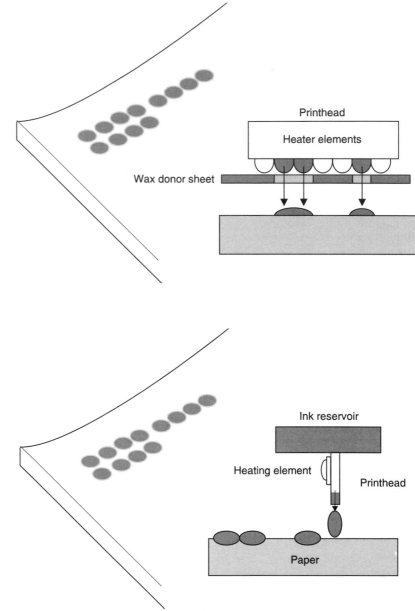

Fig. 6.3 Diagram of inkjet delivery system.

as the absorbency of the paper controls the brightness and definition of the image. It is possible to use good quality art paper for exhibition purposes.

Greyscale images are produced from a black ink cartridge, while colour machines have a two-cartridge system, one for black and another containing cyan, magenta and yellow.

Although the printing process is slow, the technology has the advantage of working at any size. By a process of scaling up the transport mechanism and the size of the nozzles, printers can be made to output prints A0 size and larger (Figure 6.3).

Resolution

The resolution of laser printers, inkjet and thermal wax printers is normally quoted in dots per inch, typically 300–600 dpi. This measurement is deceptive as it refers to the number of overlapping dots that can be printed in a line length of one inch. The actual number of visually separate dots is much lower than this.

The design of printers is based on their role as producers of high quality text. Text can be considered as individual items of line art. Therefore the higher scanning rate and the greater overlap of scan means that the continuity of the line is assured.

Laser, inkjets and thermal wax printers all use opaque colours to produce their images, so the photographic technique of dye formation to simulate colours is not applicable. Their operation also means that they are only capable of forming a single dot size, so that a true halftone technique is also unavailable.

The solution to the problem is to introduce simulated halftone representation or 'dithering'. This should not be confused with halftoning in its more established form.

In its simplest form, representative halftone is a method of representing greyscale.

The representative or simulated halftone

The complexity of the halftone system will depend on the number of different shades that the image will show. Different tones are produced by creating larger groups of dots in different patterns to represent the different shades of tone or colour in the image.

In the simplest example a matrix of 2 × 2 dots can represent five separate tones:

1. no dots yields white;
2. a single dot yields 25 per cent grey;
3. two dots yield 50 per cent grey;
4. three dots yield 75 per cent grey;
5. four dots yield 100 per cent black.

The above could equally apply to shades of a colour. By increasing the size of the matrix, the number of tones will increase. By increasing the matrix to 4 × 4 the system is capable of printing the 17 tones from 0–16. With a similar colour dithering pattern, using the cyan, magenta and yellow colours, a representation of all other colours can be achieved (Figure 6.4).

File size for simulated halftone devices

The effect of the simulated halftone is to reduce the effective resolution of the printer from the quoted lines per inch to a figure derived from the lines per inch divided by the size of one side of the matrix. Therefore in a black and white laser capable of 600 dpi which claims to print 256 shades of grey, the effective resolution is: 600 divided by 16 = 37.5 dpi.

Therefore, to print a 4 × 4-inch image, the required file would only be recording the difference between each group of 16 × 16 at 37.5 dpi = 22 Kb as opposed to sampling at 600 dpi = 5.5 Mb.

Fig. 6.4 Representative
halftone.

Because the printer can only print a single size dot it creates
tones by filling in a matrix of 16 dots. The lightest will have a dot
in number 0, a 50% tone will have dots in all numbers up to 8

Although other factors have been introduced to improve the
quality of the simulated halftone system, it is worth testing any
printer by producing a series of sample files and printing them until
quality becomes affected, in order to establish the optimum size
versus quality.

The other drawback of the simulated halftone is the effect of
banding, where the dots form patterns within the image.

To improve the quality of simulated halftoning, laser printer
manufacturers have introduced the capacity to produce two sizes of
dots to give smoother edges to the dot groups. In the inkjet field,
developments in paper technology and the use of transparent inks
allow output approaching continuous tone.

Continuous tone printers

These devices use the photographic principle of transparent dyes to
allow colour to be created. The technique also utilizes a slight
blurring of the individual elements of dye to allow blending between
adjacent elements of image to give the appearance of continuous
tone.

Thermal dye sublimation printer

This type of printer has become very popular in recent years, giving
improvements in both speed and quality of the image produced.

Fig. 6.5 Diagram of thermal
dye sublimation printer.

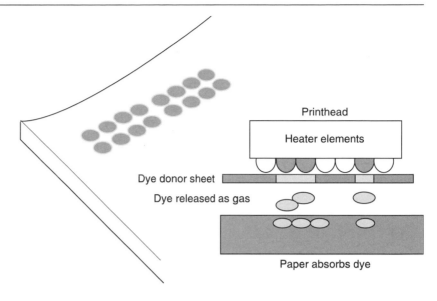

Method of operation

This system of printing uses a system of transferring a dye from
magenta, yellow, cyan and, in some machines, black ribbon on to a
paper surface. A heating element the width of the paper vaporizes
the dye on the donor ribbon surface which is then absorbed into the
surface of the paper. The image is generated by applying three or
four passes of the donor ribbon to a single sheet of paper. The regis-
tration of the paper is crucial to the quality of the final image. As
this dye is transparent, each pixel on the page can represent any
colour by varying the amount of the three or four colours. The action
of the dye being absorbed into the paper also means that the individ-
ual pixels join together to form a seamless area of colour similar to
a true photographic print.

Pictography

This system uses laser technology to beam the image on to a chemi-
cally impregnated donor sheet inside the machine. Red, green and
blue lasers are used to form the image on the surface of the donor
material which is then brought into contact with the paper surface and
heated. The activating element in the system is a small amount of
distilled water which is removed by the heating process. The donor
sheet remains in the case of the printer and as the process uses a silver-
based system, the silver can be recovered from the donor sheets.

Both these devices will deliver results almost indistinguishable from
a photograph, although they both require the use of special papers
to print the image. Prints from early dye sublimation models suffered
from fading, but later models have incorporated lamination layers
with incorporated ultraviolet filters.

Table 5.1 Comparison between 'desktop' printers

Printer type	Relative printer cost	Relative paper cost	Time 1st print	Speed reprint buffer	Relative quality	Resolution	Maximum printer paper size	Normal printer paper size	Special paper
Inkjet	Low	Medium	4 mins	N/A	Low*	300 dpi	A1+	A4	Yes*
Colour laser	Very high	Low	30 secs	30 secs	Low	600 dpi	A3	A3	No
Thermal wax	Medium	High	5 mins	3 mins	Medium	300 dpi	A4	A4	Yes
Thermal dye	High	High	5 mins	3 mins	'Photographic'	+	A3*	A4	Yes
Pictography	Very high	High	4 mins	1 min	'Photographic'	+	A4	A4	Yes

Note:
The first copy of an image requires interpretation of the computer file into a format compatible with the method used by the printer to print colour; subsequent prints require shorter times as the last print is held in the printer's memory/buffer.
+ Both thermal dye and pictography use a system that makes resolution comparison unreliable.
Maximum paper size refers to the largest machines available using the technology. In the case of the inkjet printer, larger, high-end models are available, but are not included in this table. They are generally of very high quality.
* The quality of inkjet printers is dependent on the quality of paper used. For best results, use special inkjet paper.

Colour proofing

The process of creating a colour facsimile for approval by the client has long been an established practice in the publishing world. This requirement is necessary because a print run may produce tens of thousands of copies of each publication, and any mistakes in the colour, images or text must be corrected before the print run is started. There are several classifications of proof and various methods of production: positionals, position proof, composite, for position only (FPO), black and white comps. These are representations of the elements that comprise the page and show the structure only and no attempt is made to give colour accuracy.

Soft proof or on screen preview

This is the page as represented on the computer monitor. The colour, contrast and resolution are limited by the calibration and construction of the monitor. Always bear in mind that the monitor display is composed of glowing phosphorescent dots, while the printed output will be composed of ink or dye on paper. Also, try to achieve a constant viewing condition for the monitor. In the same way that proof colour prints should be viewed under a standardized light source, so should computer monitors.

Typical position proof devices

1. Thermal wax printers.
2. Low cost inkjets.
3. Laser printers.
4. Colour photocopiers.

Digital proof or colour comp

This is an attempt to represent the page content and colour using a technology other than the ink on paper process. The danger here is that the gamut of the two output devices differs substantially. The process can give a good result if the image is modified by a colour space system to represent the limitations of the CMYK colourspace of the final published result. This manipulation of the image requires a skilled operator who is aware of the input and output profiles of the input device and target device, as well as the intervening processes that will affect colour. The major drawback of this type of proof is that the actual structure of the image will differ from the printed page.

Typical 'digital proof' devices

1. High-end inkjets (e.g. Iris printer).
2. Thermal dye sublimation printers.

Contact proof or separation-based proof

This attempts to simulate the actual dot structure, dot gain and colour of the final printed page. This is more accurate but expensive. The

four separations are created as four separate sheets on clear film and viewed together in a register termed an overlay proof, or alternatively the four colours are created on layer material and laminated on to a single sheet termed a laminated proof.

Typical 'contact proof' systems

Matchprint A system devised by 3M uses a method of creating four-colour CMYK separations using the same data that will generate the final printing plate. Each separation is placed on the relevant coloured laminate and the resulting sandwich exposed to ultraviolet light. The coloured laminate softens when exposed to the light and a process is applied to remove the softened areas leaving a positive image of each layer constructed of the same dots as the printed page. The process is applied to the four layers of coloured laminate which are then bound in register and sealed.

Cromalin A solution produced by the Dupont Company uses the same technique of generating the four separations CMYK. However, the separations have a laminate applied to the backing of each film. The action of exposing the film to ultraviolet light hardens the exposed areas and leaves the unexposed areas with a sticky surface. After each exposure the laminate is passed through a processor containing finely powdered pigment of the appropriate colour which adheres to the surface. After all four layers are assembled, the surface is covered with a protective film and the composite layers hardened.

Although expensive to produce, these proofs do use the same dot structure and colour gamut as the final printed page.

Kodak Approval System This is a thermal dye sublimation system that uses the same dot structure to print the four colours on to the page. The dye ribbons in the printer are calibrated to the output inks, and the system has the great advantage of being able to print the image on to the same paper stock as the final printed page.

Press proof or press check

The final, and most expensive form of proof, this is a page printed using ink from the actual plates that will print the page. The process of making the page is complete and this is the final opportunity for checking that everything is acceptable. Any correction done after this stage will be very expensive as the plates will have to be remade.

Printing to film

Many designers, picture researchers and art buyers are happiest when dealing with transparencies rather than proof prints. There are several ways of outputting digital information to film.

Presentation graphics

Most printing devices such as thermal dye sublimation offer the option of printing on to film rather than paper. The quality of the

output will be directly proportional to the paper output quality, but will usually be good enough for projection on overhead projectors, but not for reprographic purposes. To return an image to photographic film, a large amount of data is required.

Analogue film recorders

These use a cathode ray tube on to which the image is projected. Three successive exposures are made by a camera system, one for each of the three primary colours. This system can be regarded as the automated version of photographing the computer monitor in a darkroom using a convention camera system. Resolution is always dictated by the resolution of the CRT display. Normally using 35 mm film, this type of recorder is primarily aimed at the presentation market.

Output resolutions of film recorders, showing file sizes and suggested uses.

Resolution	Number of pixels	Approx. file size	Suggested use
2 K	2,048 × 1,366	10 Mb	35 mm presentation slides low–medium quality repro.
4 K	4,096 × 2,732	35 Mb	Up to 4 × 5-inch transparencies 'photographic quality'
8 K	8,192 × 5,464	150 Mb	10 × 8-inch transparency superb quality

Digital film recorders

This system uses a laser or LEDs (Light Emitting Diodes), to 'draw' the image on to the surface of the film. The resolution can be increased by controlling the dot forming the image and the number of pixels it draws to form the image. The system is designed to recreate 10 × 8-inch transparencies from images retouched on high-end systems. The size of files needed to generate a film image is very large. A 5 × 4 transparency would typically require 60 Mb of data. It is also possible to produce negatives, which can then be printed on to photographic paper.

Film recorders depart from convention by expressing their resolution in K rather than dots per inch. K refers to the number 1,024, meaning the addressability of the system. Typical values are 2 K, 4 K and 8 K. Addressability is the maximum number of pixels recorded across the length of the film output. For example, a 2 K film recorder will expose 2,048 pixels in the 1.5-inch (35 mm) length of 35 mm film.

A system has recently been introduced for output on to photographic paper. Aimed primarily at those requiring large print runs, such as estate agents or wedding photographers, two units are currently available, one exposing single sheets of paper, the other having both the exposure and washless processing unit in one machine. The system uses a CRT on the end of a fibre optic bundle, which actually comes into contact with the paper, so that no relay lenses are required. The digital information is converted into a

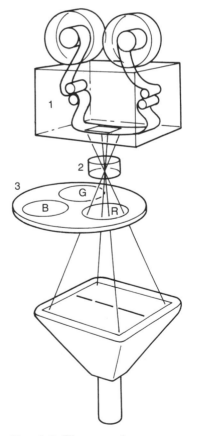

Fig. 6.6 Film recorder.

scanning beam which exposes the paper in a single scan. The first print takes approximately 5 minutes, and subsequent prints of the same image can be produced at the rate of 100 per hour. A full 10 × 8-inch print requires 21.6 Mb, and can be printed on to any surface of photographic paper. The cost per print is far cheaper than dye sublimation, for example.

7
Imaging in practice

The question of resolution and image size is very important in digital imaging, in the same way that it is to the silver-based photographer. It is a means of assessing the sharpness of an image, and quantifying the amount of detail present within the image. Various factors govern resolution in conventional photography – film emulsion, development, optics, etc. If the photographs are to be reproduced, then the final resolution will be dependent upon the printing process, the size of line screen ruling, size of reproduction, etc. The imaging process is a chain in which the quality of the final image is only as strong as the weakest part of it. Obviously, in any imaging system, the final criterion for resolution is set by the human eye. Photographers measure resolution in 'line pairs per millimetre', i.e. the ability of a photographic system to differentiate between two closely spaced lines on a test chart.

Very much the same sort of criteria apply to an electronic imaging system. The size of the CCD, and the number of pixels it contains, the processing of the image, and the resolution of the output device all need to be taken into account when trying to produce the highest possible quality images. The most important criterion for the evaluation of any input device is will the input image file provide sufficient data for the output image? A small image file does not necessarily mean low quality. Provided that the output image is small enough, the quality will be maintained.

The fact that the initial capture is just one part of the imaging process means that the creator of the digital file needs to have a greater understanding of the final output medium and work much closer with the other operations involved in its creation.

What are pixels?

The pixel (short for picture element) is the basic unit of electronic images, in the same way that silver grains are the basic units of photography. In photographic images, the smaller the grains, the more detail can be resolved by the film emulsion, and so with digital images, the more pixels within a given area of the image, so the more detail can be recorded. In fact, while silver-based photography is

always referred to as being an analogue system, it could equally be regarded as digital, in that the silver halide crystals in the exposed and developed emulsion are either converted to silver or not – in other words, it is a binary system just like digital imaging. The fundamental difference is that the grains of silver are of many different sizes within the emulsion, while the pixels are all equally sized. In a 'binary emulsion' such as lith or line film, the grains are nearly all the same size, and cannot therefore record shades of grey.

Each individual pixel has an 'address' and a value within the 'bitmap' – the grid containing the pixels. The value of a pixel is concerned with either its greyscale density or colour values. A pixel may have an address of X – 3.6, Y – 1.8, R – 240, G – 200, B – 12. This indicates that the pixel is predominantly yellow in colour. Adobe Photoshop and most other imaging programs have the facility of showing the address and value of each pixel – Photoshop has a 'Show Info' dialog box, showing the bitmap address and colour or greyscale values of each pixel.

In most systems in use today, pixels are square, but occasionally, they may be rectangular, round or even triangular. If an image with rectangular pixels is transferred into a program using square pixels, the aspect ratios of the image will be different, and a correction factor applied. For example, if the rectangular pixels have an aspect ratio of 2:1, the image will need to be stretched horizontally by 200 per cent to retain the proportions of the original image. Systems that produce rectangular pixels include IBM PVCs with TrueVision or Vista video boards that broadcast NTSC and PAL video. Amiga systems produce pixels with an aspect ratio of 1.45:1, while TARGA files for the PC have an aspect ratio of 1:0.97. The quality of the input file size should always be dependent on the final output usage.

Resolution This is the most important factor as it dictates the quality of the image. Undersampling the data in the image will result in pixelation appearing in the final result. Oversampling will result in wastage of time, storage space and money.

The term 'image resolution' refers to the number of pixels within an image, and is measured in pixels per inch. An image recorded with a Kodak DCS 460 camera, for example, has 2,048 × 3,072 pixels, 6,291,456 pixels in total. The resolution should be of adequate quality for the intended purpose. The term 'image size' describes the actual physical dimensions of the image. Because the number of pixels within an image is fixed, increasing or decreasing the image size (resizing) will alter the resolution. Increasing the size will cause a decrease in the resolution. Image processing programs like Photoshop have the facility to both resize and resample the image (see Chapter 4, Digital Image Processing).

When looking at the resolution of imaging devices, in particular scanners, it is important to distinguish between 'optical resolution', i.e. the actual number of picture elements on the CCD, and higher resolution created by the process of interpolation. A scanner may be advertised as having a resolution of 1,200 dpi, where in actual fact it had an optical resolution of 600 dpi, interpolated to 1,200 dpi by the scanning software.

Colour depth (bit depth or pixel depth) Again this must be of adequate quality to supply the output medium with sufficient

information. This refers to the number of bits of stored information per pixel. A pixel with 1 bit of information has only two possible values, white or black. A pixel with a bit depth of 8, has a possible 2^8, or 256 values, and a pixel with a bit depth of 24 has a possible 2^{24}, or over 16 million possible values.

Computer platform Although the current trend is for more open interchange between computer platforms, there is a fundamental advantage to working on the same platform as the other members of the production process. Conversion can have detrimental effects on the image quality, and may lead to problems in subsequent stages of the process.

The minimum and maximum file sizes for most output devices are easy to calculate, although the working area between these two limits is large, and the optimum solution can only be obtained by running tests to ascertain the quality. However, finding the *optimum* file size for a given use will save time and money in every part of the operation.

Let us examine each of the possible output media in turn to ascertain the suitability of input file size and quality.

Output media

Computer monitor resolution

This relates specifically to the display on the monitor, and should not be confused with image resolution. It is usually measured in dots per inch (or sometimes pixels per inch). Most monitors have a resolution of 72 dpi (or 75 dpi). An image with a resolution of 144 pixels per inch will be displayed at twice its actual size on a 72 dpi monitor (only 72 of the 144 pixels can be displayed in one inch on the monitor). If the images produced are only to be viewed on a monitor, such as with multimedia applications, then the images should be resized to 72 dpi if necessary.

The choice to the provider of images for computer use is whether to choose to deliver the best image possible at the maximum size monitor commonly available, or to choose to cover the lowest common denomination of system requirement. For a specific application such as an information booth, the size of monitor and the bit depth of the screen will be a known quantity and the problem should not arise.

For programs with a more general application, the general rule of thumb is to deliver an image suitable for a 12-inch monitor capable of viewing 256 colours. This will give a file size for whole screen images of about 300 Kb.

The images in most multimedia programs have a colour depth of 256 adaptive (indexed) colours. This is done for two reasons. First, the file size is reduced by a third, and second, the majority of users have monitors capable of displaying this type of image. The use of adaptive palettes means that the file refers the 256 colours to a specific 'Look-Up Table' (LUT) biased in favour of the colours in the image. If this LUT is produced well, the image displayed will be very nearly the same quality as a 24-bit image.

Internet

It is worth noting that delivery over the Internet means that not only do the restrictions mentioned above apply, but the speed of the current modem-based systems dictates that file sizes must be as small as possible if the delay between receiving images is to be viable.

Hard copy

As mentioned in the printer section, the file sizes are dependent on the output technology.

Laser printers/inkjet printers

These printers are only capable of printing a single colour ink. Other colours or shades must be created using groups of dots to represent a single shade or colour. This means that a single pixel of information in the original image is represented by a group of dots on the page. This process means that the 'effective resolution' of the printed image is lower than the value quoted for graphic or text output.

The formula for minimum file size (effective dpi) when dealing with images is: output resolution in dpi, divided by the square root of the number of shades that the printer is capable of printing. For example, a printer rated at 600 dpi, capable of printing 256 shades of grey:

$$\text{effective dpi} = 600/\sqrt{256} = 600/16 = 37.5 \text{ dpi}$$

For a greyscale image 4 × 4-inch in size, the file size will be:

$$37.5^2 \text{ (no. of pixels per sq. inch)} \times 16 \text{ (no. of sq. inches)} = 22 \text{ Kb}$$

For systems using more elaborate methods of printing, larger files will produce better results and experimentation is recommended.

For thermal dye sublimation printers the effective dpi is the dpi quoted for the printer, as the construction of each pixel dictates its colour or shade. Therefore:

$$\text{the size of file} = (\text{resolution per inch})^2 \times \text{size of image in sq. inches}$$

Using a printer with a resolution of 300 dpi capable of colour printing: for a 10 × 8-inch image, the optimum file will be

$$90,000 \times 80 \times 3 \text{ (for the three 8-bit colour planes)} = 21.6 \text{ Mb}$$

Again experimentation with smaller file sizes and observing image quality is recommended.

Film output

Analogue film recorders
In the case of film recorders, the image is displayed on a high definition monitor and photographed on to film, to be used in 35 mm slide-projected presentations. The monitor can display resolutions of 2–4 Mb of data.

Digital film recorders

This system uses lasers or LEDs to write the image on to photo-graphic emulsion which is then processed. The process is very expensive but does yield results indistinguishable from film exposed in camera. The size of file will depend on the size of film to be written. A typical file written to 5 × 4-inch film will be in the region of 60 Mb.

A formula to determine scanning resolution for output film size is:

$$\text{scan resolution in ppi} = \frac{\text{film recorder addressability}}{\text{output film length}} \times \text{scale factor}$$

For example, using a 35 mm film recorder with 2 K resolution, a 35 mm slide should be scanned at 1,365 dpi, i.e. 2,048 divided by 35 × 1.

The printed page

The majority of images processed by the computer are intended for use with desktop publishing systems, which implies that they will appear in a printed form as the final output. The printed page uses a system that is not compatible with all the computer binary representation of colour and shades used so far in the process. We will now examine the various stages in preparing an image for the printed page.

Stage one: Create the required resolution of image

The language of the printed page requires some explanation before any assumptions of image resolution are made.

The resolution of printing systems when dealing with images is quoted in lpi (lines per inch). The quality of the final image is dependent on several factors including the ink and paper quality. Typical values for different paper types used in the print industry are as follows:

Newsprint	80–100 lpi
Books	133 lpi (including this one)
Magazines	150–175 lpi
Quality reports	200–300 lpi

This measurement is a reference to the screening process formerly used to generate the dot images on the page. The process involves sandwiching a finely ruled grid screen with the receiver material in a process camera and exposing a photograph through the grid. The nature of the grid dictates that the image is broken into discrete samples, a quasi digitization of the image into small samples. The action of the grid means that the resulting image is formed as single dots in each of the squares forming the grid. The process generates a negative image in which the lighter the tone, the smaller the dot, and the darker the tone, the larger the dot. This image composed of dots can then be transferred to a printing print and used to reproduce the original image with ink dots. The number of dots per inch is dictated by the ruling of the screen, with each screen being suitable

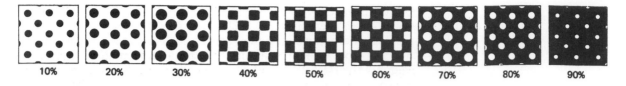

| 10% | 20% | 30% | 40% | 50% | 60% | 70% | 80% | 90% |

Fig. 7.1 Halftoned images are made up of black and white dots, in different proportions (top). Magnified screened image (bottom)

for a certain paper type and printing press. The only method of changing the number of dots is to use a different screen.

Since the advent of image setting equipment, the generation of the dots is performed by computer software and the image setter equipment writes the image to film. The computer generates a halftone dot in a similar manner to the laser simulated halftone, however, the major difference between the two systems is the image setter which is capable of thousands of dots per inch thus generating patterns far too small to be distinguished from screen-generated dots.

Resolution ratios (Q factor)

Printers use a concept known as a quality factor, or Q factor (sometimes known as a halftoning factor) when deciding what resolution is required for a particular output size.

The resolution of the original digital file is in pixels per inch or dots per inch, and the printing world uses lines per inch. The question arises as to which ratio of pixels to lines gives the optimum result.

Less than 1:1 (dp < lpi) If less than one pixel per line is used, the image will display pixelation and the software will have to interpolate between pixels to generate information. The user has no control over this process and the end result is dependent on the software's interpolation capablities. If a smaller file has to be used, the best compromise is to interpolate the file size in an imaging software package, allowing the user to choose the interpolation method (bicubic, nearest neighbour, etc.) and examine the result prior to printing.

1:1 (dpi = lpi) If the number of pixels matches the number of lines, the resulting image can display artefacts such as aliasing and colour artefacts introduced by the screening angles used to avoid moiré patterns.

Given therefore that the requirement in the conversion from dpi to lpi requires an over-sampling, the next question is how much should that over sample be?

1.25–2.0:1 (dpi > lpi) The standard rule of thumb used by the majority of the print industry is to supply twice as many dots or pixels as lines. This figure is worth testing, however, with ratios between 1.25 and 2:1, and it may well be found that there is no perceptible difference between them. Using smaller file sizes leads to a saving in both time and material cost.

2–2.5:1 (dpi ≫ lpi) The extra information supplied at ratios of 2:1 and greater gives no perceptible addition in quality. In ratios of over

2.5:1, the information is ignored by the PostScript RIP conversion process entirely.

Therefore by experimentation, a Q factor can be found within the region of 1.25–2:1. The following guidelines can be used to start the experimentation process:

1. Values of Q from 1.25 to 2.0 work well for halftone dot images: choose a Q value of 2 if screen ruling is 133 lpi and below; choose a Q value of 1.5 if screen ruling is above 133 lpi.
2. Values of Q over 2 are wasteful, leading to large file sizes.

With the advent of new screening processes such as 'stochastic' (FM, Frequency Modulated) screening, lower pixel resolutions are possible, with the Q factor falling as low as 1:1.

Figure 7.2 shows the same image scanned at various resolutions, and printed using various screen rulings. Trials like this are worthwhile to determine optimum scan resolutions for a particular application.

For desktop imaging, we have one of three possible scenarios for the conversion of an image:

1. A device with a set resolution (digital camera, supplied image file, etc.). The only question here is how large can this image appear on a printed page?

$$\text{Calculation of maximum image size in inches} = \frac{\text{Pixels}}{Q \times \text{lines per inch}}$$

For example, what is the maximum horizontal dimension of a Kodak DC40 camera file using a Q value of 1.5 and a lpi of 133? (The camera's CCD chip has 756×504 pixels.)

$$\text{Digital camera DC40 maximum image size} = \frac{756}{1.5 \times 133} = 3.78 \text{ inches}$$

2. Calculate the required number of pixels for a given print size. Given control of the scanning process, i.e. a flatbed or film scanner, how many pixels are required for a given final image size?

 Provided that the resolution of image and print are in the same units, i.e. inches,

 picture size \times lpi \times Q = number of pixels

 or:

 lpi \times Q = required resolution in dpi

 It is also possible to calculate the resolution from the magnification of the image, in which case the formula is:

 lpi \times Q factor \times enlargement factor

 or:

 lpi \times Q factor \times (size of final image/original image size)

65 lpi

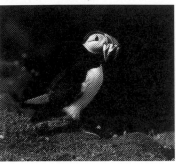

75 dpi

133 lpi

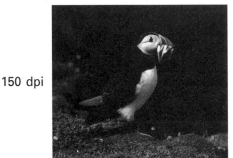

150 dpi

150 lpi

300 dpi

Fig. 7.2 Three examples of screening vs. resolution.

For example, a 5-inch printed image is required from a 2.25-inch negative, using 133 lpi, and a Q factor of 1.5:

$$133 \times 1.5 \times (5/2.25) = 443.33 \text{ pixels}$$

3. Choose the correct resolution. With a system such as PhotoCD, which resolution is the correct size for a desired printed image size?

The formula for the number of pixels will be the same as the required pixel size

$$\text{no. of pixels} = \text{lpi} \times \text{Q factor} \times \text{final image size}$$

For example, the printed image is to be 6.5-inches from a portrait image on PhotoCD and printed at 150 lpi

$$\text{no. of pixels} = 150 \times 1.75 \times 6.5 = 1{,}706 \text{ pixels}$$

The choice of five Master PhotoCD image pack resolutions is 192, 384, 768, 1,536, 3,072 pixels. Since the interpolation process in the

transfer is not under the user's control, the best option is to choose the next highest value, so the 3,072 pixel image is preferable to the 1,536. This image could then be resized in the appropriate image software package to give the required 1,706 pixels. The one rule is that if the required file is not obviously one of the given resolutions within a few pixels, then use the next size up and reduce the size of the file in software.

Stage two: Apply any necessary processing to the image

Changes in colour and tonal range should be applied at this stage. An important factor to note is the calibration of the levels contained in the image. Most printers apply a tone in the highlight areas of a printed image and reduce the amount of ink in the shadow areas. To this end, the levels contained in an image run between 10–15 to 240–245 instead of the normal 0–255. Modifications of the levels contained in the image should take this into account.

Stage three: Apply unsharp mask if required

Applying the sharpening tool after retouching ensures that the alterations to the image have the same level of sharpening. Most retouching tools apply anti-aliasing to changes in the image, this can be apparent in a loss of grain in the image when applied over a sharpened area.

Stage four: Convert the image to CMYK

There are a number of factors involved in this stage which require a level of understanding of the printing process to be used.

1. Choice of ink separation tables. This dictates the type of printing process in terms of paper ink and press to be used.
2. Undercolour removal or grey component replacement. These processes affect how information common to the cyan, magenta and yellow channels is controlled. Liaison with the printer is necessary, as choosing the wrong system will result in an unprintable image.
3. Checking of colour gamut. This option, available in image processing programs such as Photoshop, allows the user to check if any of the image colours are unprintable, given that the target gamut of the printed image on paper is smaller that the image gamut. Colours outside of the printable area can be desaturated until they fall within the required gamut.
4. Adjustment of dot gain. This is the correction for the bleeding of the ink dot into the paper surface causing an apparent increase in density to the image. Changes to the dot gain controls compensate for the effect. Adjustment should only be done in consultation with the printer.

There are several software packages that deal specifically with the separation of RGB images into the required CMYK format and

serious users of digital images in publishing should investigate these as they will offer far more control over the process than a general purpose package.

8
Communications

We are constantly being told that the telecommunications revolution is here. Companies are busy installing fibre optic and other types of cable to give us more and more television channels and greater choice with our telephones. Videophones and video conferencing are now a reality, enabling face-to-face meetings or participation in conferences thousands of miles away. The Internet has grown rapidly over the last couple of years, and now provides a means of accessing data from computer and imaging companies, communicating via e.mail, and marketing work and services. For photographers, this revolution will mean the transmission of images much faster and easier than ever before. Systems like Kodak's Picture Exchange will give publishers in London, for example, the ability to view images on their computer screens from stock libraries around the world.

This chapter examines the possible scenarios in communications, and the viability of using these systems for image transmission. The subject is littered with jargon and we can only introduce the subject here. The reader is advised to consult specific texts on computer communications for a full account.

Local connection

The most obvious need is to communicate with other computers within the same building or room. The person creating a page in a desktop publishing program needs to collect all the images and text together from a number of different computers. This can be done using a Local Area Network (LAN). The system works by giving each computer or printer an individual address. The software acts as a postman delivering or retrieving files between different computers or allowing several computers to share a common device such as a printer.

The configuration of a LAN can be as simple as a connection cable between two computers or as complex as hundreds of machines connected together over several geographically remote sites, requiring full-time supervision to maintain the service. They all share one factor in common in that there is a permanent physical connection

between the machines and that it is specifically designed for the transmission of computer digital data.

The simplest method of communication between two or more computers is the LocalTalk system – a four-wire cable that allows two-way communication. This option is inexpensive but slow – a typical transfer rate for data is in the order of 230 Kb a second. A more common solution is Ethernet. With this method, coaxial cable is used which allows much higher rates of transmission, up to 10 Mb per second and is, therefore a much better proposition when dealing with large image files. Note that these transmission rates are only the speed that data can be sent, and the performance of the computer will determine the actual speed of transfer.

The next step in communication is to exchange data between computers without a permanent connection. An obvious method is to use the telephone network.

The telephone network

This analogue system is designed to carry audio human voice frequencies in the bandwidth 300–3400 Hz. Although this does not carry the range of frequencies of a high fidelity music player, the bandwidth is sufficient to be recognizable and therefore usable. The system is not capable of carrying the digital signals that are used by computer systems.

Transmission over phone connections

The telephone network operates over copper wire conductor cables. A single copper wire is perfectly happy carrying the frequencies associated with voice transmission, but the resistance of the connection would be too great for the relatively small signals used in computing, and phone system amplification technology is incompatible with digital signals. Therefore, the only viable conclusion is to convert from digital to analogue. However, other factors will limit the analogue frequency that can be used. As the frequency increases, or in the case of data, the rate at which data is sent, the cable becomes more resistive to the signal. This resistance is called impedance. As the impedance increases, the signal stops trying to travel through the cable and instead travels across the surface of the wire. This means that on high frequency signals, only the outside surface of the cable is required. Hence the use of hollow cables in coaxial systems such as television signals. The impedance can increase to the point where the cable will stop transmitting the signal. Another effect associated with the transmission of high frequencies is inductance. This is the magnetic component of the electric signal interacting with other cables to produce interference on the signals they carry.

Because the system uses analogue signals, it allows the operator to utilize a method called 'frequency division multiplexing' to save money and cables on routes between major cities. The system samples the wave-forms of several calls, and takes a small time sample from each, constructing a sandwich of all the calls. The new signal, consisting of all the calls together, is sent down a single cable.

At the end of the cable the small time slices of each call are reassembled into their individual conversations. Due to their analogue nature, the missing data is not perceived. However, if a digital file were sent over such a system, the missing data would probably render the signal useless.

The solution to these problems is to use a device called a modem. This 'modulator/demodulator' converts the digital on/off signals into an audio signal suitable for the phone network. The device also works in reverse, and decodes the audio signal back into the digital format. The standard for all modems is 'Hayes-compatible' which is a brand name that has become synonymous with the product. A non-Hayes-compatible modem will not communicate with the majority of other systems. Points worth looking for are status lights that keep you informed of the progress of the transmission, and the ability to switch on a loudspeaker and listen to such things as lack of dial tone, crossed lines and ringing tone.

Modems are rated by a 'V' series of standards, set by the CCITT – the Consultative Committee for International Telegraphy and Telephony. One example is the V.32 bis modem, which has a data throughput of 14,400 bps.

Modems are rated in terms of their speed of transmission under ideal conditions. To examine the viability of using such a system, the units used need to be converted into a more recognizable format.

The standard unit of modem speed is bps (bits per second) or baud rate. The two terms are often misused. A modem modulating at 300 baud does transmit data at 300 bps per second, but at figures over 1,200, the two terms are not interchangeable. Although the term baud is widely used, the correct and most accurate term to use when specifying modems is bps. Typical speeds are 1,200 bps, 2,400 bps, 4,800 bps, 9,600 bps, 19,200 bps and 28,800 bps.

In dealing with digital files, the standard unit is the byte, so, 1,200 bps = 150 bytes per second (1,200/8), 2,400 bps = 300 bytes per second, etc.

For example, to send a 1,000,000-bit image over a system using 1,200 bps would take 1,000,000/1,200 = 833 s = 13 mins. However, to send a 1 Mb file would be eight times this = 104 mins.

Even at the fastest speed, assuming perfect connection and ignoring the fact that some data is needed to control the data flow, the speed is only 19,200 bps = 2.4 Kb per second. Considering that the majority of image files are perhaps several Mb of data, transmission over telephone networks is only practical using high levels of image compression. Note also that the perfect connection is seldom achieved, and the modem will attempt to slow the connection to a rate at which the transfer of data is sustainable.

The standard speeds used by most systems is either 2,400 bps or 9,600 bps. Very high transmission rates usually require matched modems of a specific type at each end of the connection. Smart modems are now available that will search for the fastest connection possible and will uprate or downrate the transmission rate to give the combination of fastest connection to least number of errors. Transmission rates are limited by the transmission medium (e.g. copper wire) and the switching capabilities of the network. In the United States, 64,000 baud is a standard transmission for digital networks, but only a few cities are equipped with such systems.

Transmission speeds

The following table illustrates transmission times of a 32 Mb file at various telecommunications speeds:

Baud rate	Time
10 Mb/sec	20 sec
1.5 Mb/s	2.1 mins
64,000 bps	52 mins
56,000 bps	1 hr
19,200 bps	4 hrs
9,600 bps	8 hrs
2,400 bps	32 hrs.

The transmission software

Most modems come with software, but they may not be the most user friendly. In general the more you pay for communications software, the less you have to do. The software will work out most of the technical issues itself. With modems and modem software, the user configurable controls can be terrifying. This is not for the faint hearted or the random button-pusher, so a list of the possible options, explanations and the normal defaults is given below.

File format The best format for both the PC and Macintosh Platform for bitmapped images is TIFF. Further details of this and other image file formats can be found in Chapter 4.

Data size This is the size of the chunks of information that the modem sends. They can be compared with the words in a vocal communication. The standard unit is 8-bits.

Data compression Most modems have the ability to compress data before transmission. The CCITT standard is V42 bis, which gives a 4:1 compression ratio in optimum conditions.

Stop bits These units are added by the modem to indicate the end of a chunk of information, similar to the spaces between words in a sentence. The normal default is 1 bit.

Parity This is a check on whether the data being transmitted is the same as the data received. This technique has been superseded, so normal setting is 'none'.

Handshake This is the signal used by the receiving computer to halt the flow of data when it is busy writing to disk, processing data, etc. Normal default is XON/XOFF.

File protocol This is the system by which both computers decide on a standard recognition system to establish the end of a parcel of chunks of information, and has replaced the function of the parity bits.

The verbal equivalent would be establishing whether a sentence, paragraph or page should be sent before it is checked as being correct. This replaces the parity error checking feature.

File protocols are usually independent of the system so you can choose the most suitable and the receiving system should follow suit.

XMODEM One of the most commonly used protocols sends data in 128-byte blocks. This is a good system on poor telephone lines due to the fact that only small amounts of bad data need to be sent again. However, the system checks every small amount and so sending extra data can be slow.

XMODEM -1 K Sends 1,024-byte blocks and therefore is faster than XMODEM.

ZMODEM A smarter system that works out the optimum block size for the condition of the phone line. It is the better choice, but if the system is throwing up a large number of retries, try XMODEM.

When travelling abroad, be aware that there are a host of different phone connectors in use, so always carry a range of different ones. Also, some countries (Germany, for example) require permits to send data through voice phone lines, so check before your visit.

ISDN (integrated services digital network) One method of improving the transmission rate is to use lines dedicated to data signals which carry voice, data and images in digital form. The connection requires that the user leases a special line between the computer and the telephone exchanges connection to the ISDN network. The computer also requires a special interface and software to connect with the system. Rates of 64,000 bps are possible with such a connection transmission. This gives an effective data rate of 8 Kb per second. A realistic attitude would still consider this too slow for uncompressed images.

Currently, the only technology available that offers the possibility of data transmission rates usable by large images fibre optic cabling. Fibre optics rely on the signal being sent down the inside of a glass tube as bursts of infrared light. As a carrier of information, light is thousands of times more effective than electrical signals. The light signal requires less amplification than its electrical counterpart, and since light waves carry no magnetic component, the problem of interference is eliminated. In general, the transmission capacity of fibre optic is only limited by the speed of the computer connected to it. The major problem with fibre optic is the cost of installing a complete new network of lines across the country. Television and communications companies are installing hybrid fibre optic. This is a system using fibre optic to connect junction points of the system but using cheaper copper connections to actual subscribers thus reducing the viability of the system. The ideal solution would be to connect the fibre direct and although the cost of the glass cable is cheaper than its copper counterpart, the skill and techniques required to connect two separate pieces of optical cable make the procedure very expensive. The problem is that the cost involved requires a major commitment to digital systems and currently in Europe, only Telecom Italia has committed itself to institute the provision of an optical system direct to the user.

CellPhone The boom of the 1980s is the cellular telephone network, but due to the systems currently used, they are unsuitable for data transmission. New systems are being introduced aimed at the data market but no standards have been set yet.

The Internet One area of the communications revolution which no one can have avoided recently is that of the Internet. It has expanded with extraordinary speed and can, if used judiciously, offer the electronic imager many services from acquiring information, communicating quickly with clients and marketing. Statistics abound, but it is thought that there are currently 30 million users, and by the year 2000, this will have risen to 750 million. Many of the computer and imaging manufacturers have their own 'home pages' with details of new products, software upgrades and technical information. At the time of writing, Kodak had information on its range of digital cameras and a selection of images from the smallest which could be downloaded and examined on the user's own computer. These could be accessed as JPEG compressed files or as raw TIFF files. Several newspapers, journals and magazines are available on the Internet, and several model agencies put model cards on the system. Photographers can place images in their own home pages, while others seeking employment can place their CVs, possibly in multimedia format. Another popular service available with the Internet is electronic mail (e-mail) where messages and files can be sent from computer to computer.

No one institution owns the Internet – service providers such as CompuServe supply the connection to it. Here, we can only offer a brief introduction to the subject, together with a separate glossary of frequently encountered terms – the Internet seems to have evolved its own language!

The Internet is basically a global network of computer networks. It was conceived back in 1969, when the Defense Advanced Research Projects Agency (DARPA) in the United States, set up a network of four computers from different sites for exchanging information. The system was called DARPANET. This had expanded to 37 computers in 1972, and the name changed to ARPANET. Up until the early 1990s, the Internet was still mainly used by government and academics.

To use the Internet, you need a computer, modem and access provider. Details of modems were given earlier in this chapter, but for Internet use, you need either a 14 400 or preferably a 28 800 bps model. Most models nowadays are fax/modems so that they can double as a fax machine as well if required.

Access providers include CompuServe, Demon and Pipex. It is worth checking the services of these providers very carefully – some have low start-up costs and relatively high monthly charges, while others offer the opposite. Choose one which has a 'POP' (Point of Presence) near to you. If not, you will be using your telephone to call long distance every time you use the system.

To search or browse the Internet, you need browser software. Two of the most common are Netscape and Mosaic. Netscape provide several 'search engines' where different types of information can be searched for.

Glossary

This is specific to the Internet: other items pertaining to communications will be found in the main glossary at the end of the book.

Browser This is the software that acts as the translator for digital data, and turns it into readable Internet pages.

E-mail This enables you to send and receive messages direct to and from your computer. An e-mail address is needed.

FAQ (Frequently Asked Questions) Most newsgroups have specific pages to deal with these, so as not to clog the system with simple questions.

ftp (file transfer protocol) This is the method by which software can be downloaded from a remote computer. Many computer companies maintain a free-access ftp site – anonymous ftp, for software upgrades.

Gopher An Internet searching device (derived from 'Go For' information), usually found within the browser.

HTML (Hypertext Mark Up Language) This is the computer language used by the World Wide Web for constructing pages with information. This data can be text, images, etc., which can be 'linked' to other pages. Many software packages such as Claris Works and Microsoft Word have HTML editing facilities.

POP (Point of Presence) The location of the access provider.

WWW (World Wide Web) A multimedia browser that can handle text, graphics, sound, video, images and all other Internet services. Browsers, such as Netscape, have the ability to handle data so that data can be sent both ways.

Useful Internet addresses
Adobe: WWW.Adobe.com
Kodak: WWW.Kodak.com
Photon: (Britain's first photographic magazine on the Internet): http://www.scotborders.co.uk/photon/

9
Ethics and legality of digital imaging

In February 1982, the front cover of *National Geographic Magazine* had a photograph of the Egyptian pyramids, with camels in the foreground, set against the setting sun. The image made a superb cover. However, when originally shot, the pyramids were too far apart to fit the cover format, so they were moved closer together using digital imaging technology. The photographer was understandably angry at the modification of his image. *National Geographic* now have a policy of not modifying images. The computer used at the time was very large and expensive, and out of the reach of most photographers and magazines. With the coming of smaller, cheaper machines, the ability to enhance and modify images has now been placed in the hands of a great many people. The British tabloid press use the techniques routinely. A photograph on the cover of the *Sun* newspaper, on 30 June 1993, purported to show a monk who had run off with a young woman. However, the image that appeared was actually a composite of three photographs, the woman, the monk's head, and someone else wearing a monk's habit. Another example showed the Duchess of York's daughter, Princess Beatrice, suffering from chicken pox, who was photographed on a skiing holiday in Switzerland. Two newspapers published the pictures, the *Star* and the *Sun*. The pictures published in the *Sun* showed the princess with far more spots than that in the *Star*! Another example is that of British lorry driver Paul Ashwell who was imprisoned in Greece. The *Daily Mirror* was instrumental in obtaining his release and photographed Mr Ashwell in a *Daily Mirror* T-shirt. The *Sun* changed the name on the T-shirt to the *Sun*! One image which has caused much debate and controversy was of O. J. Simpson, and appeared on the cover of *Time Magazine*. This had been tonally altered digitally, some claiming that it was done to give Simpson a more sinister appearance.

These examples lead to inevitable questions of the ethical use of images, and legal questions of copyright violation. With increasing numbers of images being available on CD-ROM, many photographers are worried that their pictures may fall into the wrong hands, and be used or modified without their permission.

The old adage that 'the camera never lies' has never been true. The photographic process is in itself manipulative, recording three-

dimensional reality on to a two-dimensional surface of chemicals. No film gives a true replica of an original scene, merely a representation. Even the use of different films on the same subject can give totally different interpretations of that subject, while photographers routinely use different focal length lenses to distort perspective to give different emphasis to images. Even the act of framing an image in the camera to exclude part of a scene or cropping it afterwards can alter an image's message. Also, since the very early days of photography, photographers have constructed images, either in the camera by double exposing film, or in the darkroom by printing several negatives on to the same sheet of paper. Oscar Rejlander was an expert in this area, constructing some very complicated images in the 1850s. In other instances, photographers have manipulated their subjects, perhaps to recreate an event after it happened. Much controversy still surrounds Joe Rosenthal's famous image of the 'Raising of the Flag at Iwo Jima', and Robert Capa's image of a Spanish soldier being shot, and whether they were posed for the camera. Photographs and television coverage of police officers removing human remains from a house in Gloucester in March 1994 certainly *were* posed for the press. In another famous example, Trotsky is shown sharing a platform with Lenin in a photograph from 1917, but when the photograph re-emerged some years later, Trotsky had disappeared, crudely painted out, presumably at the instigation of Lenin. Other examples abound from the Communist world.

Electronic imaging in the form of television has been with us now for over 50 years, and post-production manipulation of television images is very widespread. Adding new backgrounds to scenes, removing telegraph wires and even removing or adding foliage to change the season or the period are often the norm in television drama production units.

So image manipulation is not new, but it is perhaps now easier and quicker than ever before. The British press at present is being closely scrutinised for its intrusion into the private lives of the Royal family and other famous people, and has agreed to set up a self-regulatory body, although it is unclear how it will deal with digital manipulation of images. Hopefully this will also oversee the use of digitally manipulated images, and ensure that they are used appropriately. Many publishing houses in the United States have issued statements outlining their own policy regarding image manipulation. One produced by the San Gabriel Valley Publishing Company states:

> the purpose of all editorial photography is to convey the scene as accurately as possible. There is no such thing as an innocent alteration of a news photo. There will be no alteration of any photo by any means, digital or conventional, for any purpose other than to enhance accuracy or to improve technical quality. If there is an element of a photo which is deemed unsuitable for publication, then that element may be cropped out, or another frame chosen. Cloning and similar digital or conventional techniques are specifically forbidden to be used for this purpose. If the offending element cannot be cropped out and there is no other suitable frame available, then no photo will run.
>
> Changes may be made, for accuracy – enhancement purposes only, under the guidance of the photographer who took the picture, or some other editorial staff member who was present at the original scene.

Colour balance is to be achieved by using known colours such as white or a flesh tone. Colours will not be enhanced for the purpose of making a photo aesthetically 'look better'. Photos may not be reversed left-to-right.

The ethics of image manipulation are being debated in several other areas of photography, in particular wildlife and natural history photography, where images can be constructed in the computer. Many wildlife photographers are purists, maintaining that a true wildlife image must be shot in the field, as the action happened. Others maintain that manipulating images after the photography, perhaps including zoo pictures in a natural setting, puts less stress on the animals, and that providing the action shown could have taken place then the image is perfectly legitimate (for example, Plate 3). As with all ethical debate, there are no easy answers. One thing is certain though that as the technology exists, someone will use it for the purpose of manipulation.

Several picture libraries now employ 'computer artists' to create new images, often using existing material. One in particular, Tony Stone, labels the images that it sends to clients, enabling them to choose whether to use digitally manipulated images or not. Three levels of manipulation are recognized:

1. Digital composite: where the image may be composed of several others, or have quite significant changes to the original.
2. Digital enhancement: this might have distortion, elements of image stretching or radical alteration of contrast or tonality.
3. Colour enhancement: where significant changes have been made to colour values.

These alterations would be noted on the caption to the image.

The illegal use of images or infringement of copyright, however, is another issue altogether. The Copyright, Designs and Patents Act of 1988 states clearly that the copyright holder of an image has the exclusive right to copy or publish it. Copyright is infringed when someone other than the copyright holder copies or publishes that image. The term 'copying' is defined in Section 17 of the Act as 'reproducing the work in any material form, including storing the work in any medium by electronic means'. Thus, even inputting the image into a computer is as much an infringement of the Act as reproducing it in a book or magazine. Clause 13 relates specifically to electronic storage:

Except for the purposes of production for the licensed use(s) the photographs may not be stored in any form of electronic medium without the written permission of the photographer. Manipulation of the image or use of only a portion of the image may only take place with the permission of the photographer.

It does not necessarily need to be the whole of an image that is used or copied in order to infringe copyright, but a 'substantial part of it'. Substantial is not defined, but many photographers are worried that parts of their images may be used to create new images – anything from cloudy skies to tropical beaches. There are no objective rules as to what does constitute a substantial part of an image, but in general, if the part used is recognizable, then permission from the

copyright holder is required in order for it to be used. Similar problems have arisen in the music industry where short sections of a piece of music have been joined together to form a new piece.

The Copyright Act introduced an innovatory area, that of the concept of 'moral rights'. Photographs manipulated without the consent of the copyright holder may infringe the moral rights of the photographer, even if he or she no longer owns the copyright. Under the Copyright Act, photographers have the right not to have their work 'subjected to derogatory treatment'. Section 80(2)b of the Act defines derogatory treatment as: 'distortion or mutilation of the work, or treatment that is otherwise prejudicial to the honour or reputation of the author'. No case has appeared in the courts yet, and it is interesting to speculate how a court would interpret this section of the Act. The question of what exactly constitutes manipulation is difficult. Does making an image brighter or darker for better reproduction mean that it has been manipulated? Does sharpening or blurring of the image constitute manipulation? Many images have blank space added on the top to give room for a magazine title – is this manipulation? Obviously there is the question of degree, and whether the original composition or 'feeling' of the image has been altered.

One interesting aspect of image manipulation is that of the copyright of the manipulated image. If an image is constructed from two or three separate images, each of which has a copyright owner, their original copyright remains unaffected. However, the person producing the manipulated image becomes the copyright holder of that image. Thus an image may have several copyright owners, all of whom will need to give permission for an image to be reproduced. At least one British picture library has a digital imaging suite, where new images are produced by combining existing ones. The caption to the resulting image states that it has been manipulated.

Picture libraries entering the world of digital storage are obviously concerned that producing CDs with high resolution images good enough for publication will lead to use of those images without payment. Several methods are available of making those images inaccessible. CD-ROMs are available containing hundreds of typefaces. These can be viewed on screen but if the clients want to use them, they have to make the required payment to the company, which will then issue a password to access the required font. One interesting case is that of the US stock library FPG International which in February 1994 filed a $1.4 million lawsuit against the newspaper *Newsday*. It alleged that the newspaper scanned two images from its printed catalogue, and then digitally altered them as part of a computer-generated montage. In another case, the stock library Tony Stone Images sued the Canadian software manufacturer Corel and designer Stephen Arscott for over $400 000 in 1994. Arscott had won over $100,000 in the Corel Draw World Design competition for a computer-generated design showing a Potawatamie Indian. The drawing was a direct copy of a photograph taken by Nick Vedros from the Tony Stone library. Arscott did not deny copying the photograph, but claimed he was unaware that he was breaching copyright. He claimed his drawing was legal as it had been transferred from one medium to another. The case was unresolved in October 1995.

Ray Hammond, in the *UK Press Gazette* wrote:

> Now that image libraries can be put on the Worldwide Web ... we can expect to see an explosion in (such) repurposing of information over the next few years.
>
> What about copyright? ... there are immense difficulties.
>
> Many of those from a computing background shrug, and argue that individual rights over images will have to disappear in the on-line age. Those of us more concerned with human issues know there must be a better answer ... a solution to this issue must be found before we can move safely to the world of digital images.

British photographers should also be aware that the Copyright Act applies only to images used in the UK and that all countries have differing views over what constitutes copyright, some countries do not recognize copyright in any form whatsoever. Most countries though, are signatories to the Berne and Paris Conventions which impose upon signatory countries the obligation to uphold and respect the laws of all the other countries that have signed. This has clear implications in the implementation of international image distribution by electronic methods. For example, a CD of images with limited usage rights could be duplicated in such a country and sold in a new form.

US copyright law ranges from the sensible to the absurd. For example, the trademark 'simply powerful software' is a registered name. In the field of photographic images, they have the rule 'That when it's created it's copyright' and no piece, however small, of any image can be used without permission. In practice, the best protection for image owners is to establish clear and simple usage rights for an image with the image user. These fall into the following categories:

1. The right to reproduce the image.
2. The right to distribute the image.
3. The right to display the image publicly.
4. The right to create derivative works based on the image.

Each of these rights can be divided or limited in any of several ways: the number of times the image may be published, the type of publication the image may appear in. In the case of distribution, the length of time that the image may be marketed for and the percentage of usage fee kept by the distributing party.

The major factor to consider is that with digital imaging, any duplicate of an image is a perfect replica of the original. Photographically copied images always gave themselves away by a degeneration of quality, but now, with digital technologies, the hundredth copy of an image is identical to the first.

One area of the new technology which is causing photographers great concern is that of the 'photographic photocopying' systems being introduced. Currently, two major systems are in use, the Fuji Pictrostat and the Kodak Digital Print Station. While these systems operate with different technology, their aim is to produce photographic quality copies of photographic originals. It is now possible for someone to take an album of wedding proofs along to a shop or lab equipped with one of these devices, and have prints made from the proofs. The photographer thus risks losing business from the reprints.

While both of the devices are sold with reminders to the purchaser about copyright law, there is the worry that unscrupulous dealers will copy professional photographers' work. Indeed, one women's magazine recently published a reader's letter suggesting that the costs of wedding and portrait photography could be reduced if their favourite pictures were photocopied rather than going back to the photographer for reprints. The magazine subsequently published a retraction when it was pointed out that this was an illegal practice!

There is no easy answer to prevent this practice from increasing. The technology cannot be 'un-invented'. In the music industry where copying is rife (there can be few people who do not have a cassette [illegally] copied from an LP or CD), a surcharge is added to the purchase price of the original recording. Perhaps photographers could add a surcharge to a customer's bill if reprints are not ordered?

Several attempts have been made to safeguard digital images from copying and other misuse. Various 'encryption' systems have been developed, either to help trace images or prevent access to them. PhotoCD images can now be encrypted so that viewers can only view images at base resolution or lower without the proper password. These images can be tagged with text, to include such things as photographer, copyrights and other information.

Another system is known as 'watermarking' where images are covered with a visible watermark. This might be the photographer's or library's name, logo or other information. This method is now also available for PhotoCD. Again, high resolution versions of the images remain unavailable without the correct password.

Another recently introduced system, known as FBI (Fingerprinted Binary Information), uses another method. This changes the values of the least significant bits in a series of pixels to encode a 'fingerprint' – perhaps text. The changes are very small – perhaps less than 0.5 per cent, so that a 'fingerprinted' image will appear no different from the original. The program allows millions of possible ways of encoding the fingerprint, and because the changes are distributed throughout the image, manipulation will not remove them all. In a typical image, more fingerprinting will be put into areas of high subject detail, while areas of less significance such as backgrounds will have less encoding. The system is not foolproof though, offering only a deterrent to copying rather than making it impossible. Anyone claiming copyright infringement must gain access to the actual file of the suspect image before the coding can be found. The coding survives through any file format conversion, colour space conversion, sharpening or blurring, resizing or rotating, or compression. It can be detected even when only a part of an image has been used, perhaps in a composite. It can also be used for other digital files such as audio or video.

With the tremendous advances in electronic storage and distribution of images, a few suggestions and words of advice are given to photographers and copyright holders to help safeguard their property.

Retain the high resolution file until payment

If digital images are to be distributed as samples or proofs, a low resolution copy of the file should be sufficient for the potential

purchaser to assess the suitability of the image. If the purchaser requires time to pay, state in any contract that copyright is only transferred on receipt of payment.

Watermark the image

This operation can be simply carried out in an image manipulation program such as Photoshop or as discussed above with PhotoCD. Using Photoshop, select a large typeface with white ink, select the composite option (Edit menu, Composite Controls) make the text some arbitrary transparency between 40 per cent and 20 per cent, position the text on the page and deselect it. This will have the effect of a watermark over the image. The effect works best with large type and a single word such as 'proof' or 'copy'. This system is being employed by a number of picture libraries.

Add a logo

Design a small logo or electronic business card and digitally paste this on the image file before dispatch.

Add stickers

Place stickers on the back of the print supplied to clients, so that if they are taken to a shop for photocopying, the retailer can tell immediately that they are professional photographs and that the customer does not own the copyright.

Although these measures will protect the image, they have the disadvantage that the recipient will eventually require a high resolution copy of the file at a later date. The alternative is to release the complete file to the client, a process no more damaging than trusting them with an original transparency. The best practical advice here is to clearly mark the file in some way with details of its ownership. Although none of the following methods discussed will prevent use of the file, they will all be helpful in the case of any dispute.

Add your details to the image

In the application that you are using, use the command to increase the size of the 'canvas'. Add 5 or 10 per cent to the height of the image. This will appear as white space at the bottom of the image. Details of the photographer or agency can now be added in this new area.

PhotoCD

The PhotoCD system is capable of recording all copyright information on the disk as a permanent feature. This information should be given to the bureau at the time of scanning for inclusion on the disk. This information is displayed when the images are accessed.

Clearly mark all disks, etc., with copyright details

Place labels on floppy disks, mark all disk envelopes or CD cases with a copyright notice, together with your name address and phone number.

Add information

With the Macintosh, you can add copyright details, your name, address and phone number in the comments box associated with the file. This is done by selecting the file and choosing 'Get Info' from the file menu.

Name the file

Depending on the system, use your name or initials as part of the file's name.

Appendix
Colour and the digital image

There are a great many volumes written on the subject of colour and the reader's attention is drawn to the further reading list at the end of the book. The aim of this appendix is to restrict itself to the relevance of colour to the digital image, and the possible uses of that image.

The 'real world' colour space

The rear surface of the eye is a layer known as the retina, which contains two types of light-sensitive cells – rod-shaped cells or 'rods', and cone-shaped cells or 'cones'. The rods are sensitive to changes in intensity of light, and become most active in low light levels. At night, green grass appears grey because only the rods are operating. There are three types of cone, sensitive to red, green and blue, (colour 'blindness' is generally caused by a lack of one particular type of cone) though these are not present in equal proportions. The brain assimilates the information sent by both the rods and cones to produce the full colour images that we see. One important characteristic of human colour vision is the phenomenon known as 'colour constancy', where the same colour, when viewed under a range of lighting conditions remains the same. This is not true with photographic systems, where an object photographed in daylight will appear very differently when photographed in tungsten lighting. The image viewed by the human eye is made up of a narrow band of wavelengths in the electromagnetic spectrum. The range of wavelengths visible by the human eye lies approximately between 400 to 700 nanometres. The wavelengths appear violet at the shorter lengths through blue, green, yellow and finally red as their length increases. The information received by the human eye from any object is the effect of the object's surface in reflecting or absorbing the different wavelengths in this visible band. The colour perceived of an object or scene is made up of only the reflected wavelengths of light, the corruption or distortion caused by the object's surface. A red flower illuminated by white light appears red as it is absorbing all wavelengths other than red and it reflects the red wavelengths.

The colour perceived by a human viewer is dependent on three elements of the surface:

1. The amount of absorption and reflectance of the surface to different wavelengths of light.
2. The wavelength of the light illuminating the surface.
3. The amount of light illuminating the surface (although this will only alter how light or dark the colour appears).

The human eye can distinguish a total spectrum of shades from violet to red in the scene. This spectrum is only possible because there are an infinite number of types of surfaces all with different properties. The problem arises when these different 'colours' are represented on a single object such as a piece of paper. The reflectance of parts of the paper can be modified by the application of ink, but the physical reflectance of the paper can only be modified so far.

Since the object in a scene has no inherent 'colour', but relies on modifying or distorting the original light, the perceived colour will differ if the illuminating light itself is not white. A red flower viewed using blue light will appear black as there is no red light to reflect.

The two colour systems

In physics it is possible to create two separate systems of colour. They are generated by modifying either the wavelength of the light or the reflectance or absorption of the material.

The additive system

If the three primary colours of light, red, green and blue, are projected so that they overlap, the area where they all overlap will be white. So white light is a mixture of equal amounts of red, green and blue light. But, as can be seen, there are areas on the diagram where only two of the colours overlap. For example, where red and green overlap, a yellow appears. One way of expressing this is that white light minus blue gives yellow. Blue and yellow are termed complementary – when blue is added to the yellow light, white reappears (a blue cast on a colour transparency is corrected by the use of a yellow filter). Thus, the following combinations are:

> red and green create yellow (complementary to blue);
> blue and green create cyan (complementary to red);
> red and blue create magenta (complementary to green).

This group of six colours, together with white, is termed 'additive colour'.

The subtractive system

The second method of mixing colour relies on modifying the reflectance or absorption of the material using pigment and keeping the wavelength of the light constant as a white source. Using the secondary colours, the three colours are overlapped and three new colours are formed:

yellow and magenta create red;
yellow and cyan create green;
cyan and magenta create blue.

The theory holds that when the three secondary colours are overlapped, they generate black (transmit or reflect no light), but impurities in pigments, and the nature of the reflectance and absorption of the material mean that in practice the three combined give a dark brown colour. This, we shall see, will cause problems later.

Mapping colour

The human eye can perceive 10 million different colours. It is therefore important to provide some method of classification that will aid in the differentiation of these colours. This is essential to many people, including paint and printing ink manufacturers, photographers and designers. Such methods are termed 'colour models' or 'colour spaces'.

The major function of colour models is to describe the physical components of a colour in a way that can provide a definitive description to a third party. One of the simplest is to classify colours according to their three physical properties of hue, saturation and luminance.

A colour can be described by its three component elements:

1. Hue is the name of the colour as distinguished from others of the spectrum, e.g. red, green, yellow, etc.
2. Saturation is the percentage of the colour in a sample, e.g. less blue, blue, more blue, pastel pink, etc.
3. Luminance (brightness) refers to how light or dark the colour appears. The same object will appear lighter or darker when viewed either in bright light or shadow, but the hue and saturation of the colour will remain the same, e.g. light blue, blue, dark blue, etc.

This system of mapping colour is termed hue, saturation, luminance or HSL, and the problem is how to represent a function with three co-ordinates on a two-dimensional surface.

In the first instance, the colour or hue elements are arranged around the edge of a circle, the centre of which is given a set luminance. As the colours approach the centre of the circle, their saturation decreases. For example, examining the outer edge of the circle, the colours are at 100 per cent saturation and as they approach the centre their saturation (strength of colour) decreases until it reaches zero at the centre.

This model, however, is only true for a fixed luminance. In order to plot different values of luminance, different circles must be plotted. Increasing the percentage of black will darken the colour until at 100 per cent black no colour is seen. Similarly increasing the amount of white will lighten the colours until at 100% white. The resulting shape if all the plots are placed on top of each other is of a double-ended pyramid with a circular base at the centre plot.

In 1976 the Commission Internationale de l'Eclairage (CIE) developed two systems for measurement and calibration of colour

Fig. A1 Hue/saturation.

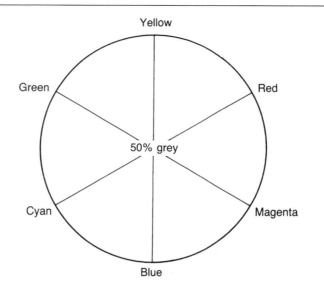

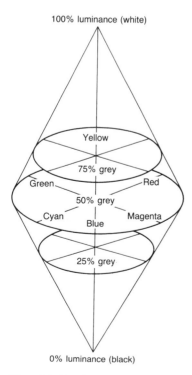

Fig. A2 Hue/saturation/
luminance.

space. The first, termed CIELUV, encompasses the range of colours available when the light source illumination is mixed. The CIELAB system covers all the colours available in the additive system, and describes the widest range of colours. In the digital world of computing, the second system is far more relevant, as it covers the subtractive mixing of colour as used in the printing industry.

The main advantage of the CIELAB system is that it is optimized for the human eye's response to colour. This means that the cross-section of the colour model is not a regular circle but rather a lopsided triangle with two curved sides. On this model it is possible to map the colour range available in different media. The area inside the plot, showing the range of colours available to the device or process is termed the 'colour gamut'.

Measuring colour

In order to utilize the system with an image, accurate methods of measuring these qualities are necessary, and various devices are manufactured for the purpose.

Colour transmission densitometer

This measures the proportion of cyan, magenta and yellow light transmitted by the film as optical densities.

Colour reflection densitometer

This measures the proportion of cyan, magenta and yellow light reflected by a colour in the case of a photographic print or printed sample.

Tristimulus reflection colorimeter

This measures the attributes of hue, luminance and chroma of a colour. It can give a more critical appraisal in creating exact colour matching.

The mapping of colour using systems such as CIE colour space should not be confused with the graphic industries' designed colour space systems. These are relevant only to graphic and text files containing specific colours such as copyright logos, etc.

Designed colour space (graphic design)

This is a matching system for the graphic designer. Colours are based on a numbered system and the designer chooses from a book of printed samples. A removable swatch of the colour or colours can be attached to the artwork. The printer can then make reference to charts of ink mixing to render the exact colour or, in the case of problem colours, apply a separate ink to the production of printing. The system works on the principle that the samples are printed on to the same type of paper and have the same finishing techniques applied to them as the required colour. Examples of this swatch system include Pantone, Focaltone and Trumatch. The major disadvantage of all these systems is that they all relate to the CMYK colour space. This space has a smaller gamut than the photographic input, therefore it works best with graphic images.

The path of an image to the printed page and the colour range available to each stage are as follows.

Photographic film

If the subject is photographed on to film, then the image is stored on a piece of film containing a silver halide emulsion. The colours are recorded by three layers each sensitive to a different wavelength of light, a blue sensitive layer, a green sensitive layer and a red sensitive layer. During processing, a dye is formed of a complementary colour to the layer in which it is formed. Thus, yellow dye is formed in the blue layer, magenta dye is formed in the green layer, and cyan dye is formed in the red layer. The amount of dye formed is proportional to the exposure. The dyes are transparent so that when the transparency is viewed, light passes through the three layers. The relative proportions of the three dyes will yield various colours. Light passing through an area containing yellow and magenta dye will give red, for example.

All the layers are transparent and the density of dye is proportional to the intensity of colour. Certain colours are achieved as follows:

Black: all three layers have full saturation.
White: no dye is present.
A primary colour: two secondary layers have full saturation (e.g. to represent red, magenta and yellow are fully saturated).
A secondary colour: just one layer is saturated (e.g. to represent cyan, just the cyan layer is saturated).

The area within the five-sided shape on Plate 6 represents the colours recordable on photographic transparency film.

The next step is to use a film scanner. This in itself uses components that affect colour, but we will ignore these for the present. The image is viewed on a computer monitor.

The computer monitor

The image is scanned into the computer where it is translated into the RGB colourspace. The first issue in the computer translation is the colour depth of the image file. To create a black and white image, the computer stores the image in a series of pixels (small dots). The image is composed of an array of these dots, each dot being either black or white. This information is processed by the computer as a series of binary numbers either 0 or 1 to represent black or white. Because these pixels are represented by a single binary digit, the file is termed a 1-bit file. The computer records a zero for the absence of light and a one for its presence.

Fig. A3 One-bit image.

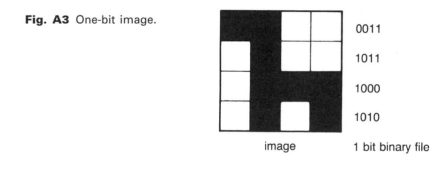

0011		
1011		
1000		
1010		

image 1 bit binary file

Binary system

In the decimal system, all numbers are recorded in groups of tens, giving the familiar tens, hundreds, thousands system. In contrast, the binary system uses a base of two instead of ten.

A single binary number will record: 0 = 0 or 1 =1. A two digit binary number will record 00 = 0,01 = 1,10 = 2,11 = 3.

Fig. A4 Two-bit image.

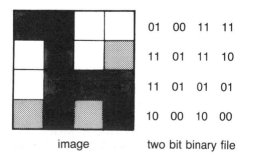

01 00 11 11

11 01 11 10

11 01 01 01

10 00 10 00

image two bit binary file

By increasing the number of bits allocated to each pixel, the number of shades of brightness will increase. This is termed the bit depth of the image.

Number of bits	Number of levels of brightness
1	2
2	4
3	8
4	16
5	32
6	64
7	128
8	256

The standard number of bits per pixel in greyscale images is 8. This will give 256 levels. The convention in computers is to count from zero. The image is recorded as black as zero and white as 255 (although some programs operate in the reverse of this). In the computer, the colour information is recorded in three channels. A single channel is dedicated to each of the three primary colours red, green and blue. Each of these channels is essentially a monochrome image, and the total number of colours available for recording will be dependent on the bit depth of a single channel.

Since all computer systems handle data in groups of bytes, and because a byte is made up of 8 bits, the simplest system is to use a single byte for all colours. Failure of the number 8 to be divisible by 3 is circumvented by allocating the blue channel only 2 bits to blue, which is chosen as the human visual system is more sensitive to red and green.

For colour images with 1 byte per three channels the total number of colours will be:

3 (red) \times 3 (green) \times 2 (blue) = 2^8 = 256 colours.

By increasing the allocation of bits per channel to 16 bits, the total number of colours will be:

6 (red) \times 5 (green) \times 5 (blue) = 2^{16} = 65,536 colours.

The maximum allocation allowed by computer processing is 1 byte per channel or 24 bits, also known as True Colour. This system gives

8 (red) \times 8 (green) \times 8 (blue) = 2^{24} = 16,777,216 colours.

Some digital systems claim to capture images at 10 or 12 bits per channel, but this data must be processed into 8 bits in order to be read by the computer. Files of this format are termed RGB files.

RGB colourspace

There are two separate issues at this stage of the translation. The first is the translation to a digital form.

Each of the smallest composite parts (pixel) of the image is divided into three channels red, green and blue, the intensity of which, assuming the image has 8 bits per colour, is represented by a numerical value between 0 and 255, dependent on its intensity. The

best way to think of this is to imagine that the value zero switches on that channel and 255 switches it off.

Certain colours are achieved as follows.

Black: the red, green and blue channels all have a value of zero.
White: the red, green and blue channels all have a value of 255.
A primary colour: just that channel has a value of zero (i.e. to represent red, the red channel has a value of zero).
A secondary colour: two primary channels have a value of zero. (i.e. to represent yellow, red and green channels have a value of zero).

Computer monitors

The next consideration is the method by which colour monitors operate. The monitor projects three tiny dots of red, blue and green light. These are so small that the human eye integrates the three colours into a single point.

Three electron guns (one for each of the three colours red, green and blue) fire electrons at a regular array of tiny circular dots of three types of phosphor coated on the inside of the glass faceplate of the screen. These emit red, green and blue light when 'excited' by the electrons. The three colours are arranged either in triangular patterns known as triads, or as strips (as in the Sony Trinitron system). These patterns are small enough that when viewed at a distance, the human eye integrates them to solid colours on the screen.

If none of the phosphor is excited by electrons, the triad appears black.
If all of the phosphor is excited by electrons, the triad appears white.
If just the red phosphor is excited by electrons, the triads appear red.
If the red and green phosphor is excited by electrons, the triads appear yellow.

The main limitation of this system is that black is only the normal colour of the screen when switched off, therefore the appearance of contrast can be deceptive. Examining the CIELAB diagram of the monitor, the area in which the colours are available is smaller, and the monitor is deficient in the green and yellow area of the spectrum.

At this stage of the process, the image is constructed of the three channels of red, green and blue, the additive system used by light. Since the final step will be the use of ink, the data needs to be translated into a subtractive system of cyan, magenta and yellow.

CMYK

The translation of an RGB image into CMY is a perfectly valid step. However, the combination of the three colours printed together would fail to produce a true black. In order to overcome the problem,

printers use a system of four-colour printing, the fourth 'colour' being black. In order to avoid confusion with blue this 'colour' is represented by the letter K. In order to be acceptable to the system used to print a page, the three-channel RGB file must be converted into a four-channel CMYK file by a suitable software program. (It is important to note that computer screens are not capable of displaying CMYK images and any image shown on the screen has been converted back into RGB to be displayed on the screen.) The page containing the file is then sent to a film plate and finally to a press.

The printing press is not able to print shades of colour in the way that a monitor can show different levels. It can only print one of four opaque colours. In order to simulate the various shades of colour, it uses the principal of halftoning. This is a method of simulating shades of colour so that they become acceptable to the human eye. Close examination of a monochrome printed page, such as a newspaper, will reveal the image as being formed of dots. The intensity of the tone will result in larger dots, white having the smallest or no dot and black the largest size of dot. Patterns of cyan, yellow, magenta and black dots give the impression of all other colours and tones. The gamut contained in the colour space is the smallest of all and is also dependent on the type of paper and printing system used.

Conclusion

Examination of the respective colour spaces available to each subsequent stage show a smaller area in each resulting in less colours being available. This degradation of the image is a certainty, given the physical laws governing each stage of the process. The only control that can be made is to ensure that the translation from each stage is done with the minimum amount of information loss.

The process of optimizing the conversion of the scanners colour gamut from, for example, a film scanner to the printed page would require the following:

1. A profile containing the colour gamut or bias of the scanner.
2. A profile for every conceivable form of printing system/media that the output could ever be printed on.
3. The user chooses a specific output medium when using the scanner.

To produce profiles for every system for every scanner would obviously be very time consuming and costly. Also the system requires that the user knows the type of use or printing press at the time of the scanning. This system would work well in a closed production environment such as a newspaper, but fails when transferred to the reality of desktop publishing.

Device-independent colour

Under this system, only one profile is required, the conversion from the colour gamut of the device into or from CIELAB colourspace. Using this common gamut (that is sufficient to contain all other colour gamuts), any input colour can be translated into any output.

The concept is similar to a publisher having authors in a number of counties. In order to share the contents of their books, either each country can translate their books into every other country language requiring vast numbers of translators, or they all choose a single language and translate their books into this common tongue. Each country now only needs a single translator. Returning to the digital image, the advantage of the system is that new devices only require conversion into CIELAB space to be compatible with all existing equipment.

Colour spaces

Currently there are a number of colour space systems, all based on this principle. Both the Macintosh and the PC are integrating colour management systems into their operating systems and independent manufacturers are also introducing colour management systems to utilize these programs.

Glossary

Algorithm A set of rules (program) by which the computer resolves problems.

Aliasing Refers to displays of bitmapped images, where curved lines appear to be jagged due to the way they are composed of square pixels (sometimes referred to as 'staircasing' or 'jaggies').

Alpha channel An 8-bit greyscale representation of an image often used for storing masking information about an image.

Analogue A signal that simulates sound or vision by electrical analogy e.g. variations in voltage producing corresponding variations in brightness.

Artefacts Extraneous digital information in an image resulting from limitations in the device used to create the image. Examples include noise, aliasing, blooming, colour fringing.

Aspect ratio The relationship between the height and width of a displayed image. For television it is 3:4.

Baud rate A measurement of the speed at which information is transmitted by a modem over a telephone line. Baud rates are in terms of bits per second (bps) and typical speeds are 1,200, 2,400 and 9,600 baud. Strictly speaking, at speeds over 1,200 bps, the terms baud and bits per second are not completely interchangeable.

Binary Numbering system using two digits, 0 and 1. In imaging terms, black or white.

Bit Short for binary digit – a single number having the value either 0 or 1. Eight bits make up 1 byte.

Bitmap A binary representation of an image, in which each bit is mapped to a point on the output device, where the point will either be on (black) or off (white).

Bitmapped An image formed by a rectangular grid of pixels, each one of which is assigned an address (x, y co-ordinates) and a value, either greyscale or colour.

Bits per pixel (bit depth) The number of bits used to represent the colour value of each pixel in a digitized image. One bit/pixel displays two colours, 2 bits four colours, 3 bits eight colours, etc. In general, n bits allows 2^n colours. A 24-bit display shows 16.7 million colours.

Blooming A problem with older CCDs that causes pixel level distortions when the electrical charge created exceeds the pixel's storage capacity, and spills into adjacent pixels. Newer CCDs incorporate anti-blooming circuitry to drain the excess charge.

Brightness range Refers to the range of brightnesses within a subject being imaged, or the range of brightnesses capable of being captured by an imaging system.

Byte The standard unit of binary data storage in memory or disk files: 1 byte containing 8 bits can have any value between zero and 255.

Cache High speed memory chips which store frequently used instructions. This is much faster than using conventional RAM.

CCD Charge Coupled Device. A solid-state image pick-up device that produces an electrical output analogous to the amount of light striking each of its picture elements.

CD-I Compact Disk Interactive. A version of CD that carrys text, audio and vision for interactive uses.

CD-ROM A form of CD used for storing digital data of all types (e.g. Kodak PhotoCD). It is capable of storing 650 Mb, but cannot be updated or changed by the user.

CD-R A recordable (once only) CD. *See* WORM.

CIE Commission Internationale de l'Eclairage. An international group set up to produce colour standards – the name given to a colourspace model. *See* colour space.

Clipping Loss of shadow or highlight detail due to the conversion of grey tones lighter than a certain value to white, or darker than a certain value to black.

CLUT Colour Look-Up Table. *See* LUT.

CMYK Cyan, magenta, yellow and black. The four colours used by printers to produce printed colour illustrations.

Colour fringing An artefact in CCDs where colour filtering conflicts with information in the subject.

Colour space A three-dimensional space or model where the three attributes of colour, hue, saturation and brightness, can be represented e.g. CIE colour space, Munsell colour space.

Colour trapping A printing term referring to the solution to slight misregistrations in the printing process. If two colours are misregistered, a white line will appear around the object. Trapping is the process of adding extra colour to fill in the gap created. Programs such as Photoshop have trapping capabilities.

Compression A digital process that allows data to be stored or transmitted using less than the normal number of bits. Video compression refers to techniques that reduce the number of bits required to store or transmit images. Compression can be lossless, lossy or visually lossless. There are several types, of which the JPEG standard is becoming widely accepted for imaging.

DCS Digital Camera System. The name for Kodak's digital camera, based on the MegaPixel imager attached to conventional Nikon cameras.

Desktop colour separation. An image file format consisting of four separate CMYK PostScript files at full resolution plus a fifth EPS master for placement in documents.

Digital A signal that represents changes as a series of discrete pulses – bits.

Digitize Convert into digital form. Digitization is subdivided into the processes of sampling the analogue signal at a moment in time, quantizing the sample (allocating it a numerical value) and coding the number in binary form. A digital image is made up of a grid of points. There is no continuous variation of colour or brightness. Each point on the grid has a specific value. Digital images are recorded as data, not as a signal.

DIMM Dual In-Line Memory Module. A modern version of the SIMM (qv.) used to increase the RAM of a computer.

Dithering A method for making digitized images appear smoother using alternate colours in a pattern to produce a new perceived colour e.g. displaying an alternate pattern of black and white pixels produces grey. It has also become widely used as a reference to the process of converting greyscale data to bitmap data, and thus to a reduced grey tone content.

Dot gain The increase in the size of the halftone dot when it is printed on paper with ink. The effect is caused by the ink spreading into the paper.

Dots per inch The measurement of a printer's resolution – the maximum number of dots that can be printed per inch of page e.g. 300 dpi.

Dynamic range A measurement of the range of light levels recorded by a CCD or other sensor.

EGA Enhanced Graphics Adapter. A standard that specifies 640 × 350 pixels with 16-colour capability from a palette of 64 colours.

EPSF Encapsulated PostScript Format. This refers to a standardized disk file format used widely in desktop publishing software. It is a file containing PostScript (qv.) commands, with additional data to enable it to be incorporated in other documents. The main data is 'encapsulated' by these additional commands.

Ethernet A system of networking computers and peripherals together to send data rapidly to each other.

FPO For Position Only. A low resolution version of an image used to indicate its position within a document.

Field Half of a picture, composed either of the odd or even line scans which interlace to form a complete frame.

File formats The overall format in which an image file is saved. Choosing the correct format for saving images is important to ensure that the files are compatible with various software packages. Examples include TIFF, EPS, PICT.

Filter A software routine which modifies an image by changing the values of certain pixels. Examples are sharpening filters and distortion filters.

Floppy disk The name given to a 3.5-inch disk (or 'diskette') used for storing relatively small amounts of computer data. There are two capacities available, double density (storing approximately 700 K) and high density (storing approximately 1.4 Mb).

Floptical The name given to a 3.5-inch magneto-optical disk.

Frame Video data is transmitted as two interlaced fields which make up a frame. In a 50 Hz system, a complete frame is transmitted every 1/25th second.

Frame grabber Hardware that takes the analogue signal from an imaging device and digitizes it into RAM.

Gamma The relationship between input data from an electronic image and output data telling the monitor how to display an image.

Gamut The range of colours which can be displayed or printed on a particular colour system.

GUI Graphical User Interface. A computer interface such as the Macintosh system or Microsoft Windows, which uses graphical icons to represent computer functions.

HMI Hydrargyrum Medium Arc Iodide. A specialist type of light source which is continuous and flicker free, and is recommended for certain digital cameras.

Hard disk The term used either for an internal or external rigid disk used for reading and writing computer data. Many different capacities are available, including several types which are encased in plastic and can be removed from the drive mechanism (e.g. Syquest).

Histogram A graphical representation of an image showing the distribution of grey or colours levels within an image.

Image processing Techniques that manipulate the pixel values of an image for some particular purpose, e.g. brightness or contrast correction, changing the size (scaling) or shape of images, or enhancing detail.

Imagesetter A high resolution device producing output on film or photographic paper usually at resolutions greater than 1,000 dpi. Usually a PostScript device.

Indexed colour A single-channel image with \8 bits of colour information per pixel. The index is a CLUT containing up to 256 colours. This range of colours can be edited to include those found within the image.

Internet The worldwide network which links computer systems together.

Interpolation A method for increasing the apparent resolution of an image whereby the software mathematically averages adjacent pixel densities and places a pixel of that density between the two.

ISDN Integrated Services Digital Network. A telecommunications standard allowing digital information of all types to be transmitted via telephone lines.

ISO speed The rating applied to photographic emulsions to denote the relative sensitivity to light. Most digital cameras have 'equivalent' ISO ratings, to enable comparison with film.

JPEG Joint Photographic Experts Group. A widely used compression routine used for still photographic images.

Lines per inch The scale used by printers when specifying the halftone screen used in a printing process. This book uses a screen with 133 lpi.

LUT Look-Up Table. A preset number of colours used by an image (sometimes CLUT – colour LUT).

LZW Lempel–Ziv–Welch. A lossless compression routine incorporated into TIFF.

MAVICA Magnetic Video Camera. The first still video camera, produced by Sony in 1981.

Modem MOdulate and DEModulate. A device for converting digital signals into analogue for the purpose of sending data down telephone lines.

MPEG Motion Picture Experts Group. Like JPEG, a standard compression routine, used for video, audio and animation sequences.

Multimedia The combination of various media e.g. sound, text, graphics, video, still photography, into an integrated package.

Noise Random, incorrectly read pixel data or extraneous signal generated by a CCD, even when no light is falling on it. May be caused by electrical interference.

NTSC The TV standard used in the United States and Japan. Has 525 lines/60 fields.

Object-oriented A graphics application, such as Adobe Illustrator, using mathematical points based on vectors to define lines and shapes.

OCR Optical Character Recognition. Software which, when used in conjunction with a digital scanner, converts pages of typescript text into editable computer data.

Paint A program which defines images in terms of bitmaps rather than vectors.

PAL The TV standard used in the UK and much of Western Europe. Has 625 lines/50 fields.

Parity A form of error checking when transmitting data.

PCMCIA card Personal Computer Memory Card International Association. Formed in 1989 to establish worldwide standards for credit-card sized memory devices. Various types are available including Type I, II and III.

PDL Page Description Language. A set of instructions which relays to the output device information relating to the placement of images, text and other data. An example of PostScript.

PEL *See* Pixel.

PhotoCD Kodak's proprietary system of recording film images on to a CD disk.

Pick-Up device A camera tube or solid-state image-sensor that converts light on its target into an electrical analogue. In the case of solid-state devices, this is a matrix of minute photosensitive cells called a CCD.

PICT The name given to Apple's internal binary format for a bitmap image. A PICT image can be directly displayed on a Macintosh screen or printed. The resolution is relatively low, and the images cannot be scaled to another size without loss of detail.

Pixel Picture element. The smallest area capable of resolving detail in a pick-up device or displaying detail on a screen, thereby fixing the maximum horizontal resolution. Conventional TV/video does not have pixels (sometimes called 'pels'). The image from the CCD in a camcorder is in the form of pixels, but is converted to a continuous video signal.

Pixellation A subjective impairment of the image in which the pixels are large enough to become visible individually.

Platform The type of computer system e.g. Macintosh or PC.

Plug-In A small piece of software often supplied with scanners and other peripherals, allowing the user to access and control those devices through an image processing software package such as Adobe Photoshop. Many third-party manufacturers (such as Kai's Power Tools™ and Convolver™) market extra filters and other

special effects as plug-ins to programs like Photoshop. When installed, the plug-in becomes an item on one of the program's menus.

PostScript A page description language used in laser printers to simulate the operations of printing, including placing and sizing text, drawing and painting, graphics and preparing halftones from digitized greyscale images. It has become a standard way of 'driving' high quality printers.

RAM Random Access Memory. Temporary memory created when the computer is switched on. The size of images which can be opened is dependent on how much RAM is installed in the computer.

Raster A series of scanning lines which provides uniform coverage of an area. The number and length of the lines are related resolution.

Raster graphic A graphic image, created by scanners, digital cameras or 'paint' programs, which has individual components that are individual pixels.

Replication A form of image resampling where the exact colours of neighbouring pixels are copied. This should only be used when doubling or quadrupling resolution i.e. 200, 400, 800 per cent, etc.

Res A term used in place of ppi to define image resolution. Res 12 equals 12 pixels per millimetre.

Resampling Changing the resolution of an image, either by discarding unwanted pixels or interpolating new ones.

Resizing Changing the size of an image without altering the resolution. Increasing the size will lead to a decrease in image quality.

RIFF Raster Image File Format. An image file format for greyscale images. Has the chief advantage of offering significant disk space savings by using data compression techniques.

RIP Raster Image Processor. A device which converts a page description language such as Postscript into the raster form necessary for output by an imagesetter, film recorder or laser printer.

RISC Reduced Instruction Set Computing. A modern microprocessor chip which works faster than previous versions by processing fewer instructions (found in the Apple PowerPC computers, for example).

RGB Red, Green, Blue. The three primary colours used in monitor displays.

ROM Read Only Memory. A memory unit in which the data is stored permanently. The information is read out non-destructively and no information can be written into memory.

Resolution The ability of a recording system to record and reproduce fine detail. There are two resolution figures in video: horizontal and vertical. Video resolution is given as lines per picture height. In digital systems, resolution is the number of pixels on a display surface. CRT resolutions are usually given as number of pixels per scan line, and the number of scan lines eg. 640×480 NTSC, 768×512 PAL. Printer resolutions are usually given as dots per inch e.g. 300 dpi. A CCD may have resolution figures of 600,000 pixels, giving 1,212 pixels horizontal, by 500 vertically delivering 480 lines of horizontal resolution.

SCSI Small Computer Systems Interface. An industry standard for connecting peripheral devices to computers.

Signal to Noise Ratio The relationship between the required electrical signal to the unwanted signals caused by interference (usually measured in decibels: db).

SIMM Single In-Line Memory Module. A small circuit board containing chips used to increase the RAM of a computer.

Soft display The display of images on computer monitors or television screens.

Stochastic screening A new alternative to conventional screening that separates an image into very fine, randomly placed dots as opposed to a grid of geometrically aligned halftone cells.

Sublimation The process by which a solid becomes a gas without first passing through a liquid phase.

SV Still Video. An electronic still camera employing a solid-state pick-up device in the focal plane, and recording the analogue signal on a SV floppy disk (or memory card) for subsequent playback. The disks can record 50 fields or 25 frames together with a limited amount of audio. The disks can be erased and re-recorded.

Syquest Proprietary name given to a range of removable hard disks.

Thumbnail A very low resolution version of an image used for sorting and finding images.

TIFF Tag Image File Format. A standardized image file exchange format. It has been adopted by many manufacturers which support high resolution graphics. TIFF files cannot be printed directly, they must first be loaded into an application.

TGA (Targa) A file format used for saving and transferring 24 bit files on PCs.

TWAIN Technology Without An Interesting Name. A cross platform interface for acquiring images with scanners and framegrabbers.

USM Unsharp masking. A procedure for increasing the apparent detail of an image, performed either by the input scanner or by computer processing.

VGA Video-Graphics Array. An electronic display standard that defines a resolution of 640 × 480 pixels with a 16-colour capability, and 320 × 200 pixels resolution with a 256-colour capability from a palette of 256 K colours.

Vector graphic An image composed of geometric shapes such as curves, arcs and lines rather than the pixel-based bitmap.

Video The analogue electrical signal generated by an image sensor.

Virtual memory A technique for increasing the apparent size of memory available by using memory from the hard disk. It is generally very slow.

WORM Write Once, Read Many Times. An optical disk that can only be recorded once with data. This cannot be erased or changed.

WYSIWYG What You See Is What You Get. This refers to the relationship between the screen display and final output.

YCC A colour model which is the basis of Kodak's PhotoCD system.

Further reading

This is not intended to be an exhaustive list of books and articles on digital imaging but more of a list of major references that we have found particularly useful.

Books

Agfa. A series of booklets on various aspects of digital imaging, including: *An Introduction to Digital Scanning, Digital Colour Pre-Press*, Vols 1 and 2, and Digital Photo Imaging.

They are available from: Agfa Pre-press Education Resources, PO Box 200, Stephenson Road, Groundwell, Swindon, Wilts SN2 5AN.

Baxes, G. (1994) *Digital Image Processing*, Wiley. A good, easy to understand account of the technicalities of image processing. Includes floppy disk with DIP program and test images for PCs.

Cost, F. (1993) '*Using PhotoCD for Desktop Prepress,*' RITC Research Corporation.

Gosney, M. and Dayton, L. (1995) *The Desktop Colour Book*, MIS Press, New York. A good, easy to understand introductory guide.

Green, P. (1995) *Understanding Digital Colour*, Blueprint, Graphic Arts Technical Foundation. An excellent introduction to colour reproduction processes. Includes CD-ROM with test images, etc.

Hunt, R.W. (1995) *The Reproduction of Colour* 5th edn, Fountain Press. One of the standard textbooks on colour photography and imaging systems.

Jackson, R., MacDonald, L. and Freeman, K. (1995) *Computer Generated Colour*, Wiley and Sons. A good general introduction to colour on the computer.

Kammermeier, A. and P. (1992) *Scanning and Printing*, Focal Press, Oxford. A good general introduction to digital scanning and output.

Pfifner, P. and Fraser, B. (1994) *How Desktop Publishing Works*, Ziff Davis, Calif. An excellent guide with outstanding illustrations.

Index